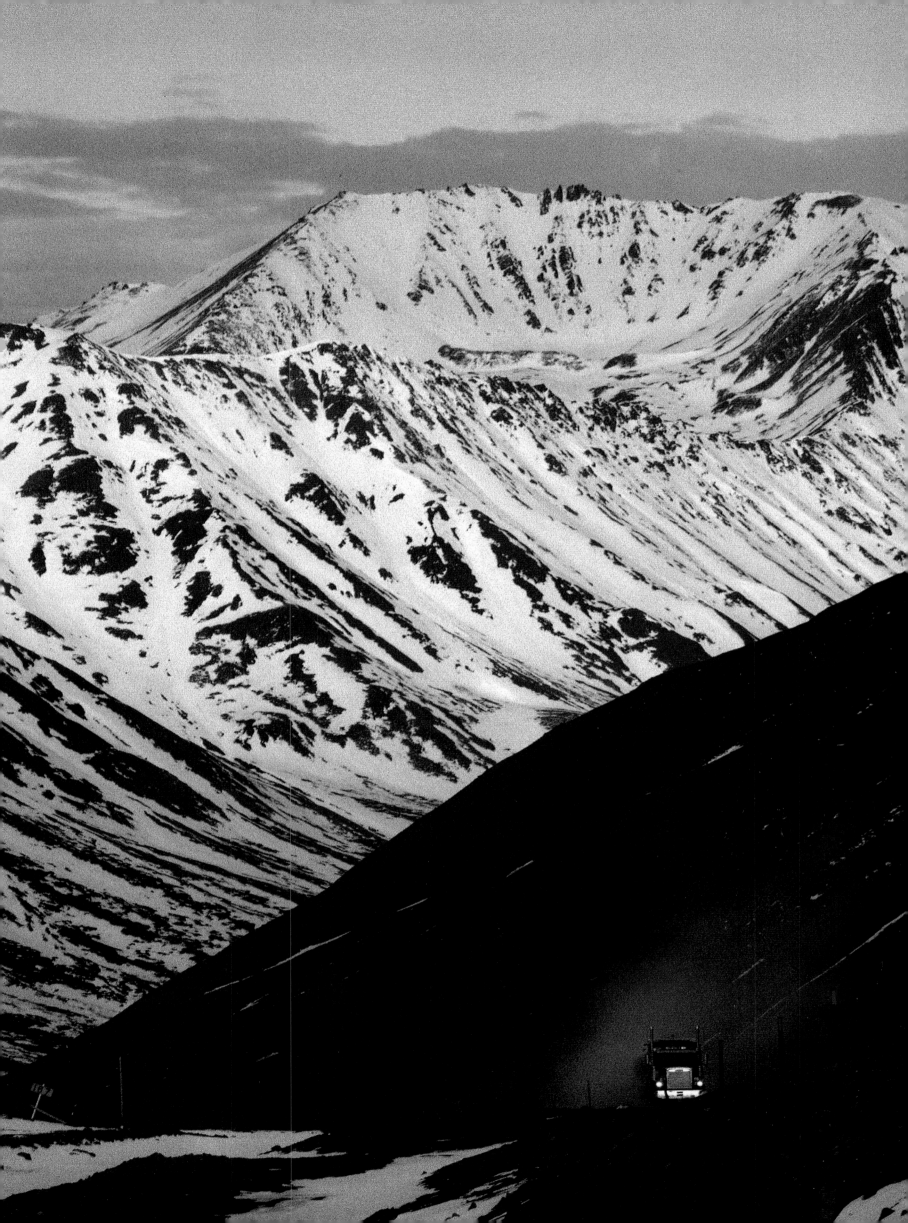

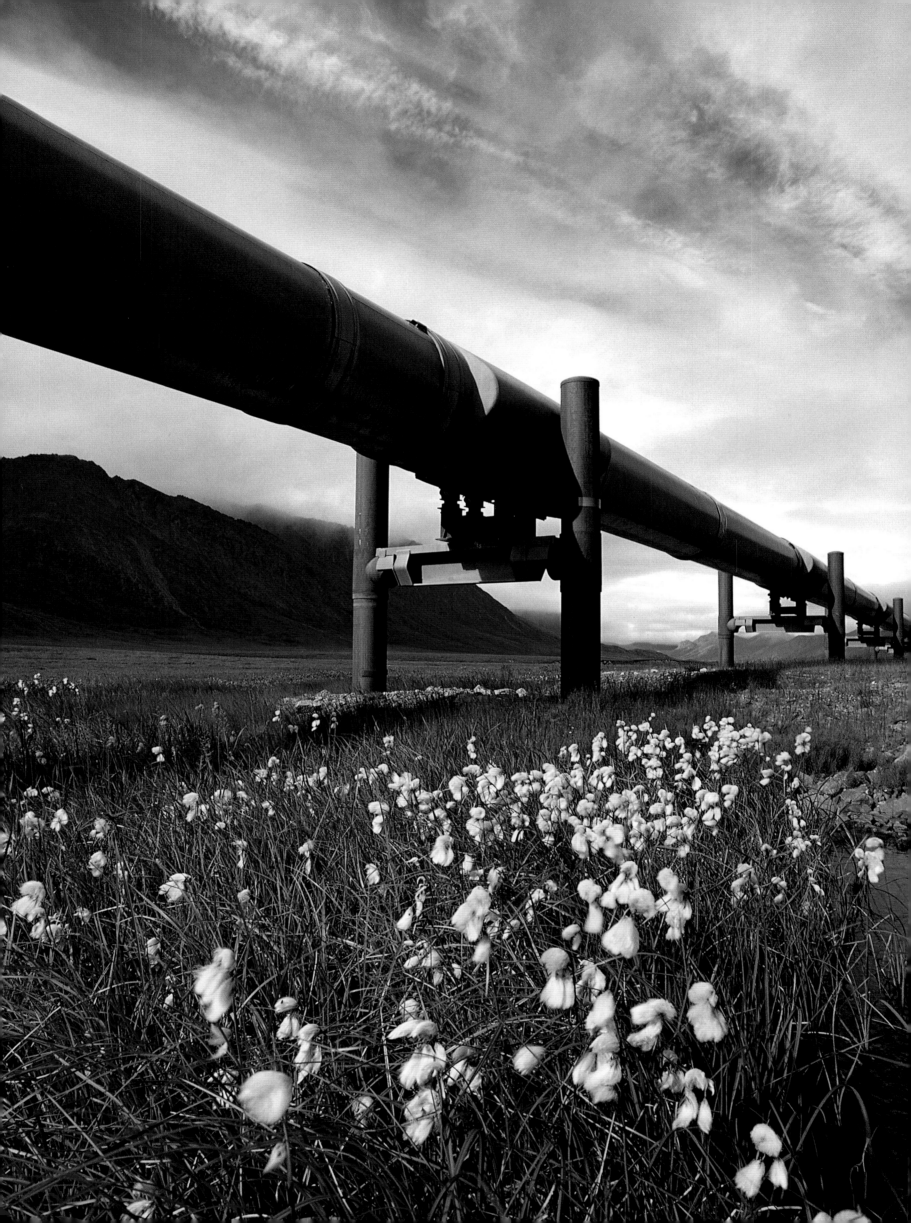

CROSSING ALASKA

ESSAYS BY MICHELLE A. GILDERS

FOREWORD BY GOVERNOR TONY KNOWLES

GRAPHIC ARTS CENTER PUBLISHING®

International Standard Book Number 1-55868-309-7
Library of Congress Number 97-70192
Photography copyright notice see page 144.
"Alaska's Flag" song © by the University of Alaska
is reproduced on page 27 with permission.
Quote from *The Trans-Alaska Pipeline Controversy* © by Associated University Presses
is reproduced on page 39 with permission.
Essays and compilation of photographs © 1997 by Graphic Arts Center Publishing Company
Published by Graphic Arts Center Publishing Company
P.O. Box 10306 • Portland, OR 97296-0306
President • Charles M. Hopkins
Editor-in-Chief • Douglas A. Pfeiffer
Managing Editor • Jean Andrews
Photo Editor • Diana S. Eilers
Technical Editor • Robert Senner
Research Assistant • Wendy Rousalis
Designer • Robert Reynolds
Production Manager • Richard L. Owsiany
Cartographer • Ortelius Design
Book Manufacturing • Lincoln & Allen Co.
Printed in the United States of America

To the thousands of men and women who built
and operate the trans-Alaska pipeline,
and to its neighbors across Alaska.
MICHELLE A. GILDERS

Graphic Arts Center Publishing
Company thanks Alyeska Pipeline
Service Company and its employees
for the opportunity and access that
made this book possible.

We didn't know it couldn't be done.
FRANK MOOLIN JR.,
a senior project manager
during construction,
Alyeska Pipeline Service Company.

◁ ◁ A winter scene greets a truck in Atigun Pass in the Brooks
Range. Atigun Pass crosses the Alaska Continental Divide separat-
ing rivers that drain north into the Beaufort and Chukchi Seas from
those that flow south and west to the Bering Sea. ◁ Elevated on
vertical support members, or VSMs, the forty-eight-inch-diameter
pipeline straddles cottongrass *(Eriophorum angustifolium)* and
other tundra vegetation. △ Milepost 0, at Pump Station 1 on
Alaska's North Slope, marks the start of the eight-hundred-mile
trans-Alaska pipeline. It crosses three mountain ranges and more
than eight hundred rivers and streams before reaching Valdez.

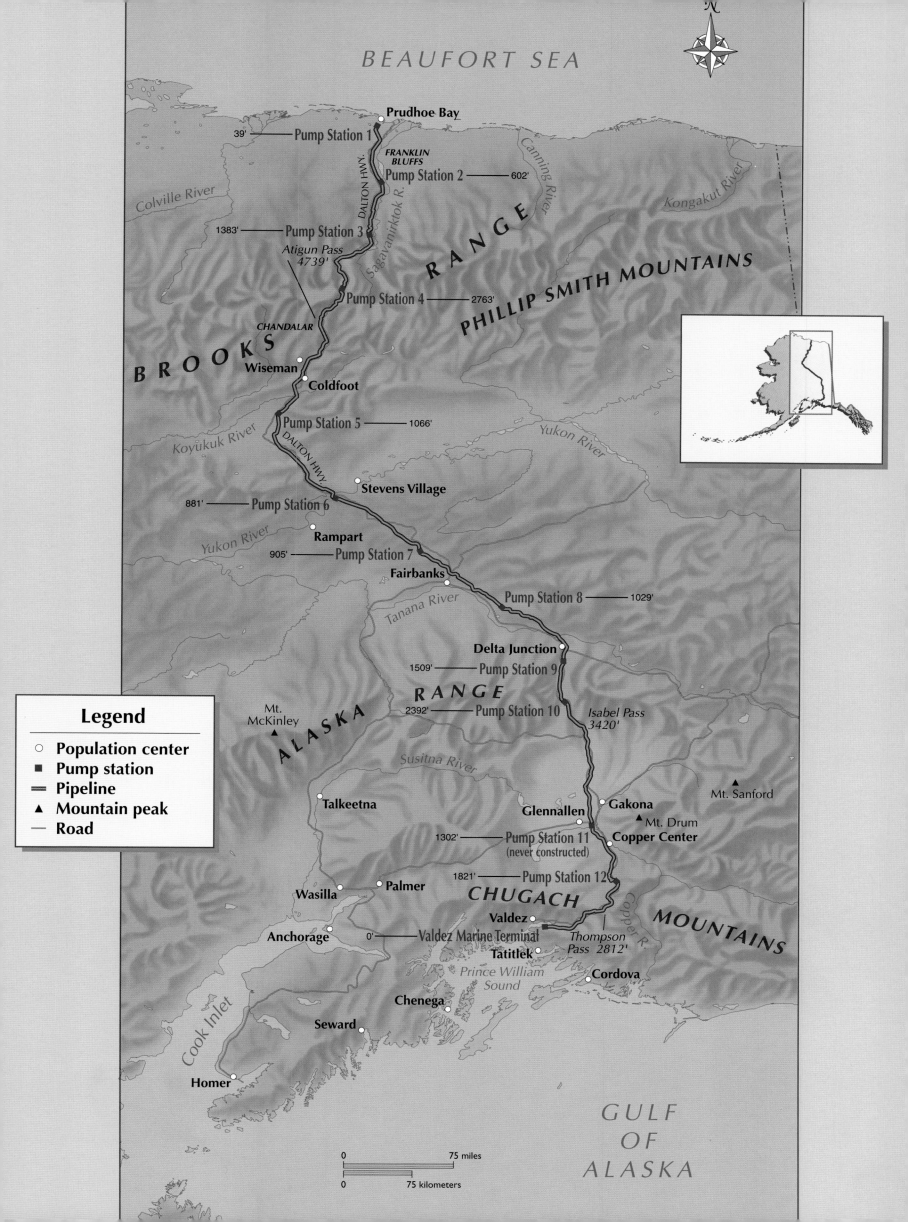

BEAUFORT SEA

Prudhoe Bay

39' ── Pump Station 1

FRANKLIN BLUFFS
Pump Station 2 ── 602'

DALTON HWY.

1383' ── Pump Station 3

Atigun Pass
4739'

Pump Station 4 ── 2763'

RANGE

PHILLIP SMITH MOUNTAINS

CHANDALAR

Wiseman
Coldfoot

B R O O K S

Pump Station 5 ── 1066'

DALTON HWY

Koyukuk River

Yukon River

Stevens Village

881' ── Pump Station 6

Yukon River

Rampart

905' ── Pump Station 7

Fairbanks

Pump Station 8 ── 1029'

Tanana River

Delta Junction

1509' ── Pump Station 9

R A N G E

Mt. McKinley

2392' ── Pump Station 10

Isabel Pass
3420'

A L A S K A

Susitna River

Mt. Sanford

Talkeetna

Gakona

Glennallen

Mt. Drum
Copper Center

1302' ── Pump Station 11
(never constructed)

1821' ── Pump Station 12

CHUGACH

Wasilla

Palmer

Valdez

Copper R.

MOUNTAINS

Anchorage

0' ── Valdez Marine Terminal

Thompson Pass 2812'

Tatitlek

Cordova

Prince William Sound

Chenega

Cook Inlet

Seward

Homer

GULF OF ALASKA

Legend

○ Population center
■ Pump station
━ Pipeline
▲ Mountain peak
─ Road

0 ──── 75 miles
0 ──── 75 kilometers

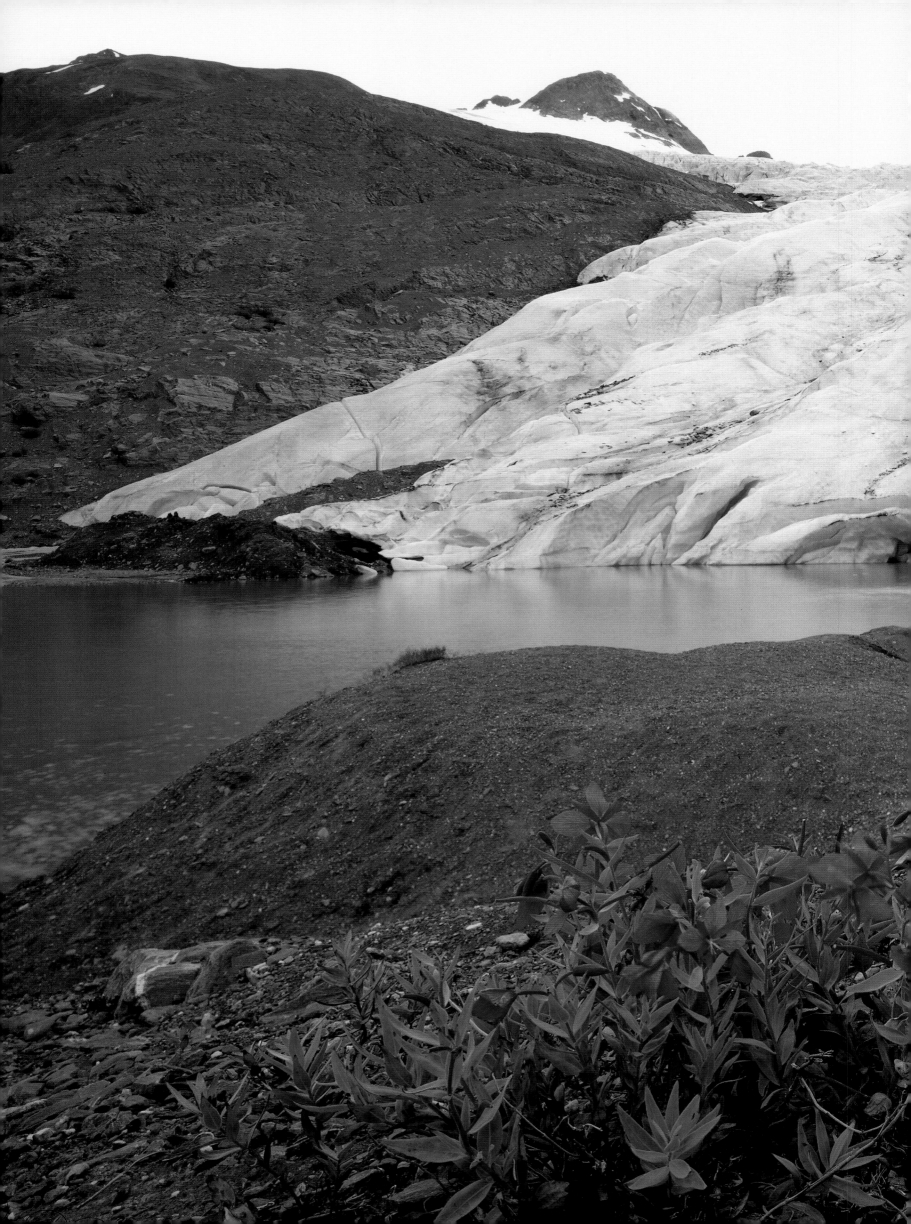

Foreword

by Governor Tony Knowles

Two decades ago, a welder near Pump Station 3 completed the final weld on the trans-Alaska oil pipeline. Twenty days later, valves opened to allow the first North Slope crude to enter the pipeline and begin the eight-hundred-mile journey to Valdez. Since that day, more than eleven billion barrels of oil have been pumped through the trans-Alaska pipeline—enough oil to fill more than fourteen thousand tankers at the Valdez Marine Terminal.

Both as an engineering conception and a construction project, the trans-Alaska pipeline was mammoth in its scope and undertaking. In its first twenty years, the pipeline has meant jobs for a generation of Alaskans, revenues to fuel state services, and a reliable source of domestic crude oil for the United States.

Throughout those twenty years, Alaska men and women have worked hard to ensure that the pipeline is safe and maintained to the highest standards. They work in some of the most extreme conditions imaginable, and we who benefit from their effort and vigilance say "Thank you" and celebrate their achievement.

Oil running through the pipeline is Alaska's lifeblood—it has paved our roads, put our children through school, and built our homes. Throughout the state, oil revenues have meant good jobs, excellent educational opportunities, and safe, healthy communities for Alaska families.

Alaska is blessed with a bounty of natural resources: fish, wildlife, timber, scenic beauty, minerals, oil, and natural gas. These resources constitute the backbone of Alaska's economy. They also constitute a responsibility—a responsibility to be a fair and wise steward; to develop these resources—but not at the expense of the strong environmental values we as Alaskans cherish. I call that responsibility "doing it right."

◁ *Governor Tony Knowles (left) greets Alaskans at the annual Governor's Picnic in Fairbanks.*
◁ ◁ *Dwarf fireweed* (Epilobium latifolium) *paints the gravel moraine in front of Worthington Glacier near Valdez. As the glacier retreats, it leaves behind a barren landscape that is gradually colonized by plants. The first invaders to gain a foothold are opportunists needing little soil. As these pioneer species grow and later die, they trap fine particles and organic nutrients, creating an environment that allows other plants to take root. The landscape is gradually transformed from barren gravel to lush shrubland and, in areas that are receptive, ultimately to forest.*

Following the *Exxon Valdez* incident, the eyes of the world were upon us. Through the combined efforts of everyone involved—Alyeska, the oil companies, shippers, state regulators, the Coast Guard, and the Regional Citizens Advisory Council—Alaska has emerged as a world model in the safe transportation of oil.

More can and will be done as we build on our success, for we share a common goal: the best and safest oil transportation in the world. Our commitment to responsible development is also strengthened by the dramatic improvements in technology that have occurred since the days I worked as a roughneck on North Slope oil rigs. Improved techniques such as directional drilling have significantly reduced the footprint of development on the arctic tundra.

By working together and maintaining high standards, we can tell the world that Alaska is open and ready for business. Our continued insistence on doing it right holds open the promise of future development of North Slope oil fields like Northstar, Alpine, West Sak, the National Petroleum Reserve, and the coastal plain of the Arctic National Wildlife Refuge—fields that can keep the pipeline full for years to come. The pipeline will remain a powerful economic force in the decades ahead and continue to make Alaska an enviable place to call home.

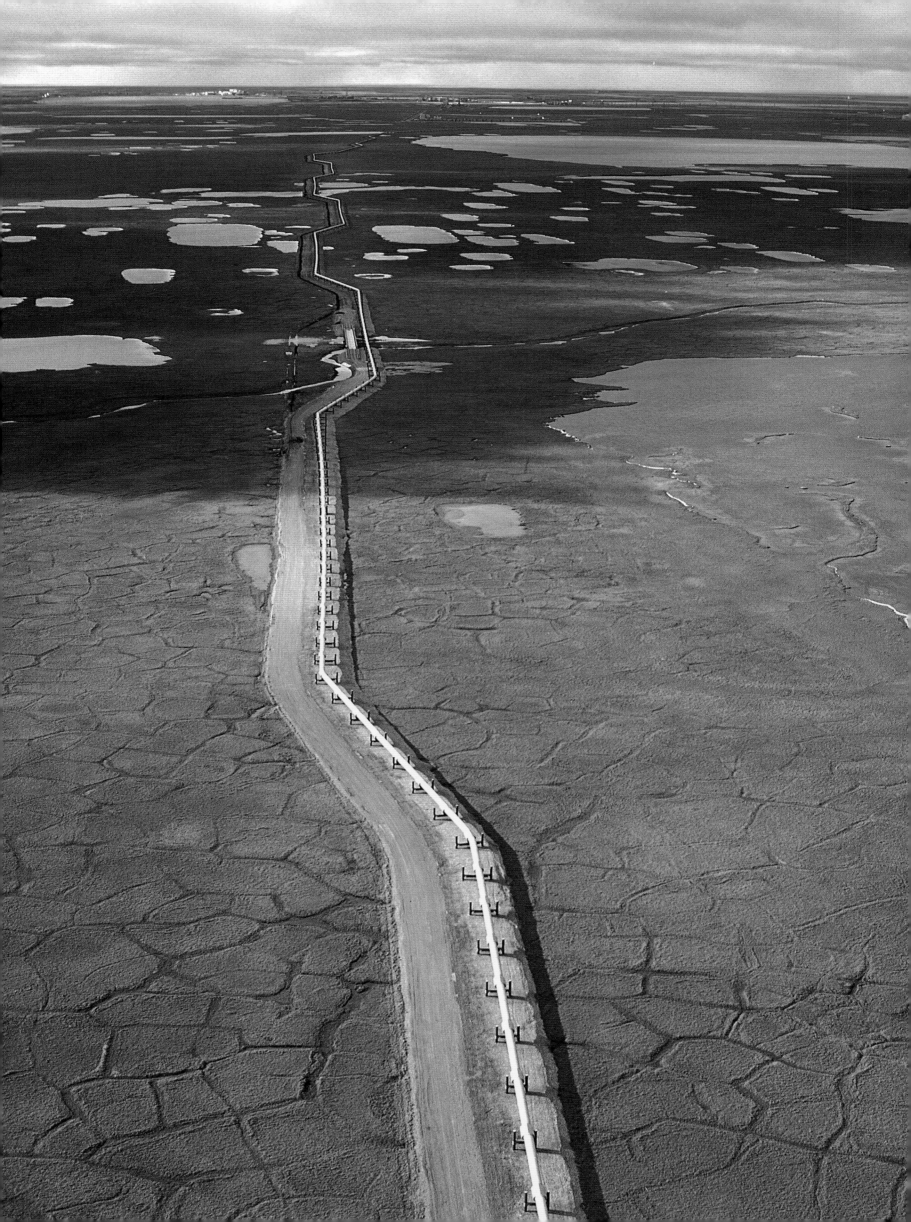

Overview

Alaska is a land described through superlatives: awesome, incredible, stunning. But Alaska is more than the words we use to capture its essence. It is home to Inupiat, Yupik, Tlingit, Koniag, Chugach, Haida, Eyak, Tsimshian, and Athabaskan. To the maritime Aleuts, Alaska is *Alyeska*, "the object toward which the action of the sea is directed," and to the Russians it is *Bolshaya Zemlya*, "the Great Land."

Alaskans enjoy the size of their state, and they take pride in the remoteness and individuality that isolation brings. They speak of "Outside"—Alaskans' term for anywhere outside their own state—with equal parts longing and disdain.

Alaska's diversity is evident from the height of its mountains to the depth of its valleys, from the cold of its glaciers to the heat of its volcanoes. Nineteen peaks rise to over fourteen thousand feet, including Mount McKinley, or Denali—the High One—at 20,320 feet, the tallest mountain in North America. Half of the world's active volcanoes and half of all earthquakes recorded in the United States are in Alaska. The state has 33,904 miles of shoreline and 30,000 square miles under permanent ice. With a climate that ranges from frigid arctic to damp temperate—from 90°F summers to -60°F winters—this is truly an extreme land.

In Alaska, even the largest of human engineering feats can seem small, and perhaps that is as it should be. The goal for many who live and work in this Great Land is to achieve the greatest of accomplishments while leaving the smallest of traces.

This book is about one of those feats—the trans-Alaska pipeline that stretches eight hundred miles from the oil fields at Prudhoe Bay, on the Beaufort Sea, to the marine terminal at Valdez, on Prince William Sound. Like Alaska, the pipeline is in a class by itself. It is immense, it is unique, and it is the result of the combined work of thousands upon thousands of people, from designers to engineers, biologists to truck drivers, welders to geologists. The trans-Alaska pipeline runs the gamut of scenic vistas and professional expertise. No other project has mobilized such a diverse group of people with such a focused goal: to build a pipeline that begins 250 miles north of the Arctic Circle; crosses three mountain ranges, twenty major rivers, and more than eight hundred creeks; rises to 4,739 feet; and ends in Valdez, the northernmost year-round, ice-free port in the United States.

I had the opportunity to see Alaska from the vantage point of the pipeline, and to see the wilds of Alaska through the eyes of those who built the line and who maintain it today. This book is my interpretation of what I, and some of the finest photographers in the world, saw. The photographs and essays in *Crossing Alaska* represent a very personal journey through some of Alaska's most vibrant lands.

This book cannot, and does not seek to, give a complete history of the trans-Alaska pipeline; there are other texts that fill that role. My objective is to take you on a visual—and I hope poetic—journey across Alaska. The trip will take you through some of the world's most spectacular scenery, and, from the corner of your eye, you may glimpse the pipeline making the same journey.

I have seen Alaska in all of her seasons, and she will always take my breath away; I hope she does the same for you.

MICHELLE A. GILDERS

◁ *The unpaved James Dalton Highway stretches southward in front of an Alyeska truck. The 415-mile "Haul Road," as Alaskans call it, provides the only ground access to the Prudhoe Bay oil fields. Paralleling the pipeline corridor, the road joins the rest of Alaska's highway system seventy-seven road miles north of Fairbanks.*
◁ ◁ *On Alaska's North Slope, the level tundra is patterned by frost polygons. In winter, as the active layer freezes, the intense cold causes the ground to contract and fracture. When summer briefly returns, water collects in these fractures, forming an intricate system of interconnected troughs. Pump Station 1 is visible on the northern horizon.*

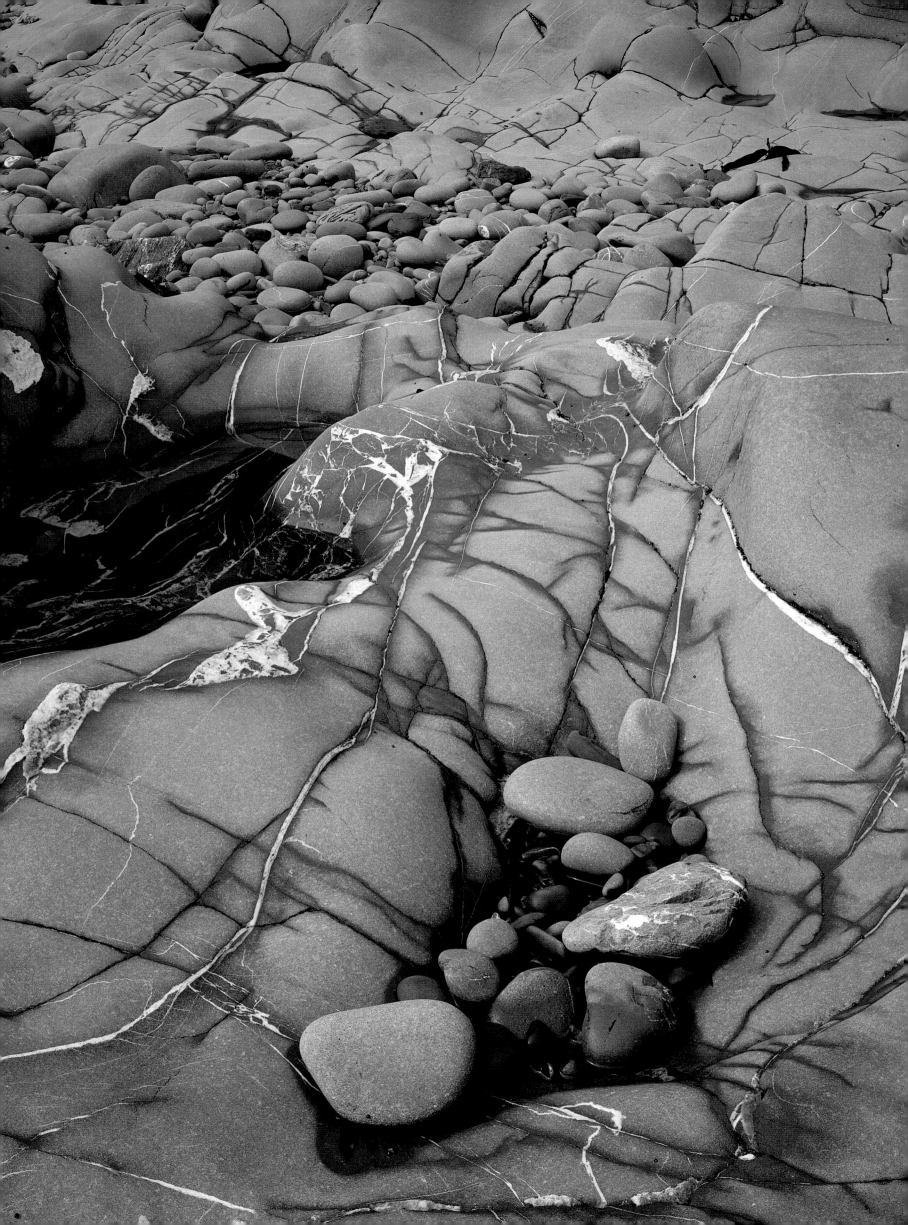

Alaska has a challenging prehistory that is still being unraveled by those with a rare patience. But science is not the only seeker of this past. There is a different past, a past of myth and legend told by generations long ago. In these myths we find impressions of a human experience borne by the rocks and living things. Alaskan Native mythology is filled with images that seek to explain the unexplainable. Among these legends, Raven takes center stage.

When Raven was born, he learned how to fashion canoes, build houses, and make fire. Raven's father promised that one day he would be strong enough to make a world. But Raven couldn't wait. He got some rocks and dirt and water and tried to make a world on his own. He made an awful mess. Just when he thought he had finished, the mountains would fall off, or the oceans would run dry. He lost his temper many times, sometimes kicking the world away with his foot. Finally he gave up and tossed the lumpy, mismatched mass of rock and dirt away. And that is how the world has stayed to this day.

Alaska has had her detractors, and with them a variety of derisive nicknames. When Secretary of State William Henry Seward achieved the Great Land's purchase from Russia in 1867, he was lambasted for wasting the 7.2 million dollars (two cents per acre) the territory cost. Editorials and political opponents called the place an "icebox," "Icebergia," "Walrussia," and "Seward's Folly." The territory, forever locked in snow and ice, was good for neither man nor beast. What was Seward thinking?

Now, 129 years later, it is early May. The industry-chartered Boeing 737 has just landed at Prudhoe Bay, a few miles shy of the Beaufort Sea, with incoming oil field workers, each ready to begin a one- or two-week tour of duty. It is -5°F; the wind is from the northeast at fifteen miles per hour. That means the windchill is close to -40°F. Elsewhere in the Northern Hemisphere, May is well on the way to being summer. On the Arctic coast, summer is still a half-remembered dream.

Alaska winters have been described in many ways. They are harsh, unforgiving; they do not suffer fools lightly. Mistakes made at 40 below can be fatal. But winter in the North has another side, beyond the cold that threatens your extremities or the ice crystals you swear you can feel forming in your lungs. Winter takes on a magical air when the snow lies still and the sky is clear and as dark as the deepest abyss. It is then that lights shine and shift across the blackness

The Making of Alaska

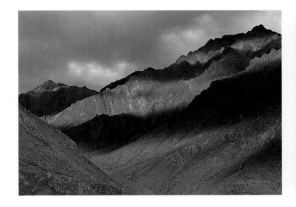

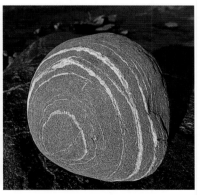

like some wonderful celestial fireworks display. Scientists call the lights the *aurora borealis*; skywatchers simply call them the northern lights.

Those who have seen the aurora—whether green or blue or, more rarely, a luminous red—gain a vision of northern lands that separates them from those who live to the south. Witnesses see a light show sixty miles above their heads, and perhaps listen for the fabled auroral sound that has eluded scientists for years. For most, seeing the curtain of light twist and turn as it reflects in snow and ice— deepening in color, then fading—is the chance to experience something extraterrestrial while keeping their feet firmly on the ground.

For fifty-six days, winter's night grips Prudhoe Bay. Then, the sun returns, and dark December yields to a May, June, and July of continuous light. Now, at winter's end in early May, the flat, white landscape is so bright it distorts perspective and distance. Snow hides all signs of lakes, ponds, and rivers. The level horizon is broken only by ice-core mounds known as pingos, and the space-age buildings housing the approximately twenty-five hundred men and women who work here.

◁ The rock forming these peaks in the Brooks Range belongs to the Sadlerochit formation. At Prudhoe Bay, this same formation is buried six thousand feet beneath the tundra and is the host rock for the North Slope oil deposits. △ Sometimes geology and art merge in a single rock by a stream. ◁ ◁ Along the shores of Prince William Sound, abstractions in rock and boulder abound, their forms softened by endless pounding of the sea. White veins of quartz cut through the dark rock.

The Arctic Coastal Plain—the North Slope to Alaskans—stretches for 190 miles from the Beaufort Sea southward to the Brooks Range. This vast expanse of tundra was once part of the Tethys Sea that existed around 250 million years ago and was located roughly where the Mediterranean Sea is now. A hundred million years later, in the late Jurassic or early Cretaceous period, numerous small basins in the earth's crust filled with marine sediments and trapped the organic debris that would become petroleum. Today, the coastal plain holds the largest oil fields ever discovered in North America.

This remote place is the start of the eight-hundred-mile trans-Alaska pipeline, built and operated by Alyeska Pipeline Service Company. Covering a fraction of Alaska's area (10,000 acres out of 375,000,000), the pipeline corridor is the only conduit for oil to flow south, and parallels the only road connecting the North Slope oil fields with the rest of Alaska and the rest of the world.

I have been to the North Slope many times, but my travels were always confined to the coastal tundra bordering the Beaufort Sea. Now, for the first time, I am going to traverse Alaska in a single journey, north to south, driving 415 miles along the James Dalton Highway to the tiny community of Livengood, 77 miles along the Elliott Highway from Livengood to Fairbanks, 11 miles through Fairbanks, and then 360 miles down the Richardson Highway to Valdez.

My guide is Jay McKendrick, Professor of Agronomy at the University of Alaska Fairbanks. A soft-spoken man with intense blue eyes, Jay drove to Alaska in 1972 in a Chevy Suburban when the land was dark and 60 below, and—despite being run off the road by a water truck—he stayed. Throughout our journey, he delights in pointing out revegetation test plots established along the pipeline corridor—the right-of-way granted to Alyeska by the federal and state governments to aid in building, operating, and maintaining the pipeline. We are traveling in a sparkling clean, full-size pickup, one of the distinctive red trucks used by Alyeska employees and

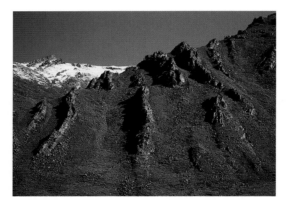

▷ In Atigun Pass, vertical rock strata bear silent witness to the intense forces of nature.
▷ ▷ Horsetail Falls grace Keystone Canyon near Valdez. The trans-Alaska pipeline crosses the canyon upstream of nearby Bridal Veil Falls. During construction, workers installed settling ponds to trap sediment, so the falls remained crystal clear throughout the entire construction process.

contractors. Our truck may be clean as we start out, but the dust and grime of the gravel road will turn it a uniform gray in a surprisingly short time.

As we begin our drive down the James Dalton Highway, named for an engineer involved in early oil exploration, a sign proclaims "No Services for the Next 244 Miles." It is comforting to know that, with Alyeska's permission and support, we can stop at their pump stations to refuel, dine, and rest; we are just a radio call away from help.

The Dalton Highway—or Haul Road, as most Alaskans affectionately call it—is all gravel and cuts a dark line through the snow. Gravel is the foundation of development in arctic Alaska. A three- to six-foot-thick gravel pad is laid on the tundra to prevent the underlying permafrost—the permanently frozen subsoil—from melting and slumping, thus providing a stable surface for vehicles and structures. Permafrost is pervasive in Alaska, continuous north of the Brooks Range, and discontinuous elsewhere. In Alaska, no other feature has such a direct effect on construction.

As we leave Prudhoe Bay, we see the buildings, equipment, and storage tanks of Pump Station 1, marking the start of the trans-Alaska pipeline. Here crude oil begins its journey south. At its peak in 1988, the pipeline transported more than 2.1 million barrels per day (a barrel is 42 gallons, or 159 liters). The amount has since declined; any increase will depend on new oil discoveries.

During construction, twelve pump stations were planned to move crude oil through the line. Eleven were ultimately built. In 1996, nine pump stations actively

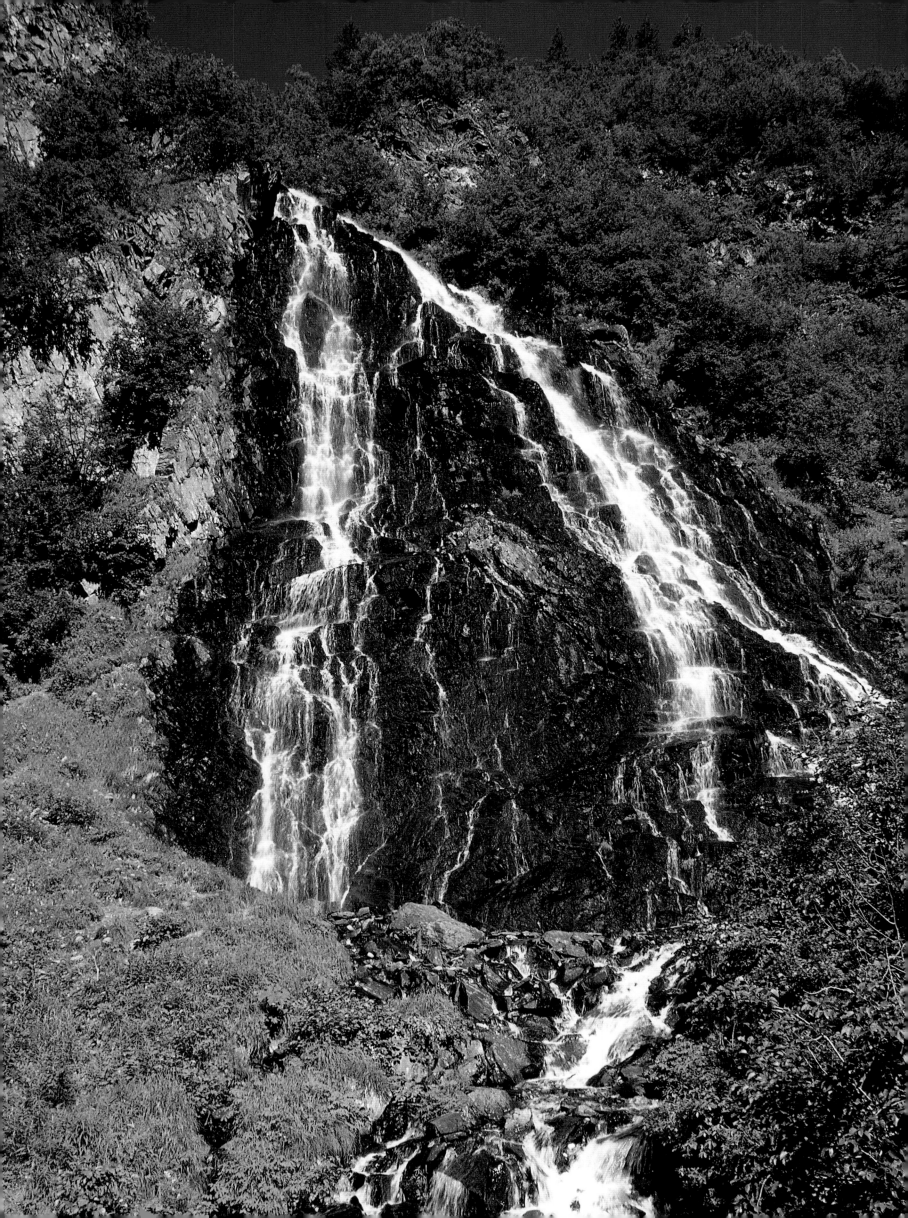

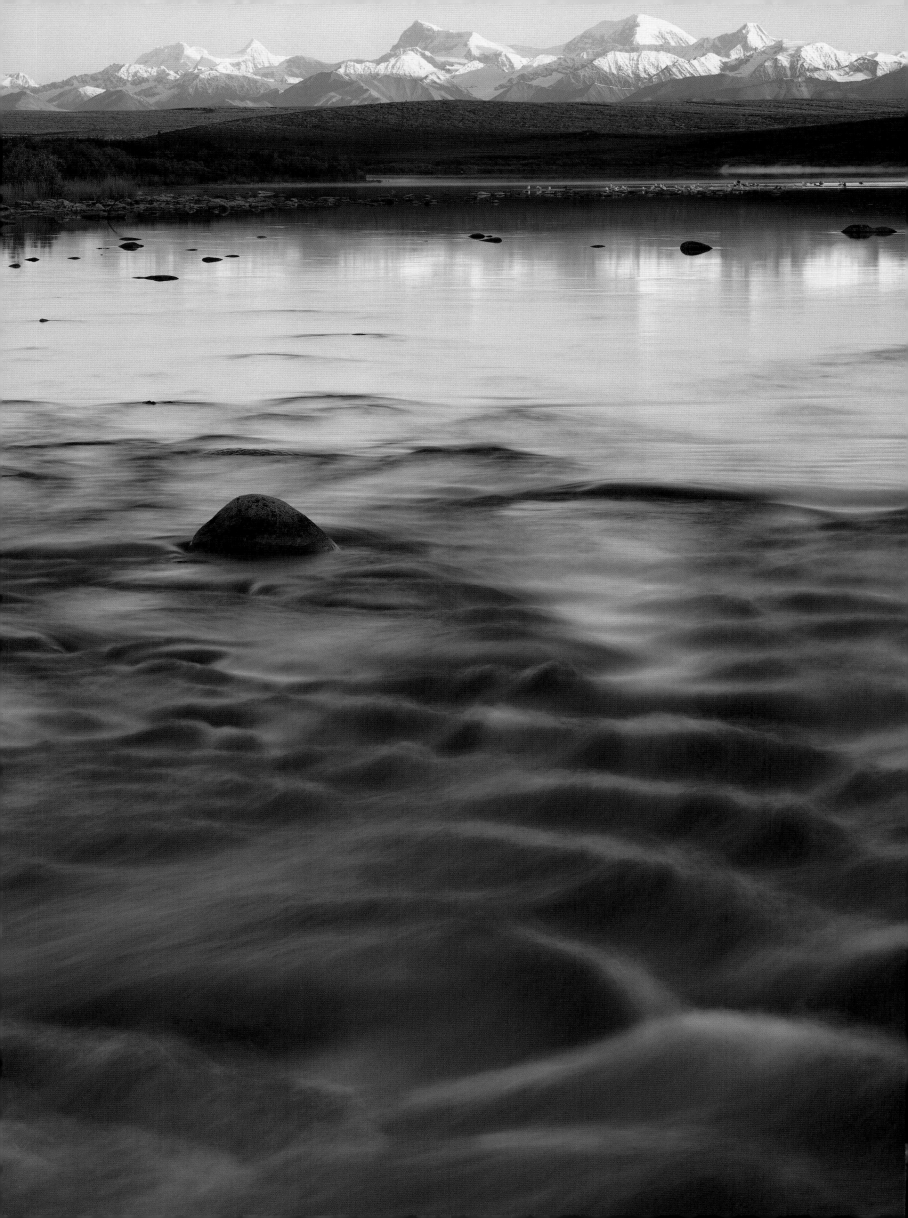

pumped oil. That number will vary, depending on oil production rates and operational economics. Twenty-five to thirty-five people staff each pump station, and each station has crude-oil holding capacities ranging from 55,000 to 420,000 barrels. Pump stations also have power plants that generate between 1.3 and 4.7 megawatts of electricity per day. It takes fuel to make energy, and it takes energy to move fuel.

As we leave Pump Station 1, the pipeline is visible for only twelve miles before it disappears belowground. In these thaw-stable, permanently frozen soils, the pipeline can be safely buried without risk of settlement. Except for its brief emergence at Pump Station 2, the pipeline remains buried for seventy-three miles. Along its eight-hundred-mile length, roughly half of the pipeline is buried, and half is aboveground.

As we head south, the wind drives the snow like sand on a beach, forming snow dunes and whipping smokelike crystals across the road. Alaska is blanketed by multiple layers of snow throughout the winter, although the amount varies by year and region. Here on the North Slope, this land of snow and ice is essentially a desert. Prudhoe Bay receives no more than five to seven inches of precipitation each year—the same amount as the Sahara. The lack of rain and snow in the Far North, however, does not translate into an arid landscape.

The incongruity of a desert marked by a mosaic of tundra wetlands, ponds, and creeks in late June is explained by the permafrost that lies just a few feet below the surface. The arctic wetlands remain wet, fed by melting snow and rivers, because the water is trapped above this impermeable barrier. It can be hard to believe that this arctic desert ever sees warm days, but summer really does transform the land. In July, temperatures can exceed 70°F. The flat whiteness becomes an intense green; melting snow reveals distinctive polygon-patterned ground formed by frost action.

Seventy-degree weather begs for T-shirts and shorts, but on the North Slope, warm, still days are known as bug days; layered clothing is shed at a price. Caribou gather in river deltas and on gravel bars, sometimes even venturing out on nearshore ice floes in the Beaufort Sea, flanks twitching in irritation as they seek exposed, windswept sites to escape the hordes of mosquitoes.

But with the outside temperature hovering around -35°F, thoughts of summer are pushed aside. In the distance, headlights appear high above the road. Behind them are the bodies of two trucks, one atop the other. As the strange vehicles approach, the upper image merges into the lower, and the arctic mirage evaporates.

◁ *Foxtail barley* (Hordeum jubatum) *favors disturbed areas and was one of the grasses used to revegetate the pipeline corridor as construction ended.*
◁ ◁ *Just north of Paxson, in Alaska's Interior, the mighty Gulkana River begins here at the outflow from Summit Lake. The lake provides rearing habitat for sockeye or red salmon* (Oncorhynchus nerka) *and is a contributor to the famous Copper River salmon run. The Alaska Range is visible to the north.*

At first, the late-winter landscape appears lifeless, so barren one wonders whether life could ever survive here. Then sunlight reveals a maze of tracks. The heavy depressions are caribou tracks; the frantic spirals disappearing into holes are the footprints of arctic ground squirrels; and the methodical, even-paced search patterns belong to the arctic fox. It soon becomes clear that there is a whole menagerie on this "lifeless" expanse. Yet, except for the patterns that serve as a silent testament to their presence, these arctic denizens are invisible.

About fifteen miles south of Prudhoe Bay, the buried pipeline crosses beneath the Haul Road and is now on our left, invisible between the road and the broad, snow-covered floodplain of the Sagavanirktok River. Originating on the north side of the Brooks Range about 150 miles to the south, the Sagavanirktok is one of the major rivers draining the Arctic Coastal Plain. Like many Alaska rivers, its floodplain is braided, consisting of interwoven channels interspersed with gravel islands,

many of which have a sparse cover of scrubby willows. In another month, the Sagavanirktok will become a torrent as snowmelt from the mountains overflows its channels; later, in July, the flow will be but a fraction of its peak, and many of the channels will become intermittently dry.

Franklin Bluffs rise, at first like ripples on the surface of the snow. The bluffs reach a height of more than nine hundred feet in a series of conical, toothlike projections made even more striking by the thick snow between each section. In the summer, when the Sagavanirktok is flowing again, the bluffs and river banks will be habitat to grizzly bears, abundant caribou, and an increasing number of nomadic musk ox. Jaegers and rough-legged hawks will hunt lemmings from above, and short-eared owls will sit like sentinels on pingos and river bluffs. Nesting among the indentations of Franklin Bluffs, the once endangered arctic peregrine falcon is making a welcome return.

In the distance is the faint movement of white on white as arctic fox patrol the snowpack looking for lemmings and ground squirrels. Close to the road, ground squirrels are beginning to emerge, digging upward through the snow to bask in the still-cool sunlight. Rough-legged hawks and ravens fly over a scattering of caribou. It is such a stark place for caribou in the winter, especially on this clear May day of sparkling ice and frigid temperatures. Their existence is one of stoic fortitude. Even in May, temperatures can dip to well below -40°F, and the only food to be had—lichens and the remains of last summer's green plants—must be dug from beneath the snow with cloven hooves.

The setting is spectacular. The snow glistens as though filled with stars in a negative universe. The pipeline is passing through an area of ancient moraines formed when the region was under a river of glacial ice that flowed from the Brooks Range, now about sixty-five miles south of us. Just ahead, the elevated pipeline frames the Kakuktukruich Bluff across the Sagavanirktok River. From here southward, the river

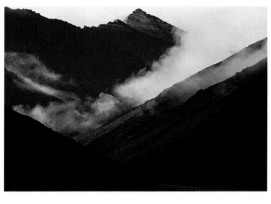

▷ Moody light and low fog add to the drama of Atigun Pass in the Brooks Range. At 4,739 feet, Atigun Pass is the highest point on the pipeline. Truckers know that here the weather can change in the wink of an eye, creating dangerous whiteout conditions.
▷ ▷ Whitewater thunders down Solomon Gulch near the pipeline terminal at Valdez. Solomon Gulch, along with Mineral Creek and Shoup Bay, was the location of a gold strike in the late 1800s, leading to a small but permanent settlement of prospectors in the area.

floodplain loses its flat, braided character and becomes a single channel as the land starts its rapid ascent to the foothills of the Brooks Range.

As we drive southward, the pipeline appears at first to straddle the peaks, but the mountains soon rise above the pipe, reaching skyward to dwarf this man-made structure beneath their seven-thousand-foot heights. Pump Station 3 is nestled in rolling topography. To the east, bluffs descend into low hills that blend with the clouds, while to the west the coastal plain rises into ancient Slope Mountain.

Ptarmigan flock by the road in numbers approaching thousands; a red fox stalks them, its legs sinking deep in snow. A mature bald eagle, a rare sight this far north of the Brooks Range, sweeps an imposing shadow across the road. When our engine is silent, I can hear the wind against the ground. The silence has a taste here, and a smell—sensations wrapped in the cold that I can feel deep in my lungs. The pipeline remains aboveground now, dipping in places designed to allow caribou to cross over the pipe, although elsewhere caribou walk directly under the elevated line. The pipeline meanders across the landscape, its zigzag structure giving it a seemingly aimless character, as though it is not quite sure of its direction. These zigzags were actually incorporated into the design to allow for the linear expansion or contraction of the pipe from temperature changes in the oil.

The vertical support members, or VSMs, that hold the insulated pipe above the ground are equipped with crossbeams to allow the pipe, mounted on a sliding

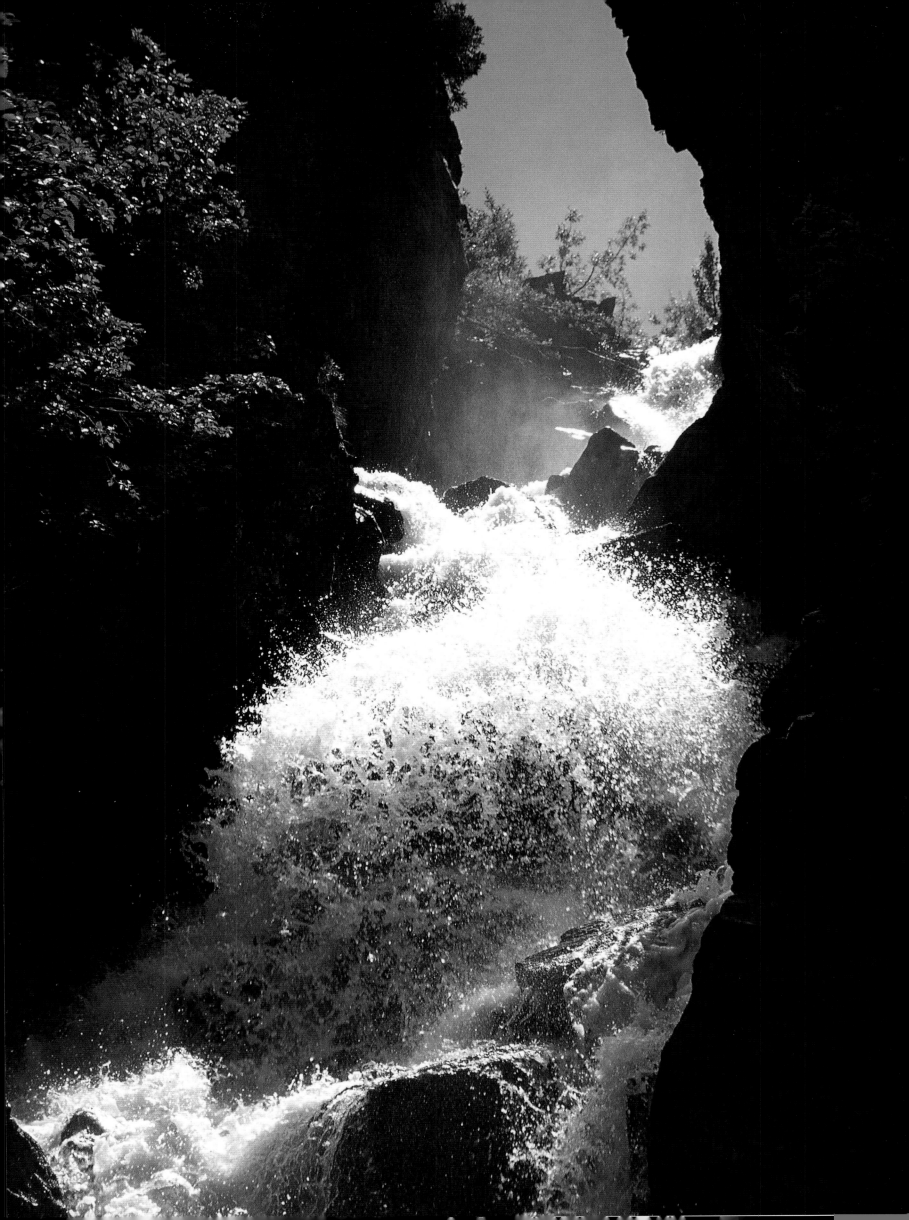

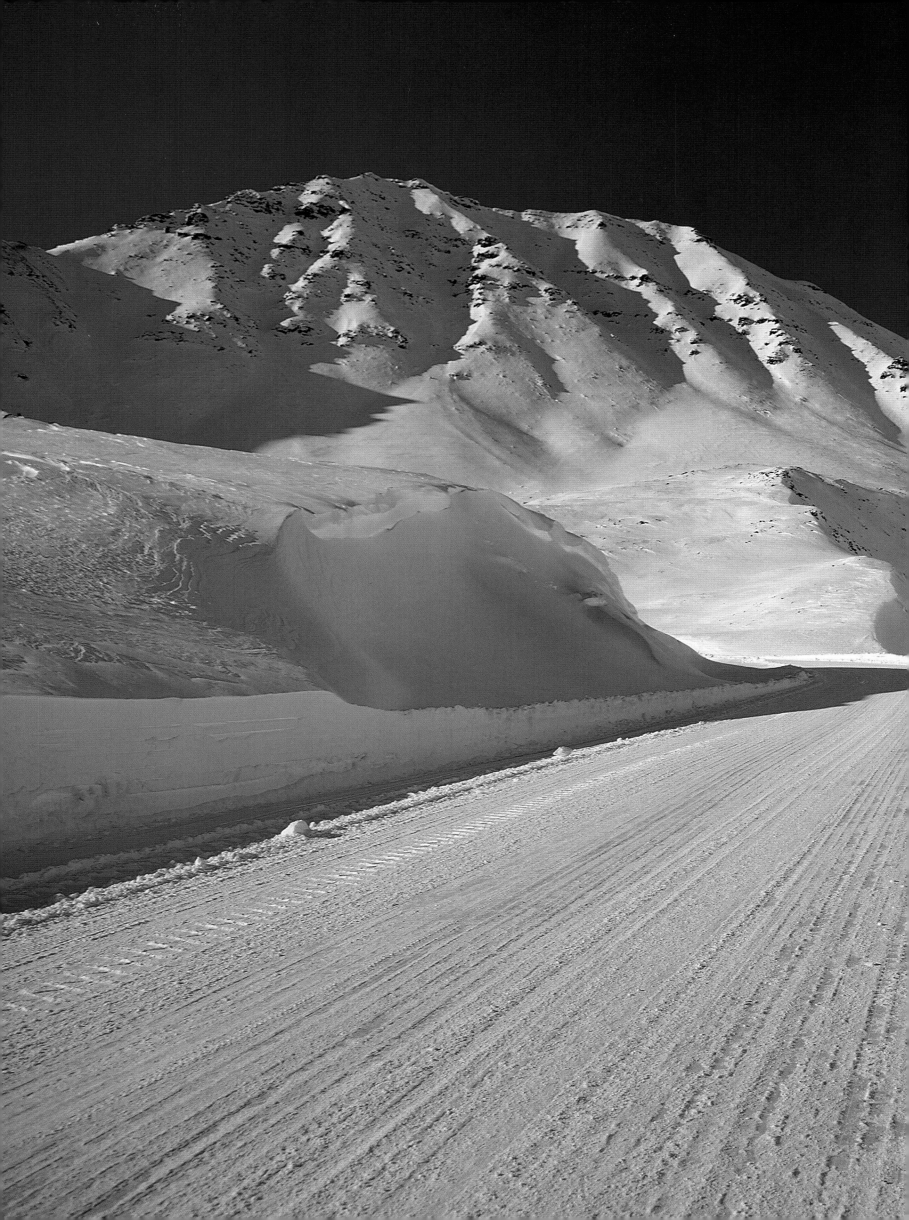

saddle, to move freely from side to side as the pipe expands or contracts, or in the event of an earthquake. Many VSMs contain sophisticated but simple heat-transfer systems. When the air temperature is below 28°F, this system carries warmth back to the surface, where it radiates into the air, preventing the permafrost from thawing.

Southward, undulating hills with the smooth lines of a body's contours begin to lift, forming the Brooks Range foothills. The hills dwarf the silver pipeline as they turn into mountains, and as we approach Pump Station 4, the moon is on the ascent.

In this May-time there is a battle between the sun and moon. Moonrise does not herald darkness as it once did. The mountains balance the moon on their slopes, barren ground finally showing through as spring begins to drive winter from their flanks. Sunset lasts forever as the sun brakes its descent, setting the ridges on fire and silhouetting caribou against the not-quite-night sky. It is 12:30 at night as we watch caribou against the red of the fading sun. Without the engine's warmth, the temperature in the cab would plunge in seconds. It is -25°F outside, and getting colder.

Winter is fading from the hills and valleys; soon the Arctic will warm beneath a never-setting sun. In temperate climates, this seasonal transformation occurs gradually, with budding leaves and the colors of daffodils and crocuses. In the Arctic, one season passes into the next with an unrelenting alacrity.

Beyond Pump Station 4, the pipeline follows the Atigun River upward through a valley rich with cirques and U-shaped troughs: signs of a glacial past. On the valley floor, alluvial fans and rock glaciers flow from the hills with geologic slowness, and vertical rock strata stand silent witness to the forces that made and continue to warp these mountains. The road ascends dramatically, reaching 4,739 feet at the summit of Atigun Pass: the pipeline's highest point. The pass is like a physical crescendo, the top of the world; here is the Continental Divide separating streams that drain north into the Arctic Ocean from those flowing south and west to the Bering Sea. Snow rarely vanishes from here; the wind has an edge to it. Ahead, the pipeline and road wind down the south side of the pass like twin rivers rushing from a common source. With the pass behind us, the road begins its descent down to the Chandalar Shelf, a broad plateau that sweeps away, roadless and remote, to the east. The road follows the Dietrich River and the middle fork of the Koyukuk River through the spectacular peaks that punctuate the Brooks Range.

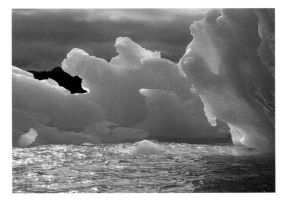

◁ Calved from the face of Columbia Glacier, small icebergs frequently dot the waters of Prince William Sound. Because glacier ice has been under immense pressure, it contains almost no air and absorbs most of the visible spectrum, reflecting only the longer wavelengths we see as blue.
◁ ◁ The Dalton Highway looks deceptively inviting as it ascends the south side of the Brooks Range. In reality, this narrow gravel road can be treacherous, with dramatic frost heaves and blinding whiteout conditions in winter; dust clouds and flying rocks in summer.

Northern vegetation has, until now, been marked by tundra on the coastal plain and low willow-shrub in sheltered valleys along rivers and streams. Trees do not grow in Alaska's Far North for a variety of reasons, the harshness of the environment being first: high winds, severe temperatures, and root-constraining permafrost. At the pipeline's Milepost 235.2, we see a signpost that marks the northernmost spruce tree on the Dalton Highway. The Arctic is losing its grip on Alaska.

Sukakpak Mountain, deep in the Brooks Range, is the most dramatic peak along the road. The rock of this mountain was originally limestone, formed from calcareous shells of billions of invertebrates deposited about 380 million years ago in an intertidal marine environment. High temperatures and pressures within the earth's crust metamorphosed the limestone, and Sukakpak Mountain is now 4,459 feet of solid marble. The road passes close by, and ice-core mounds and ice lenses dot the landscape, revealing the ice-rich nature of this arctic environment.

North of Pump Station 5, we pass through historic mining country. Between Wiseman and Coldfoot, settlements originally established on gold claims, the Haul

Road is bound by rock of Paleozoic age and older. Much of the Brooks Range itself consists of sedimentary deposits from a shallow sea that existed 250 to 400 million years ago. Calcium carbonate sediments built up in this sea, and in the Cretaceous period the deposits were pushed up to form the heart of the Brooks Range, which is up to 200 million years older than the Rockies.

The Arctic Circle wraps around the earth at 66° 33' 32" N. We confidently confirm, with our Global Positioning System receiver, that the signpost is in the right place. The Arctic Circle is the boundary of the true "Land of the Midnight Sun." At this latitude, on the summer solstice, the sun stays above the horizon for one twenty-four-hour solar cycle. Progressively north of the Arctic Circle, the summer sun remains longer above the horizon. At Barrow, the northernmost community in the United States, the sun rises on May 10 and sets on August 2, remaining above the horizon continuously for eighty-four days; in winter, the sun sets on November 18 and rises on January 24, remaining below the horizon for sixty-seven days.

The pipeline has been elevated for most of its journey south, but as it enters the Fort Hamlin Hills, just north of the Yukon River, the relatively ice-free, thaw-stable permafrost permits burial. Throughout these hills, granite intrusions are exposed on the ridges and hilltops. As we head farther south, the landscape becomes less barren, and spruce trees replace the shrub tundra. Gradually the sporadic trees form a forest that blankets the hills. This is our first view of the taiga: the vast belt of coniferous forest that sweeps through northern Europe, Asia, and North America. The Yukon River looms into view, its expanse made dark and brooding by thundershowers. It snakes around the hills with languid effort. Like a vast lake, the river dominates the heart and culture of Interior Alaska.

The Yukon is spanned by the 2,290-foot E. L. Patton Bridge (named in memory of Ed Patton, Alyeska's first president), which carries both highway and pipeline across the water. Before the pipeline there was no bridge, and commerce was tied

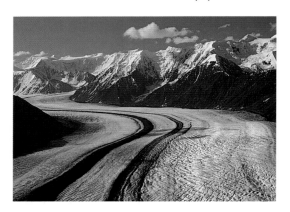

▷ Tazlina Glacier, visible from the Richardson Highway, is streaked with moraines—lines of rocky debris that have been slowly eroded from the surrounding mountains.
▷ ▷ The Chugach Mountains provide a striking backdrop to the soft colors of Emerald Cove in Prince William Sound. The peaks in the Chugach Mountains reach heights of more than thirteen thousand feet.

to the river itself; in many ways it still is. Settlements such as Stevens Village upstream and Rampart downstream rely on the Yukon for travel to fishing and hunting grounds both winter and summer. Village residents, the majority Athabaskan Natives, are crucial members of the Alyeska spill response team for the Yukon River and its tributaries in this region.

Four hundred fifteen miles south of our starting point at Prudhoe Bay, and more than 125 miles south of the Arctic Circle, we reach the official southern end of the Dalton Highway at Livengood, where a handful of intrepid settlers have established homesteads in the wilderness. Now the road becomes the seventy-seven-mile Elliott Highway that will carry us past Pump Station 7 south to Fairbanks. The rounded hills just to the north of Alaska's second-largest city present a surprisingly soft landscape made velvet by dense forest. The birch, balsam poplar, aspen, and willow that form a mixed canopy with the spruce have not yet leafed out to lighten the dark green palate of the conifers.

We are back on paved roads: the Richardson Highway that will take us all the way south to Valdez. The pipeline bypasses Fairbanks to the east, and heads south to the community of North Pole and Eielson Air Force Base. With the pipeline and Pump Station 8 distant from the road, it is the Tanana River that holds the eye. The wind blows immense clouds of silt off gravel bars in the river, and stands of spruce, cottonwood, and aspen form a mosaic in a thousand shades of green. Frost

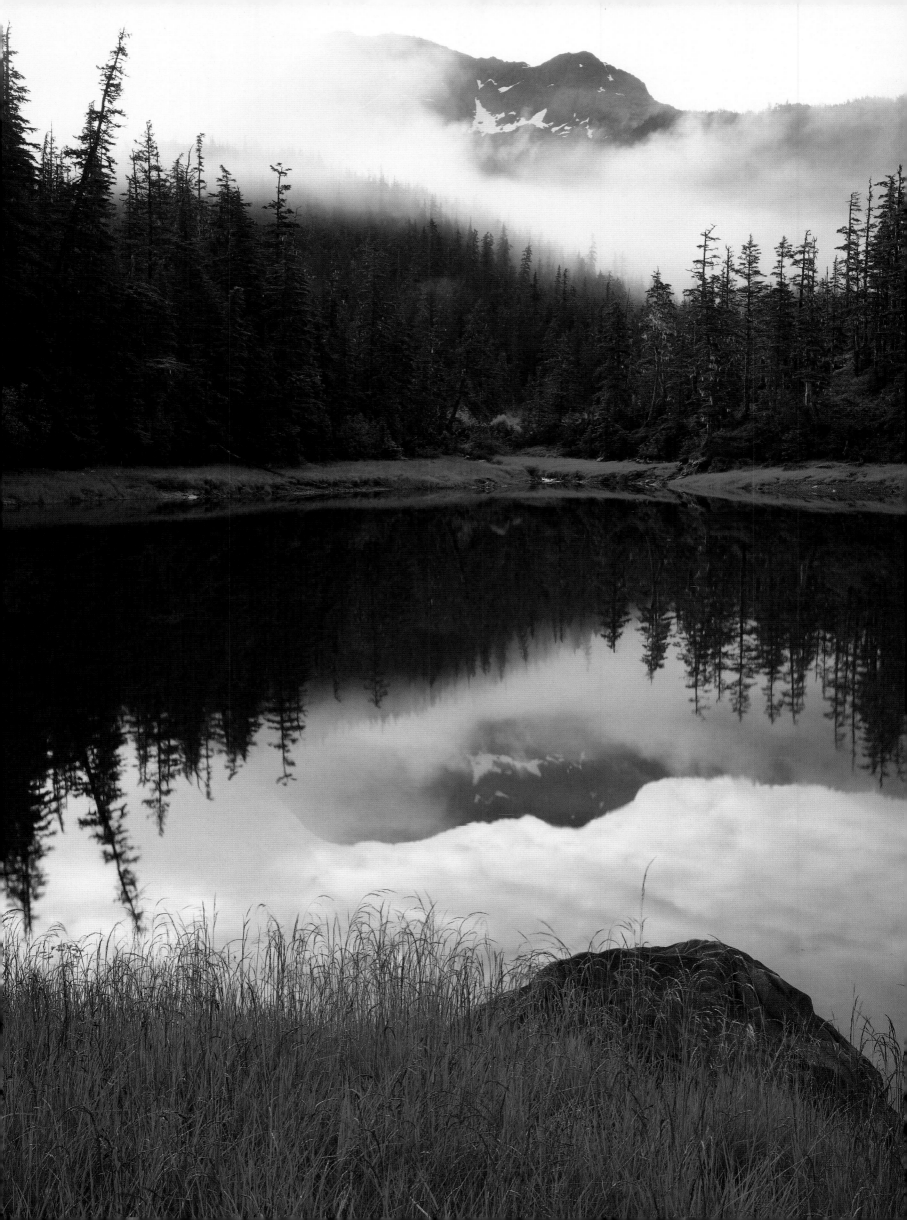

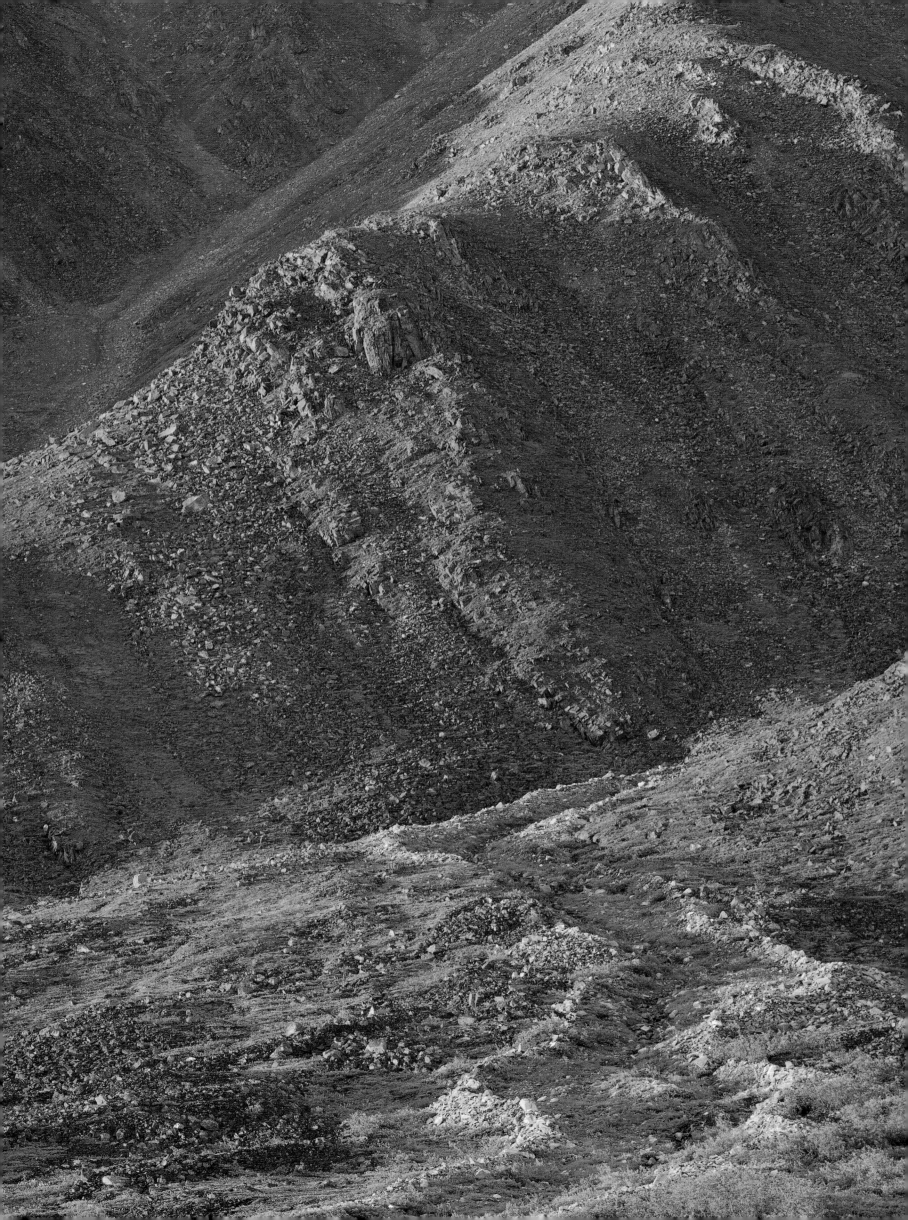

heaves—cracks and bumps in the paved road from ground movements associated with the seasonal freeze-thaw cycle—make driving an "uplifting" experience. In areas of unstable permafrost, black spruce trees appear in danger of falling over.

We pass the tiny community of Big Delta, where the Tanana is joined by the Delta River. This river, which drains the north side of the Alaska Range, is a federally designated Wild and Scenic River, popular for float trips. About ten miles down the road is Pump Station 9 and the community of Delta Junction, named for the junction of the Richardson and Alaska ("Alcan") Highways at the Delta River. Once again mountains rise ahead of us. The Alaska Range dominates the midsection of Alaska, and Denali, hidden from view this far east, is its culmination.

Interior Alaska contains some of the oldest rocks in the state. The region north of the Alaska Range is formed in part by billion-year-old Precambrian schists; it is a time scale that almost defies imagination. Donnelly Dome, 3,910 feet high, dominates a flat plain that is dotted with shrubs, scattered spruce, and kettlehole lakes. It is easy to imagine early Native peoples moving through the area, using the dome as a lookout, or perhaps reserving the site for ceremonies of religious significance.

The Alaska landscape is one in flux. Whether the land is under ice or water, or exuding molten lava, changes are occurring that transform the land over millennia in ways too subtle for us to catch in our brief tenancy. Occasionally, we see glimpses of this transformation. In 1937, west of the Richardson Highway, the Black Rapids Glacier began to surge forward, flowing up to two hundred feet per day—one hundred times faster than normal—and earning it the nickname "Galloping Glacier." Now retreating, the glacier is barely visible from the road.

Deep in the Delta River valley on the north side of the Alaska Range, the Denali Fault gives rise to the tallest peaks of the Alaska Range, including Denali itself. The geologic fracture passes north of Rainbow Mountain before running up Cantwell Glacier. Where the pipeline crosses the fault, the line was constructed to withstand twenty-foot lateral and five-foot vertical displacements.

The earth's crust is made up of plates or *terranes* that float on the viscous molten mantle beneath the surface. Convection currents in the mantle move these plates so that over millions of years, terranes that formed at the equator may eventually find their way to the poles. Alaska is made from a confusing array of these terranes, linked together over geologic time like a gigantic jigsaw puzzle. Along the edges of the terranes, faults occur where one plate pushes against another with unimaginable pressure; when the plates slip, earthquakes are the result.

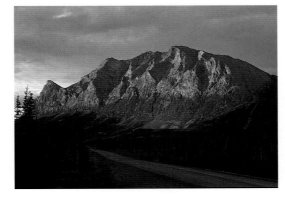

◁ *Sukakpak Mountain is made of stone which originally formed in an intertidal marine environment as limestone. Under high temperatures and colossal pressures lasting millions of years, the limestone was metamorphosed into solid marble. This mountain is a major landmark along the Dalton Highway.*
◁ ◁ *On the steep, sparsely vegetated slopes of the Brooks Range, melting snow produces "rivers" of slush and rock each spring. After the slush has gone, the rocky channels—called alluvial moraines—can be seen on the mountainsides.*

Driving along Phelan Creek, we reach the summit of Isabel Pass, which separates streams that flow northward from the Alaska Range to the Yukon River and the Bering Sea, and those that flow southward to the Copper River and the Gulf of Alaska. The highway skirts Summit Lake, headwaters of the Gulkana River, an important spawning stream for sockeye salmon. The floodplain formed by the confluence of the Gulkana and Gakona Rivers also gives rise to the mighty Copper River, which we will follow southward past Glennallen and Pump Station 11. The flat landscape offers a respite from towering scenery, but with the snowy Alaska Range behind us and the volcanic Wrangell Mountains ahead, it is but a temporary one.

Along the west side of the road, the pipeline weaves in and out of sight, hidden by the dark conifers. To the east, beyond the Copper River floodplain, the skyline is dominated by the white eminences of the Wrangell Mountains:

Mounts Sanford, Drum, and Wrangell and, farther east, Mount Blackburn. Encased in glaciers and surrounded by a multitude of other peaks, these volcanoes are in some of the most remote wilderness of the Far North. Mount Wrangell, at 14,163 feet, is the tallest active volcano in Alaska. It had a minor eruption in 1930, but its last major eruption was more than two thousand years ago. Following the 1964 earthquake, it began to show signs of renewed activity; some geologists believe the earthquake may have realigned the volcano's vents.

The Richardson Highway continues south toward Thompson Pass and Valdez, passing small lodges and roadhouses, most of them family-run enterprises, on through such villages as Copper Center and Tonsina, and past Pump Station 12.

Rising precipitously to 2,812 feet, Thompson Pass retains winterlike conditions far longer than the surrounding area, as if unwilling to give up its blanket of snow. Dark masses of cloud, heavy with rain and snow, lie across the pass. These are lethal clouds harboring winds, snow, and subzero temperatures, something it is easy to forget when the sun tinges them pink and gold. Snowfall in Thompson Pass goes beyond heavy. The pass can receive over eighty *feet* of snow each year and over five feet in a single twenty-four-hour period, bringing new meaning to the term "deep powder." It is no wonder that the World Extreme Skiing Championships are held near here each April.

The only road into Valdez is along the trail cut by the military in 1899 through Keystone Canyon and along the Lowe River. Keystone Canyon is filled with myriad waterfalls that lace the rock walls with silver skeins. In winter, these waterfalls turn solid, and ice climbers are tempted onto their glistening faces. In summer, it is hard to imagine the thundering flow of water ever being arrested.

Valdez, at the southern end of the Richardson Highway, is nestled between Port Valdez—the northeasternmost fjord in Prince William Sound—and the Chugach Mountains. Valdez has seen Alaska change from gold rush territory to modern

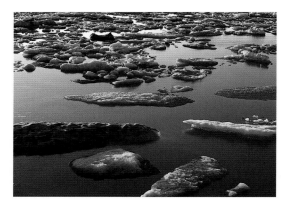

▷ In the Beaufort Sea near Prudhoe Bay, ice can be present in any month. During the brief arctic summer, sea ice can often be seen from the shore, and in some years the coast may remain ice-locked all year round.
▷ ▷ The seemingly barren spring landscape of the North Slope is punctuated by animal tracks. The low-angle sun still lacks heat, and the icy snow glints in the light as though filled with stars in a negative universe.

state. The land here is filled with a beauty that comes from thundering waterfalls, dappled mountain slopes, and emerald waters. Yet, the two terranes that form the area give this beauty a dangerous edge. The Prince William Terrane joined Alaska during the Eocene period forty-two million years ago, whereas the older Chugach Terrane to the north collided with the continent sixty-five million years ago.

It is the movements of these terranes that are responsible for the earthquakes and volcanic activity in the region. Since 1900, Alaska has experienced an earthquake of magnitude 8, on average, every thirteen years. The most devastating was the 1964 Good Friday earthquake and tsunami that cost the lives of many, including thirty-two Valdez residents. As a result of the quake, which registered 9.2 on the revised Richter scale, the entire community was rebuilt at a less vulnerable site.

Prince William Sound is the terminus of the eight-hundred-mile pipeline that has guided our journey. The Valdez Marine Terminal, where tankers are loaded, faces the town. Harbor seals haul out on exposed rocks, Steller's sea lions jockey for position on buoys, and sea otters crack urchins and crabs on their chests. At night, lights from the terminal are reflected in the water, and the snow-capped mountains, lit by a full moon, provide a momentous backdrop. Our journey completed, Prince William Sound seems to welcome us with its tidewater glaciers, fishing boats, and the smell of the sea in the damp air. The Pacific Ocean lies just beyond the islands and fjords, and so does the rest of the world.

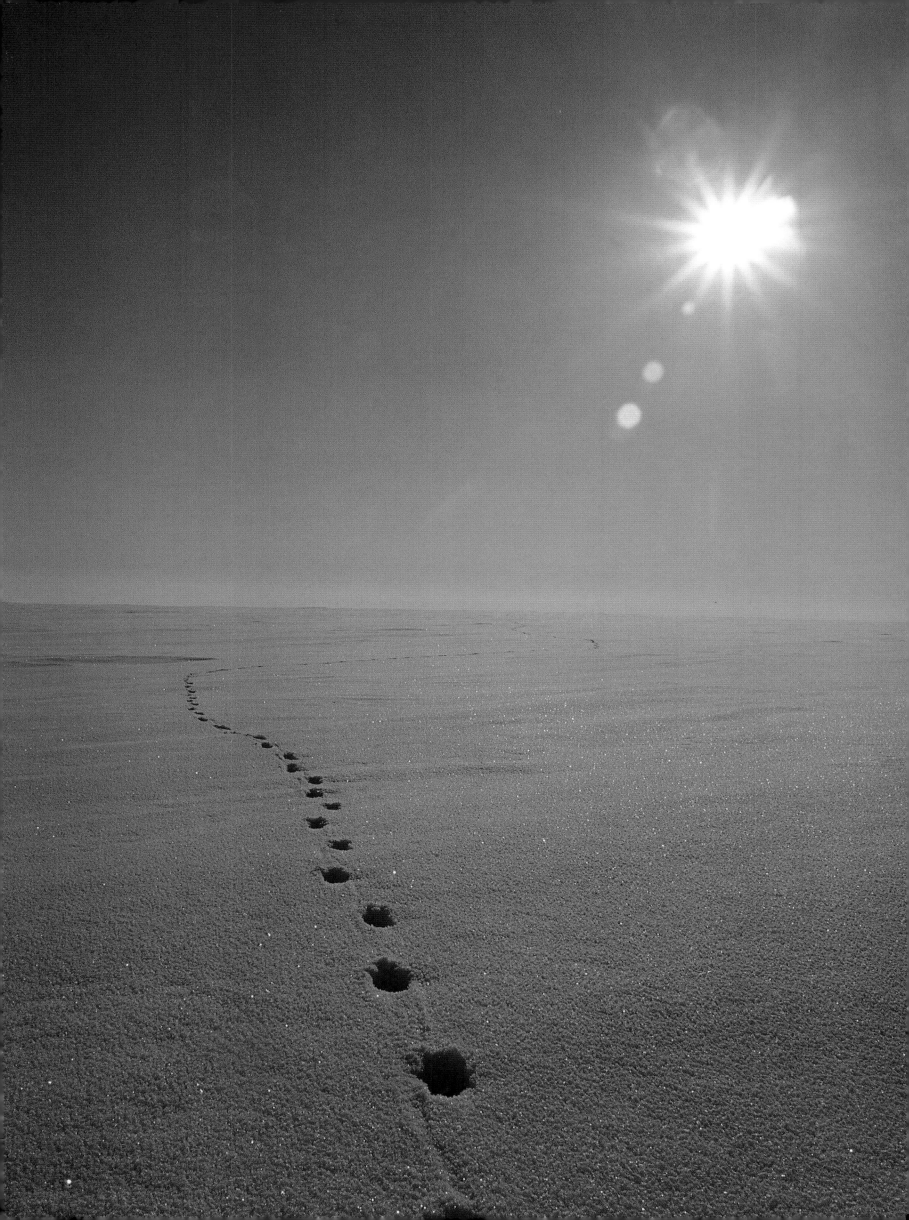

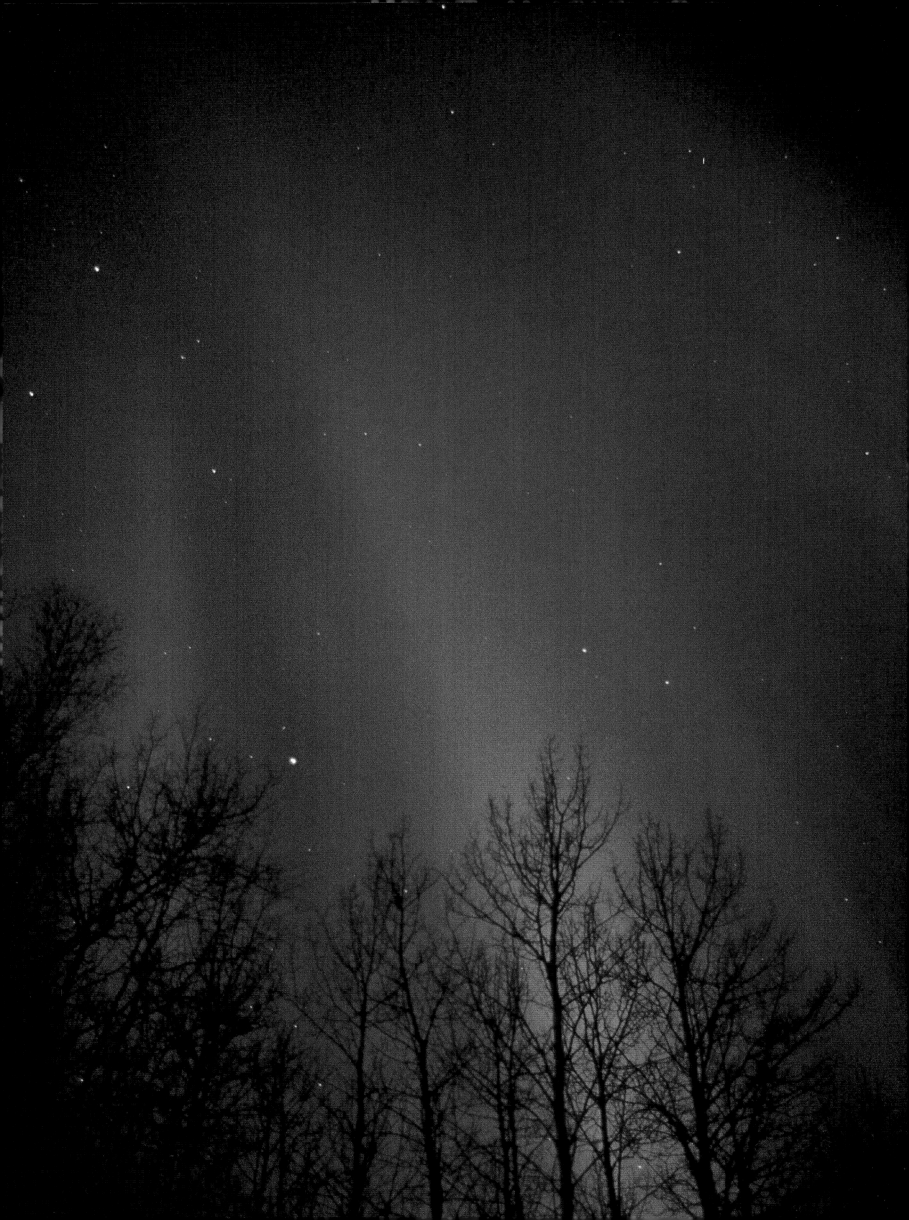

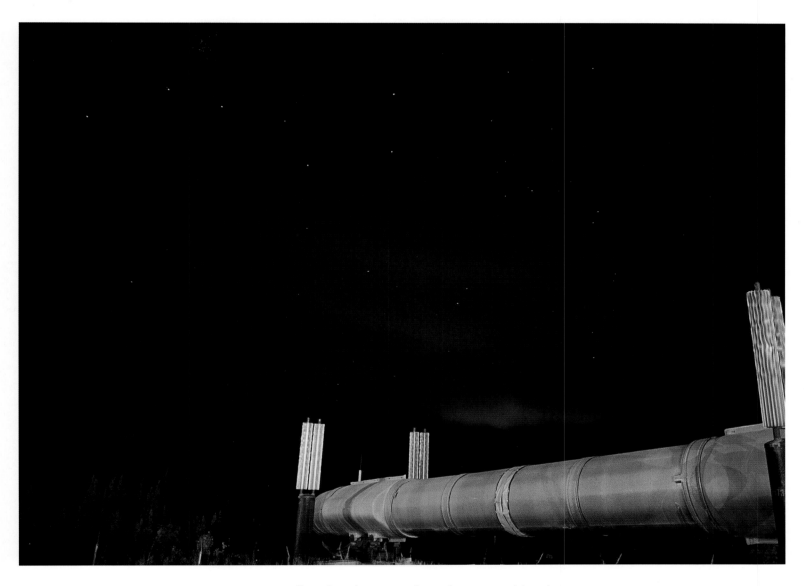

◁ Scientists tell us that the *aurora borealis* is caused by electrons and protons colliding with oxygen and nitrogen molecules in the upper atmosphere. But our hearts feel the souls of warriors long dead, hunting celestial beasts across the sky. An unearthly red aurora only intensifies these feelings. △ As the pipeline captures the light of a green aurora, the stars of the Great Bear evoke the words of Alaska's state song: *The brilliant stars in the northern sky/The "Bear"—the "Dipper"—and, shining high/The great North Star with its steady light/Over land and sea a beacon bright/Alaska's flag—to Alaskans dear/The simple flag of a last frontier.*

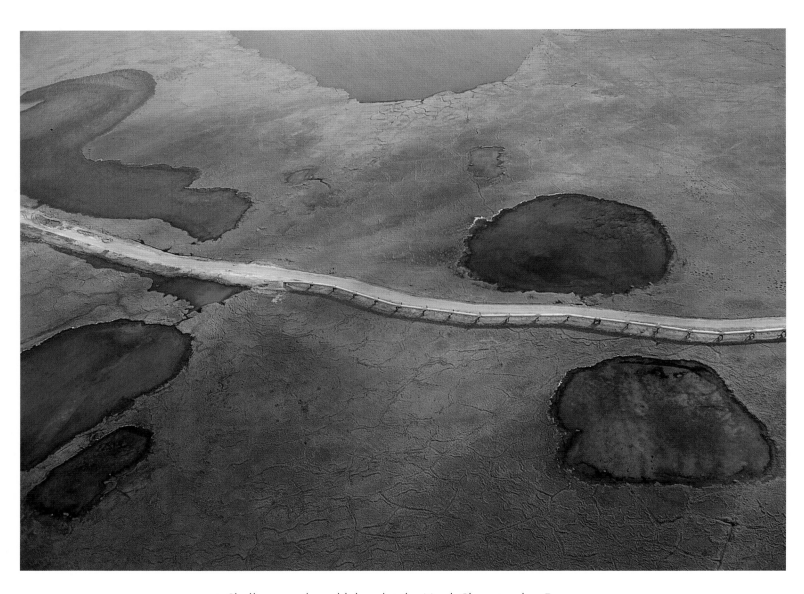

△ Shallow ponds and lakes dot the North Slope tundra. Because they typically freeze to the bottom in winter, these water bodies generally do not support fish. By June, the ponds become home to nesting migratory waterfowl. ▷ Spruce and deciduous trees create a subtle mosaic of greens in Southcentral and Interior Alaska. On well-drained slopes, white spruce *(Picea glauca)* dominate the forest, while in wetlands or peaty areas with underlying permafrost, black spruce *(Picea mariana)* take over.

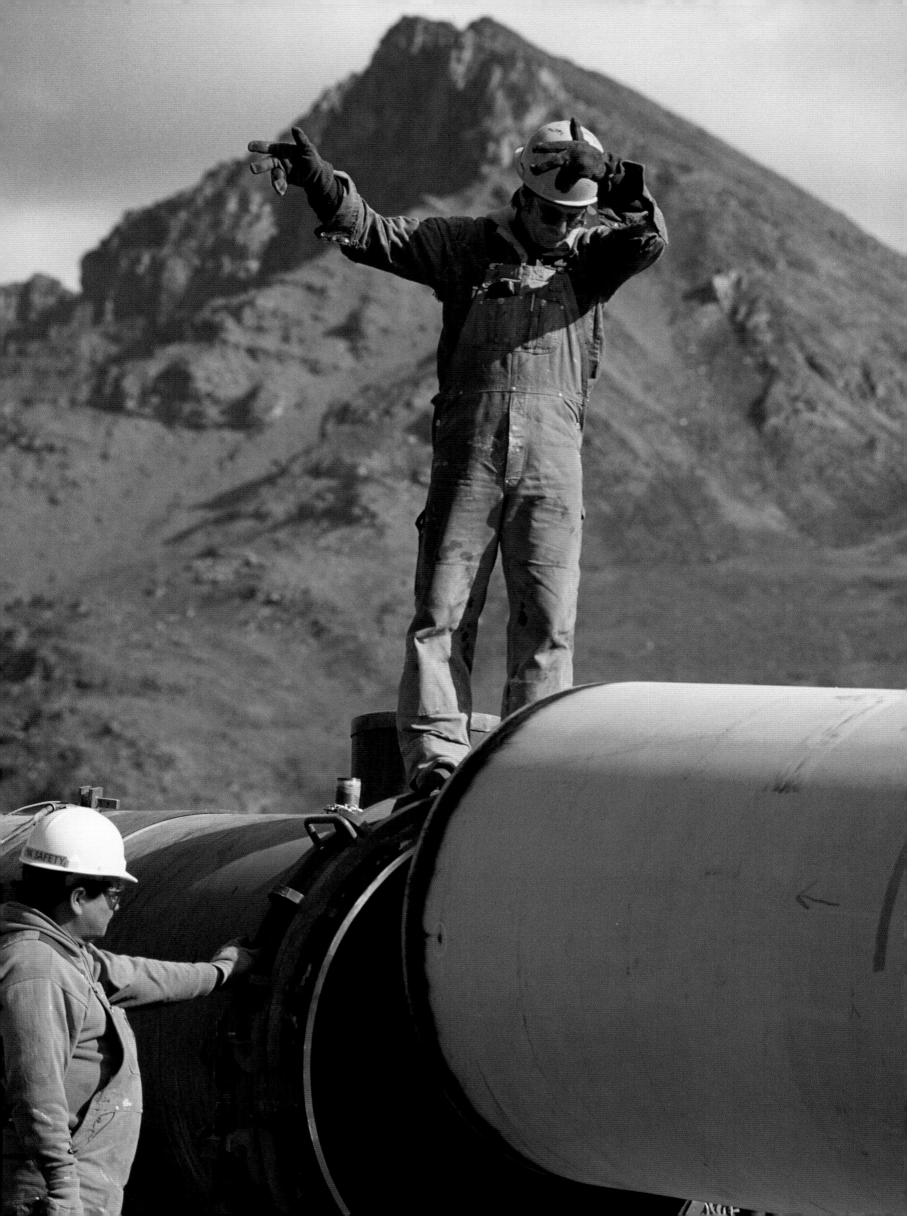

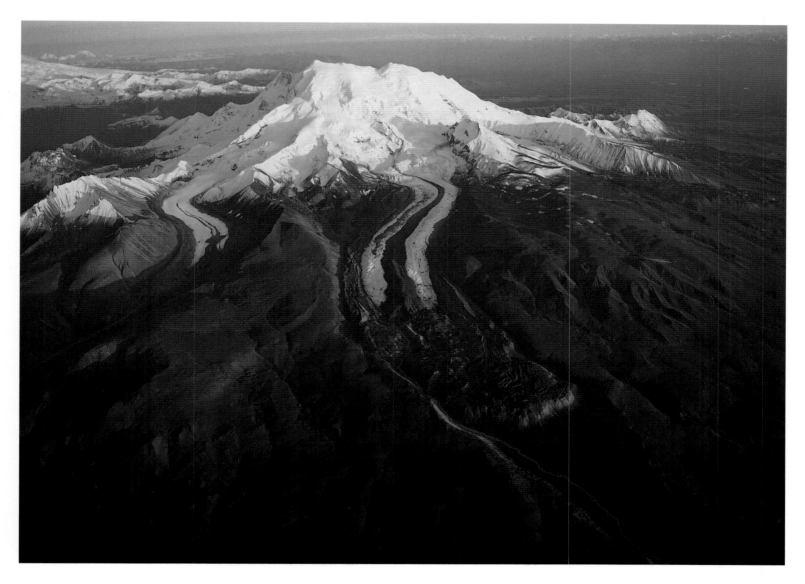

◁ Between January and August 1991, an 8.5-mile stretch of buried pipeline beneath the Atigun River was replaced because of corrosion. The project made engineering history as the first large-scale use of a "double stoppel" method to divert oil from the old pipeline section to the new. The line was shut down for only thirty-six minutes to divert the flow and complete the tie-in. Here a worker directs the positioning of a new section of pipe.
△ The skyline in the Copper River floodplain is dominated by the Wrangell Mountains. Mount Drum, shown here, is 12,010 feet tall and is visible from both the Glenn and Richardson Highways.

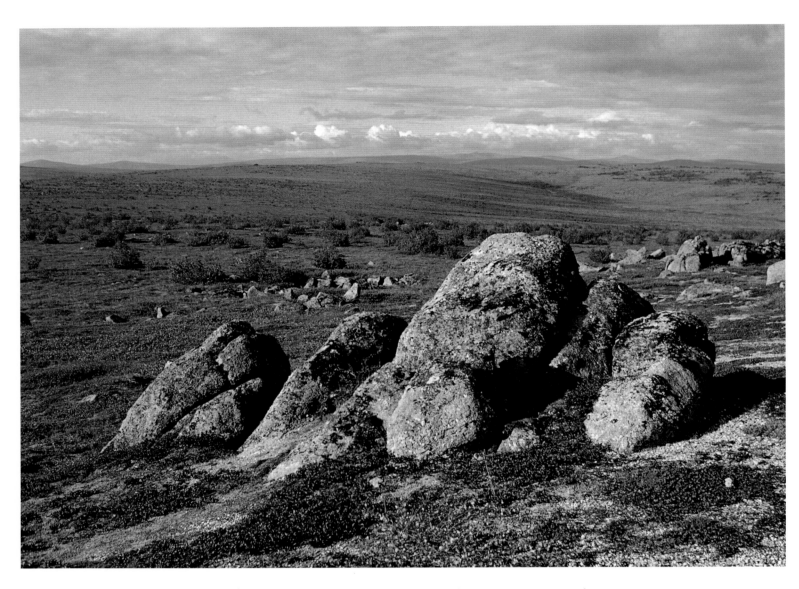

△ In the Fort Hamlin Hills, north of the Yukon River, *tors* protrude above the tundra. These granite outcrops have persisted because the region never experienced glaciation. ▷ The fecundity of short Alaska summers is embodied in this cinquefoil *(Potentilla biflora)*. As the snow recedes in late spring, a succession of wildflowers blooms profusely throughout Alaska. With the arrival of the first hard frost, the floral splendor is replaced by autumn foliage.

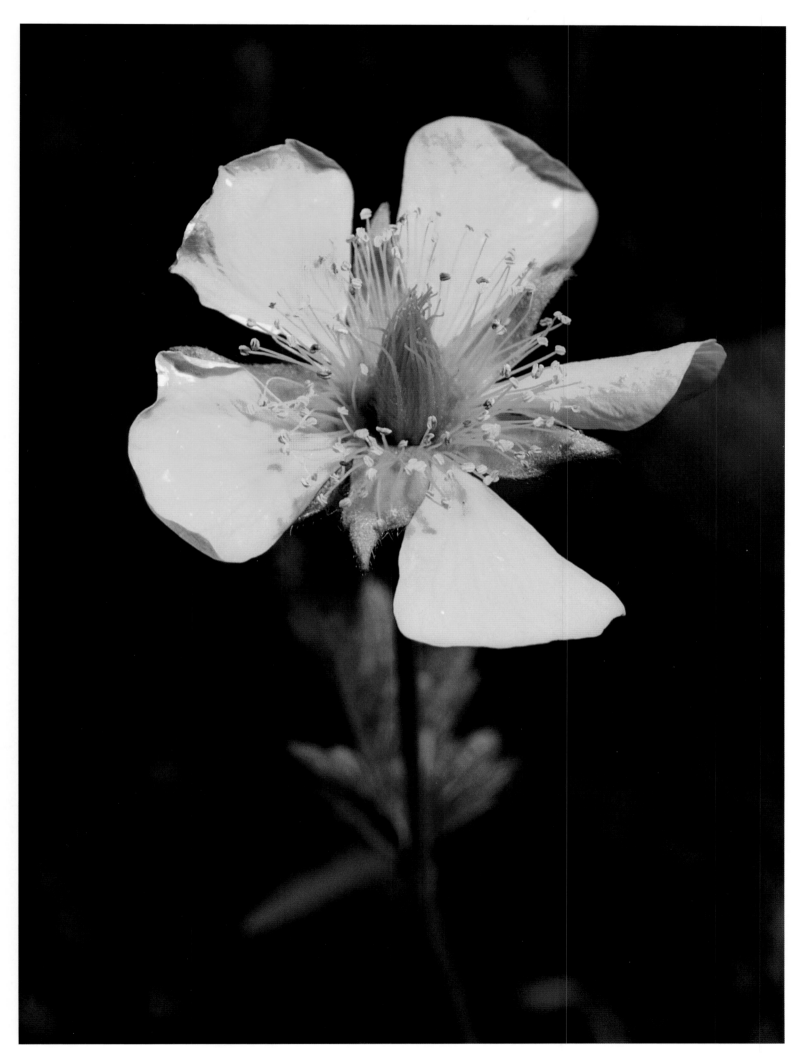

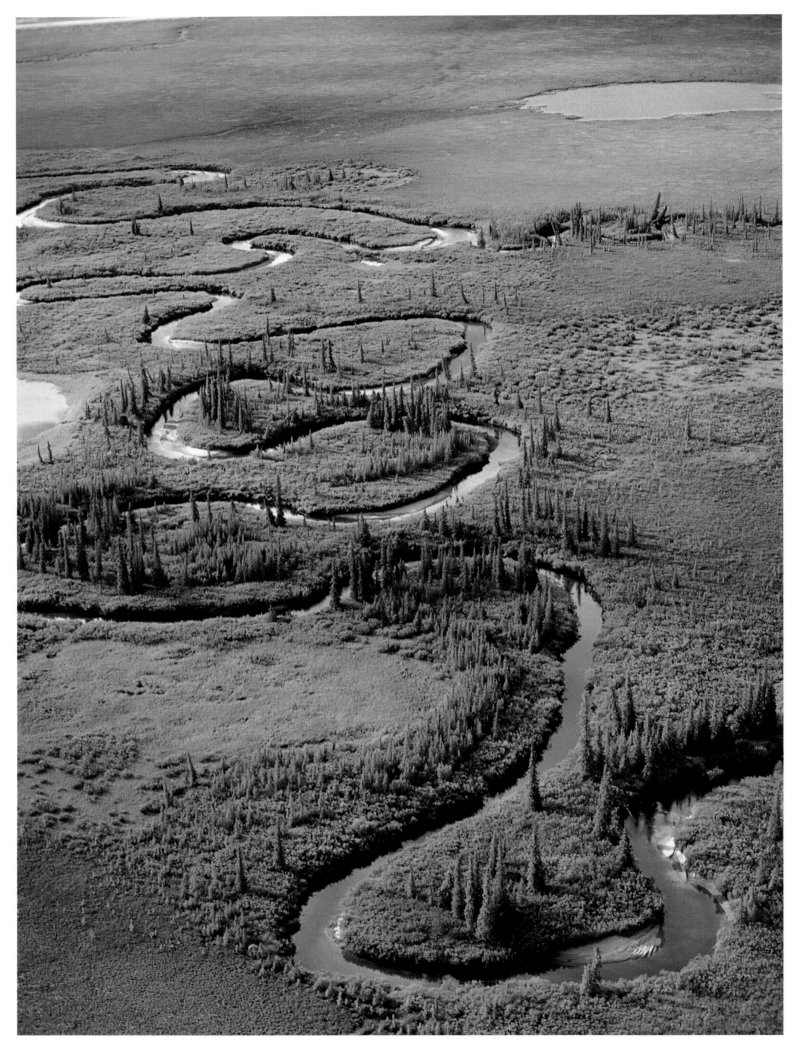

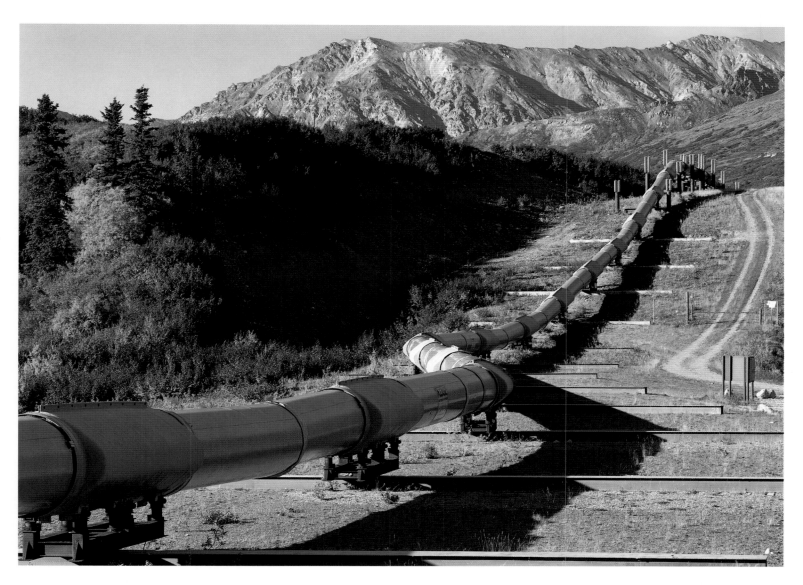

◁ The Kanuti River meanders across muskeg a few miles south of the Arctic Circle in the Alaska Interior. The river forms large loops in its yearly search for the path of least resistance. Eventually, these meanders will be cut off to form oxbow lakes as the river continuously redefines its serpentine course. △ The pipeline crosses the Denali Fault, the most significant seismic fault along the route. Here, engineers designed "sliding shoes" to allow the pipeline to accommodate ground movements of up to twenty feet laterally and five feet vertically, enough to survive an earthquake as great as 8.5 on the Richter scale.

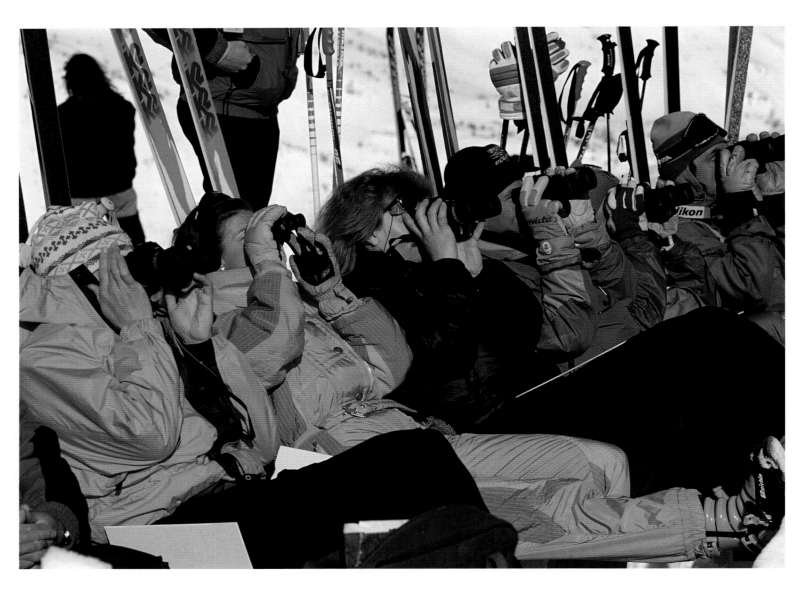

△ Since 1990, the World Extreme Skiing Championships have been held every March or April in Thompson Pass near Valdez. Approximately thirty qualified skiers from various countries participate. Here, the judges scrutinize contestants as they sweep down near-vertical slopes. ▷ Nowhere is too high, too remote, or too daring for dedicated snowboarders. The King of the Hill Snowboarding Competition was started in 1993 and follows the extreme skiing contest held annually in Thompson Pass.

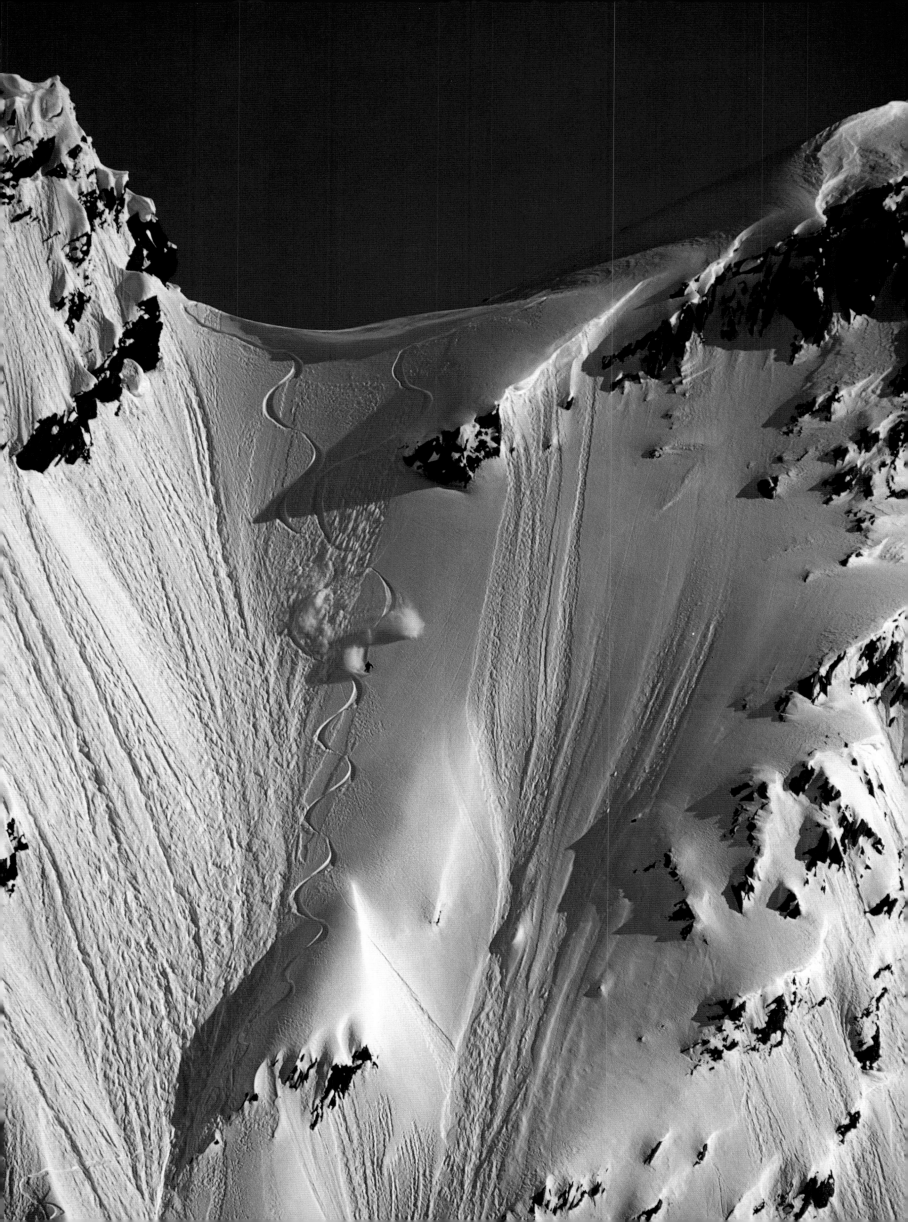

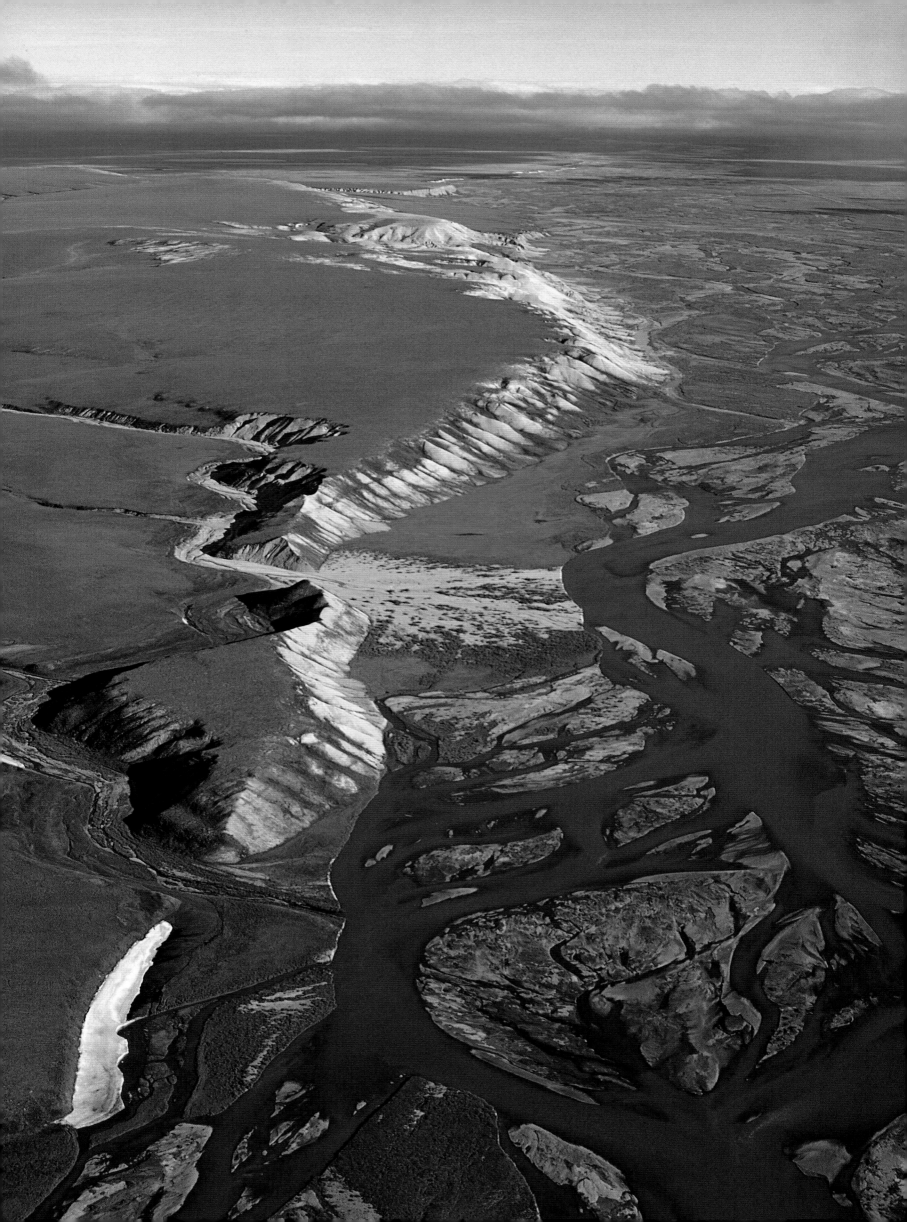

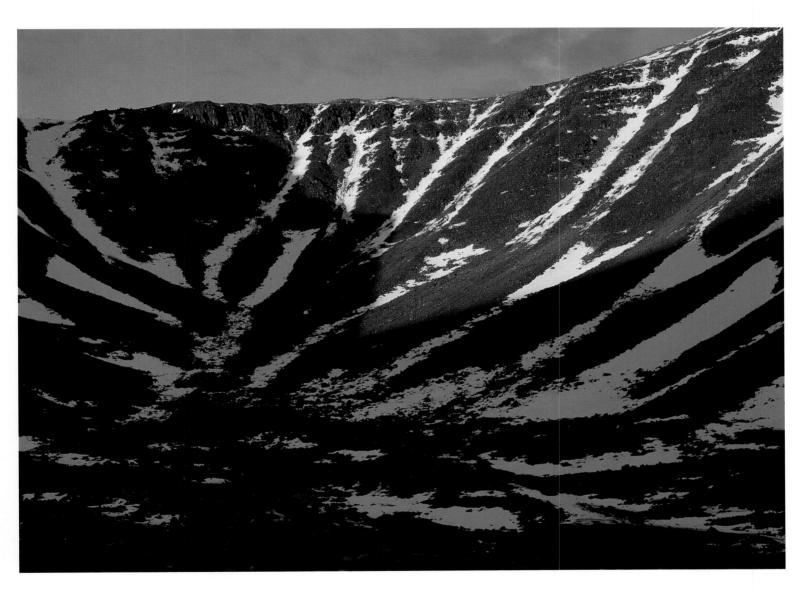

◁ The Sagavanirktok River flows north from the Brooks Range to the Beaufort Sea, passing the Franklin Bluffs. A zone of restricted activity surrounds the bluffs to protect the arctic peregrine falcon *(Falco peregrinus tundrius),* which nests on the cliffs. △ High in Atigun Pass, a cirque is patterned by snow and shadow. Cirques are half-bowls carved out of mountains by glacial erosion and frost action. ▷ ▷ "... the aesthetics of a structure in Alaska ... is inevitably judged by how it complements its surroundings; not how it stands out from them." Paul Thomas, a pipeline designer.

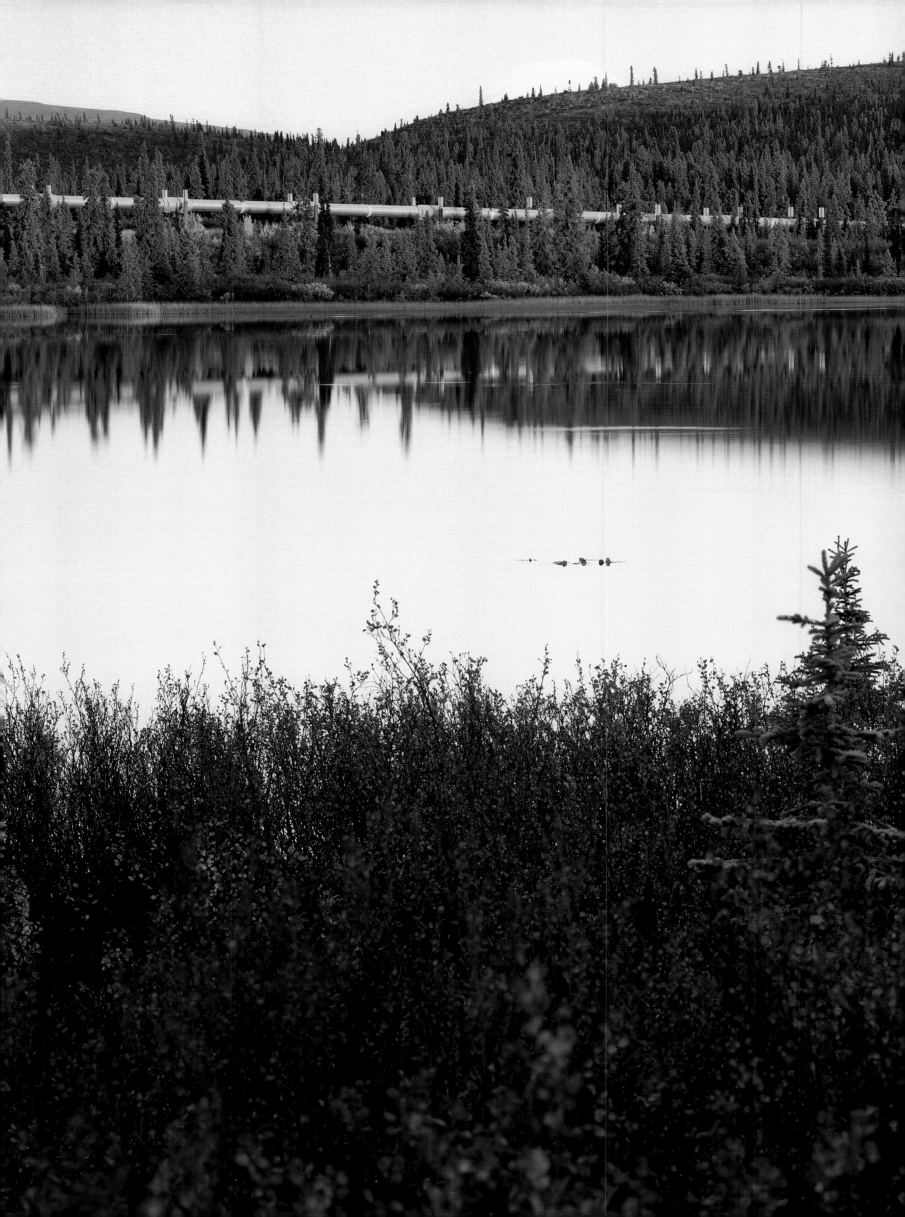

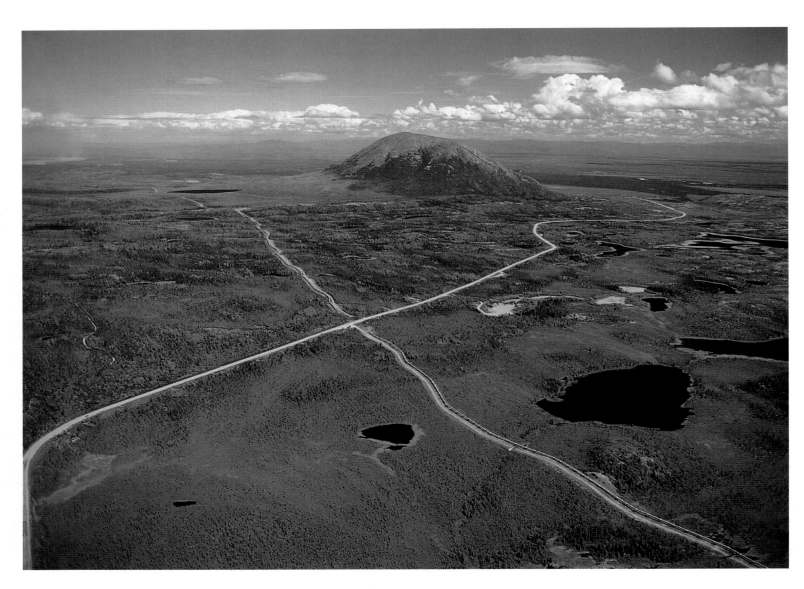

△ Donnelly Dome rises 3,910 feet above the glacially scoured landscape south of Delta Junction. The Richardson Highway and the pipeline cross the plains, sometimes parallel, sometimes seemingly with separate goals. Scattered spruce trees and low shrubs surround kettlehole lakes, formed by blocks of ice left by retreating glaciers. Locals say the first snow on Donnelly Dome means snow in Delta Junction within two weeks. ▷ The mixture of spruce, birch, cottonwood, aspen, alder, and willow creates a rich autumn tapestry of gold and green. Dramatic reds, like the high-bush cranberry *(Viburnum edule),* are closer to the ground.

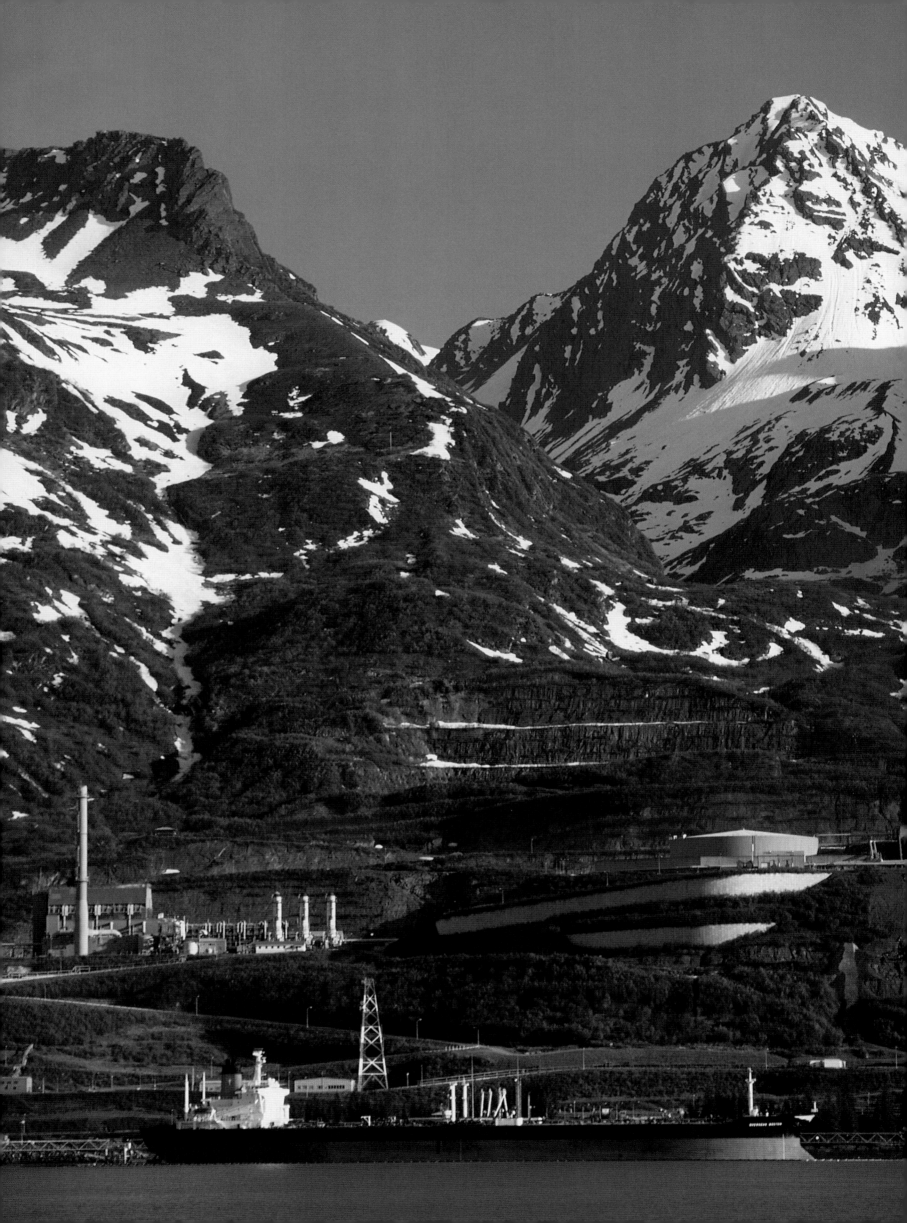

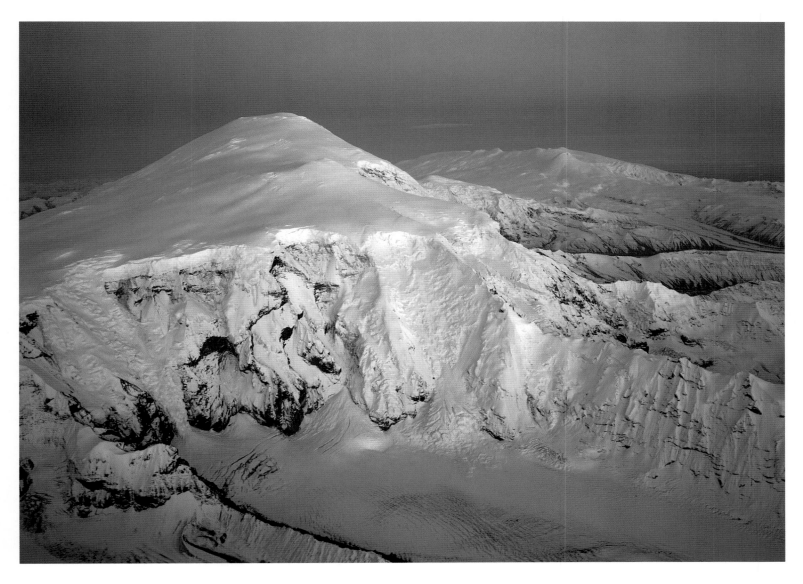

◁ The Valdez Marine Terminal operates around the clock, transferring oil from the pipeline to about seventy tankers each month. Incoming oil is metered and stored, or sent directly to tankers waiting at any of the four berths that may be in operation. While loading, each tanker is surrounded by oil-containment boom. The loaded tankers are escorted through Prince William Sound by specially equipped escort response vessels. △ At 16,237 feet, Mount Sanford is the sixth-highest mountain in Alaska. Mounts Blackburn, Sanford, Wrangell, and Drum dominate the volcanic Wrangell Mountains in Southcentral Alaska.

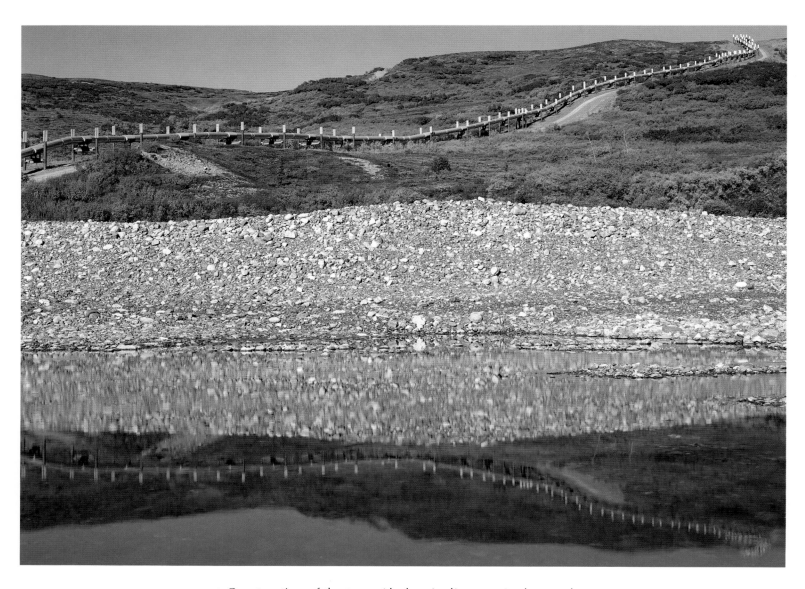

△ Construction of the trans-Alaska pipeline required more than twenty-two hundred government permits and authorizations, making it the most scrutinized and regulated construction project in history. The pipeline and related facilities occupy about sixteen square miles, or three-thousandths of one percent, of Alaska's 586,412 square miles. ▷ North of the Atigun River, reflections of golden clouds touch the surface of a still, arctic lake at midnight. The summer sun creates an afterglow in sky and water.

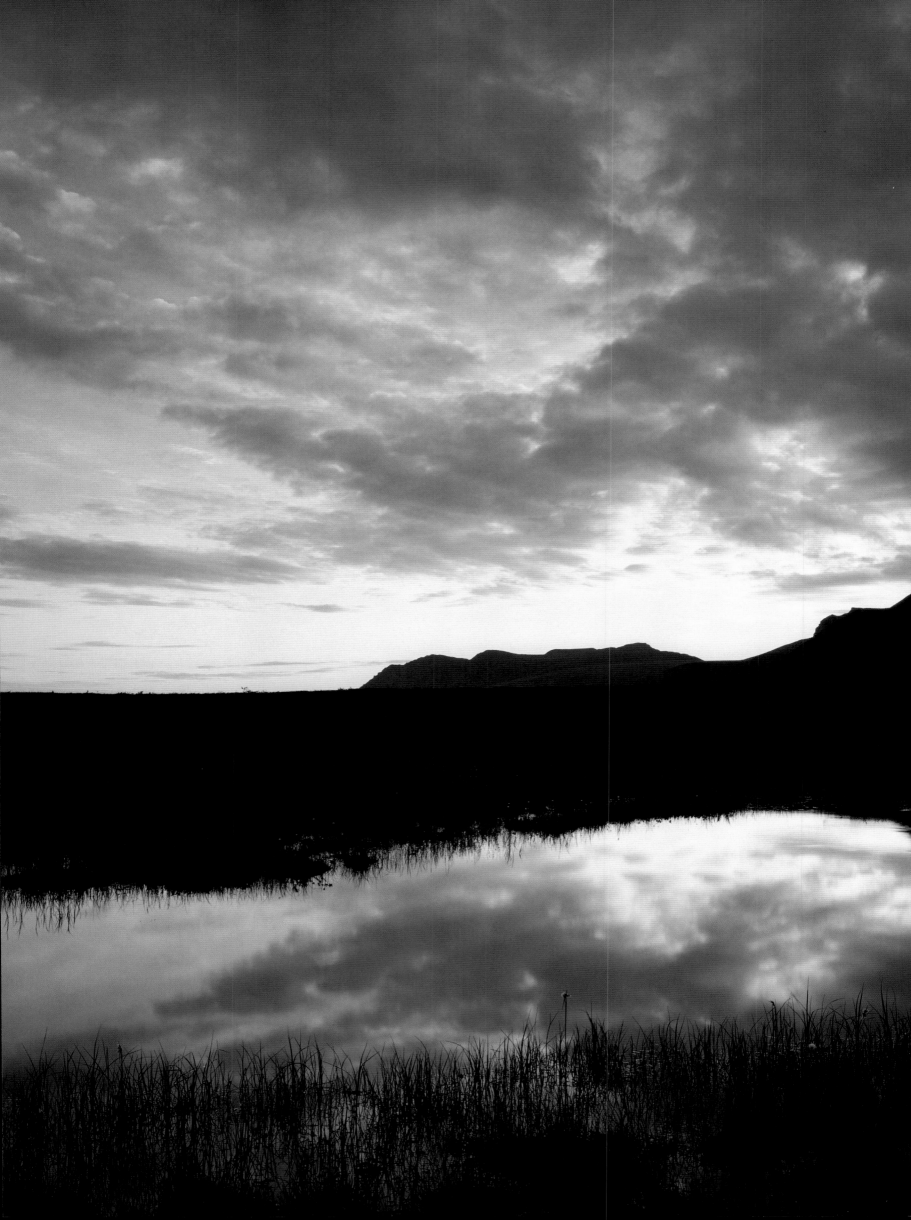

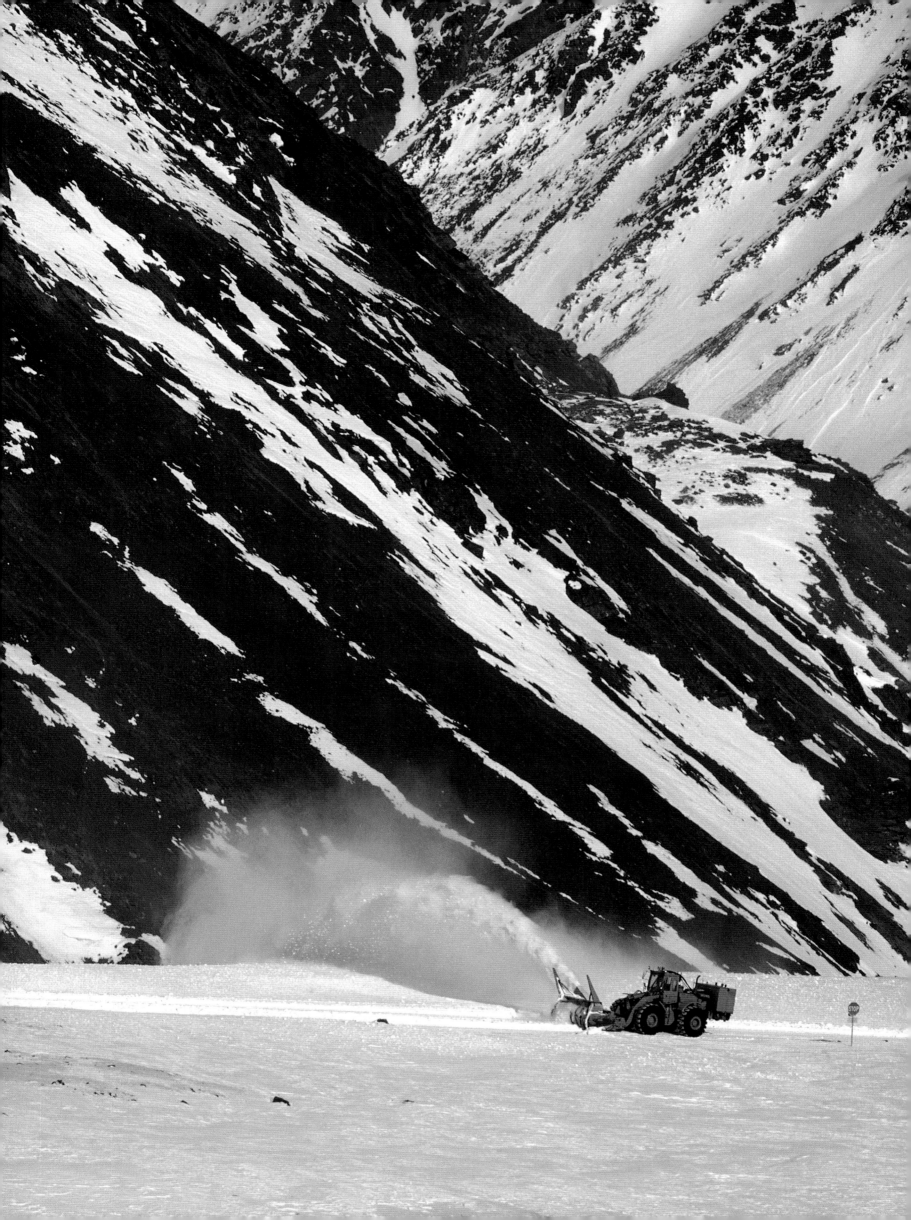

The Raven is a rich symbol of Alaskan culture and natural history. In Native legend, Raven is a creator, a hero, and a trickster. It was the raven's evident cunning, tenacity and hardiness that led to its adoption as a central figure in oral traditions throughout Alaska and the Northwest. This lustrous, iridescent bird ranges from open tundra to the depth of the coastal rainforests. Its aerial courtship displays are spectacular, and with a four-foot wingspan, the raven is a true flying acrobat. As people spread across Alaska, their settlements would undoubtedly have attracted the scavenging raven, and gradually a colorful association, which has lasted for thousands of years, was born.

Even today, as in millennia past, Alaska's people often seem to meld intangibly with the wilderness, as a moose vanishes into a thicket. In part, this almost symbiotic relationship between people and the land is the result of a small population, but in many cases it also reflects the profound respect Alaskans have for their land. In the land and its wildlife, the people of this remote state are able to see a reflection of themselves.

With remoteness comes isolation. Mountain ranges and oceans separate Alaska from the rest of the world, and the extreme climate deters some who would otherwise come here. But Alaska is a link between the New World and the Old. Long after the continents diverged, tearing apart ancient Gondwanaland and Pangea, Alaska was linked to Asia by a land bridge across the Bering Sea.

The fact that plants, animals, and human cultures are similar around the Arctic is a legacy of the time when, during periods of maximum glaciation, the sea level was lowered to the point where the continental shelf between Alaska and the Chukotka Peninsula in far eastern Russia was dry land. Plants, wildlife, and people of the Arctic share a unity born of their special adaptations. They have expanded their ranges into new lands, searching for opportunities to perpetuate their species. Herds of mammoths, bison, musk ox, and caribou roamed freely between the

The Life of Alaska

two continents, carrying bits of vegetation that would take root in new terrain. Horses moved westward, leaving their evolutionary birthplace in the New World to populate the Old.

As the glacial ice sheet surged to cover mountains, valleys, and coastal plains, it pushed life to the fringe. A few areas—Interior Alaska between the Alaska and Brooks Ranges, and the North Slope—escaped glaciation; these "glacial refugia" provided havens for some species that were later able to repopulate the land when the climate warmed.

As the climate changed, so did life. Some species flourished for only a short time, usurped by later arrivals. Others flourished longer, until out-competed or devoured by the faster, the hungrier, the more efficient. One species spread in successive waves across Alaska, some groups pushing southward and others staying on the coast or following rivers to the Interior. They began to arrive some forty thousand years ago, and continued their trek until the Bering land bridge was submerged about thirty thousand years later. They hunted with reason, planning, foresight, and cooperation, using tools and weapons. They founded cultures that learned from the land, and then learned to manipulate the land in turn. No other species would have such a dramatic and direct impact on Alaska. The first people came in search of land to live on, food to eat, shelter to live under, and energy to keep them warm. Thousands of years later, we are still in search of the same things.

◁ *The Siberian aster (Aster sibiricus) is common in meadows and on river bars. It grows throughout Alaska except in the western Aleutians and Southeast.*
△ *Dall sheep (Ovis dalli) inhabit steep mountainsides along the pipeline route. In late spring, they descend with their lambs to graze on newly sprouted vegetation.*
◁ ◁ *Alyeska relies on the Alaska Department of Transportation and Public Facilities to keep the Dalton Highway clear of snow year-round. The pipeline is buried here in Atigun Pass to protect it from avalanche hazard.*

Alaska supports a diversity of habitats that form the foundation of life for all species that live here, our own included. These habitats are associations of plants and animals, along with the physical characteristics of land or water to which they have adapted. Yet, despite their diversity, most land-based habitats in Alaska share one thing in common: beneath them lies permanently frozen ground—permafrost.

Permafrost is soil or rock (which may or may not include ice) that is perennially frozen—below 32°F for more than two consecutive years. It underlies about 80 percent of the state. North of the Brooks Range it is found everywhere and is known as continuous permafrost. South of the Brooks it is more sporadic, though still common, and is referred to as discontinuous. Only in the warmer southern coastal areas is permafrost rare.

In arctic Alaska, permafrost can be two thousand feet thick. Overlying the frozen depths is a layer of soil that thaws each summer. This "active layer" is from one to six feet thick and is the biological focus of the ecosystem. Where there is permafrost, life is confined to the shallow active layer. This is where plants grow, where microorganisms multiply, where animals derive their sustenance, and where they reproduce. Roots and burrows are more horizontal than vertical; water remains trapped at the surface. These limits impose a profound control, for plants and animals must be highly specialized to tolerate them.

The trans-Alaska pipeline corridor traverses a mosaic of habitats. Nature's communities from the North Slope to Southcentral Alaska show a transition from a frigid arctic climate to a relatively mild maritime one, with a variety of river, plateau, and mountain habitats in between. The pipeline corridor provides the observant traveler with an unparalleled cross section of the state.

Tall, dense spruce forests dominate the south, filling well-drained river valleys and clinging to south-facing slopes. Intermixed with the white spruce are alder, willow, birch, aspen, and balsam poplar, creating a patchwork of greens in

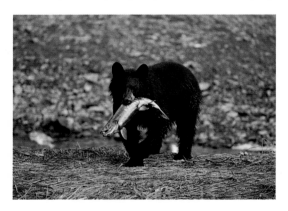

▷ The American black bear (Ursus americanus) is an omnivore: it will eat just about anything. When the salmon are running, bears become adept fishermen.
▷ ▷ An Alyeska contractor takes a moment's pause during an oil spill drill at Chenega Bay in Prince William Sound. Drills are conducted frequently and can occur at any location selected by the regulatory agencies of the Joint Pipeline Office. Safety and environmental protection are the paramount goals.

the summer and golds and yellows in the brief days of autumn. In places where permafrost creates an impermeable barrier beneath the soil, drainage is poor and white spruce and hardwoods are replaced by the stunted, shallow-rooted, acid-loving black spruce. In wetter areas, the forest is replaced by muskeg, a boggy habitat with scattered islands of black spruce. It is here that moose venture into shallow ponds to graze, submerging themselves like northern hippopotami. Muskeg is also home to mosquitoes, muskrats, and sometimes beavers—creatures with an aptitude for damming creeks and redesigning habitats that would impress an engineering professor.

At the northern limit of tree growth, toward the Brooks Range, spruce are gradually replaced by deciduous shrubs. Low-growing willows and alders make concerted inroads north along stream valleys and river floodplains, finding sheltered corridors that lead from the north side of the Brooks Range far into the Arctic. Except in these sheltered locations, treeless tundra dominates the Arctic Coastal Plain. Tundra consists of a complex variety of grasses and sedges, flowering plants, dwarf woody shrubs, and lichens and mosses. Variations in tundra plant composition occur with only a few millimeters of difference in elevation, creating an endlessly complex jigsaw puzzle of habitats.

The northward succession of vegetation types mirrors that which occurs with increasing altitude. Tall shrublands, often consisting of dwarf birch, willow, and

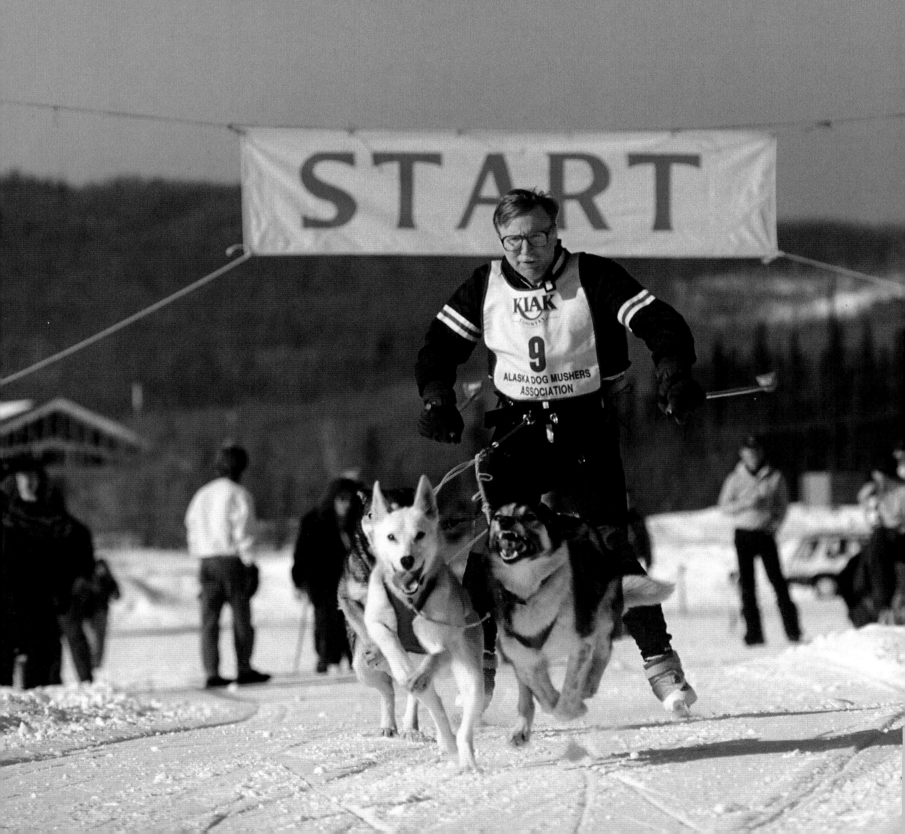

alder, cover the foothills. At higher elevations, tundra takes over, with lichens punctuated by the deep purple of mountain saxifrage and moss campion, the white of mountain avens, and—at summer's end—the tiny red leaves and glossy fruit of mountain cranberry. It is often the transition zones between ecosystems, called ecotones, where species diversity is greatest, a situation biologists call *edge effect.*

North of the Brooks Range, with permafrost omnipresent, drainage is poor, and the tundra is filled with lakes and ponds. The ground is wet, the sort of sinking wet that takes you up to your calf in water. Sedges and grasses are luxuriantly green in summer; as fall approaches, pond margins are tinged red by arctic pendant grass. Along the Beaufort Sea coast, geese heavily graze the salt marshes.

The adaptations of Alaska's plants reflect the pressures of the land and climate. Many species show what is known as *phenotypic plasticity:* the same species assumes different forms depending on local environmental conditions. A stunted willow or crooked black spruce clinging to windswept permafrost would grow straight and tall if transplanted south. A dwarf growth form is a classic adaptation to harsh conditions: high winds, poor soil, extreme cold. Northern plants often have closely spaced leaves that are dark and covered with dense hairs: all characteristics designed to retain heat and absorb sunlight. The roots may be stratified in the uppermost layer of soil; many plants have fleshy roots or storage organs to provide energy early in the growing season. Unlike their southern relatives, northern plants can resist frost damage during the most sensitive growth periods, even when they are flowering, an essential adaptation in this land of snow and ice.

Living on the land under birch and spruce, grazing over the tundra, nesting among sedge tussocks, and digging out their dens in pingos, is Alaska's wildlife. Mountains give Alaska majesty, but the wildlife is her beating heart.

The smallest wildlife can be the hardest to ignore. Insects come in all shapes and sizes and, to the casual observer, they appear to be dominated by flies—

midges, gnats, no-see-ums, oestrid flies, deerflies, craneflies—and, of course, mosquitoes. Alaska insects tend to be smaller, darker, and hairier than their southern counterparts. By flying close to the ground, being active only in good weather, and staying in sheltered areas, many of Alaska's insects reduce their exposure to cold and conserve their energy. Many species found in the

◁ *Every fisherman believes that having just the right lure can make all the difference.* ◁ ◁ *When the snow flies and the temperature plummets, some people just have to get outside. Here a skier is pulled by his three Alaska huskies in a Fairbanks race. Huskies naturally love to pull and were historically used for transportation across the state; now they are primarily bred and trained for recreational purposes.*

Arctic can metabolize at very low temperatures. Other species have the ability to produce their own chemical antifreezes, which allows them to survive the winter.

Alaskans jokingly call the mosquito their state bird; it's really the willow ptarmigan. There are almost forty species of mosquitoes in Alaska—all of them irritating. Only females feed on blood; males feed on plant sap. During egg production, the blood provides a food source for the developing larvae. Prevalent in most parts of the state from April until September, mosquitoes favor moist, low-lying areas and are most active at dusk and dawn. They are poor flyers and need reasonably warm temperatures to remain active in search of a liquid meal.

There is an ample supply of blood for the mosquitoes that swarm through Alaska's summers, and it comes in some very large packages: grizzly bears, moose, musk ox, caribou, Dall sheep, mountain goats, wolves, and humans. There are also small mammals, which spend much of their time hiding from the large ones: arctic ground squirrel, red squirrel, lemmings, voles, shrews, snowshoe hare, muskrat, and hoary marmot. Birds also provide a food source for whining female mosquitoes—

just as those same mosquitoes feed the birds. The birds give Alaska brilliant colors: red-throated loon, tundra and trumpeter swans, green-winged teal, king eider, black scoter, harlequin duck, red phalarope, ruddy turnstone, Ross' gull, golden eagle, rufous hummingbird, bluethroat, common redpoll, and rosy finch.

Still, no matter how well adapted species are to extreme conditions, sometimes extreme is just too severe. The supreme adaptation to severity is avoidance. When facing the Alaska winter, most birds exercise an adaptation not available to plants and terrestrial mammals: they fly away, heading south to warmer climes. Caribou migrate southward from the Arctic Coastal Plain to find winter refuge in comparatively sheltered valleys on the south side of the Brooks Range. Other mammals, unable to migrate long distances, wait out winter in the relative comfort of a den or burrow. Few species risk exposure and predators to emerge at -40°F.

Most birds—and 443 species are known to occur in Alaska—are transitory visitors, fair-weather friends. They begin arriving as early as April in some years, more commonly in May. They flock to river deltas, wetlands, forests, and towns. During the brief summer, they take advantage of the long days and abundant food to raise their broods. But with summer almost gone by mid-August, the birds soon congregate again to begin the southward migration. Gone are the sandhill crane, Canada and greater white-fronted geese, northern pintail and canvasback, yellowlegs, phalaropes, semipalmated and pectoral sandpipers, arctic tern, peregrine falcon, violet-green swallow, ruby-crowned kinglet, gray-cheeked thrush, and yellow-rumped warbler. Gone to California, Texas, Mexico, Central and South America, Hawaii, and—in the case of the arctic tern—Antarctica, ten thousand miles due south.

Comparatively few bird species winter in Alaska; the eider, bald eagle, gyrfalcon, spruce grouse, ptarmigan, snowy owl, gray jay, and common raven are among those that do. These are all superbly adapted to survive in cold

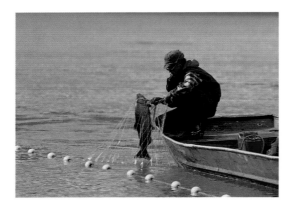

▷ When the Chinook or king salmon (Oncorhynchus tshawytscha) *are running in the Yukon River, men and women from Stevens Village work hard to bring in the catch.*
▷ ▷ Salmon hung to dry mark the end of a productive day on the Yukon. Alaska Natives cure freshly caught fish in this traditional way, which keeps the meat in prime condition through the winter.

weather. Snowy owls have the lowest thermal conductance ever measured in birds. Owls lose almost no heat from their body surface. Ptarmigan can burrow beneath an insulating layer of snow for warmth, and ravens have well-insulated footpads.

Hibernation—entering a deep "sleep" for the winter—is a method used by some mammals to survive the cold. Metabolic dormancy is a good way to avoid expending energy during the winter months, but hibernating animals must first acquire a large enough fat store to last them through the long period of fasting. At the beginning of summer, an arctic ground squirrel may weigh about two pounds. However, it must nearly double its weight to survive the winter's inactivity.

It may seem amazing that ground squirrels hibernate through the worst of the winter, whereas smaller lemmings, all three or four ounces of them, remain active all winter, tunneling to search for food beneath the snow. Lemmings must remain active because the ratio of their surface area to their body volume is large, compared to bigger animals. Energy is radiated away from the body surface as heat loss, and lemmings cannot consume enough food to survive a long period of dormancy.

Technically, bears are not true hibernators. They slow their metabolic rate dramatically, but they can wake up at any time during the winter, as people who have crawled into dens have learned to their peril. Two of Alaska's three bear species, the grizzly bear and the black bear, den for the winter. Polar bears, with the exception

54

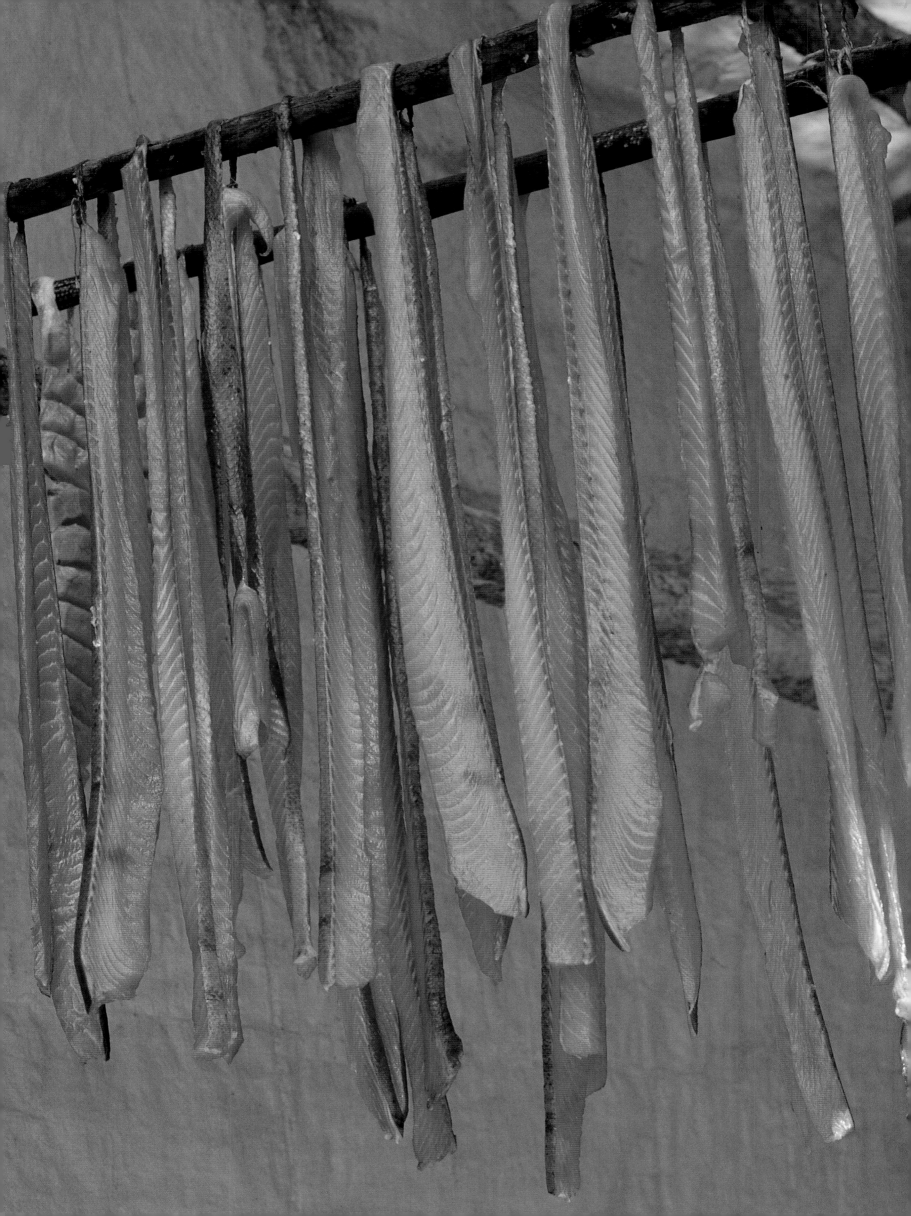

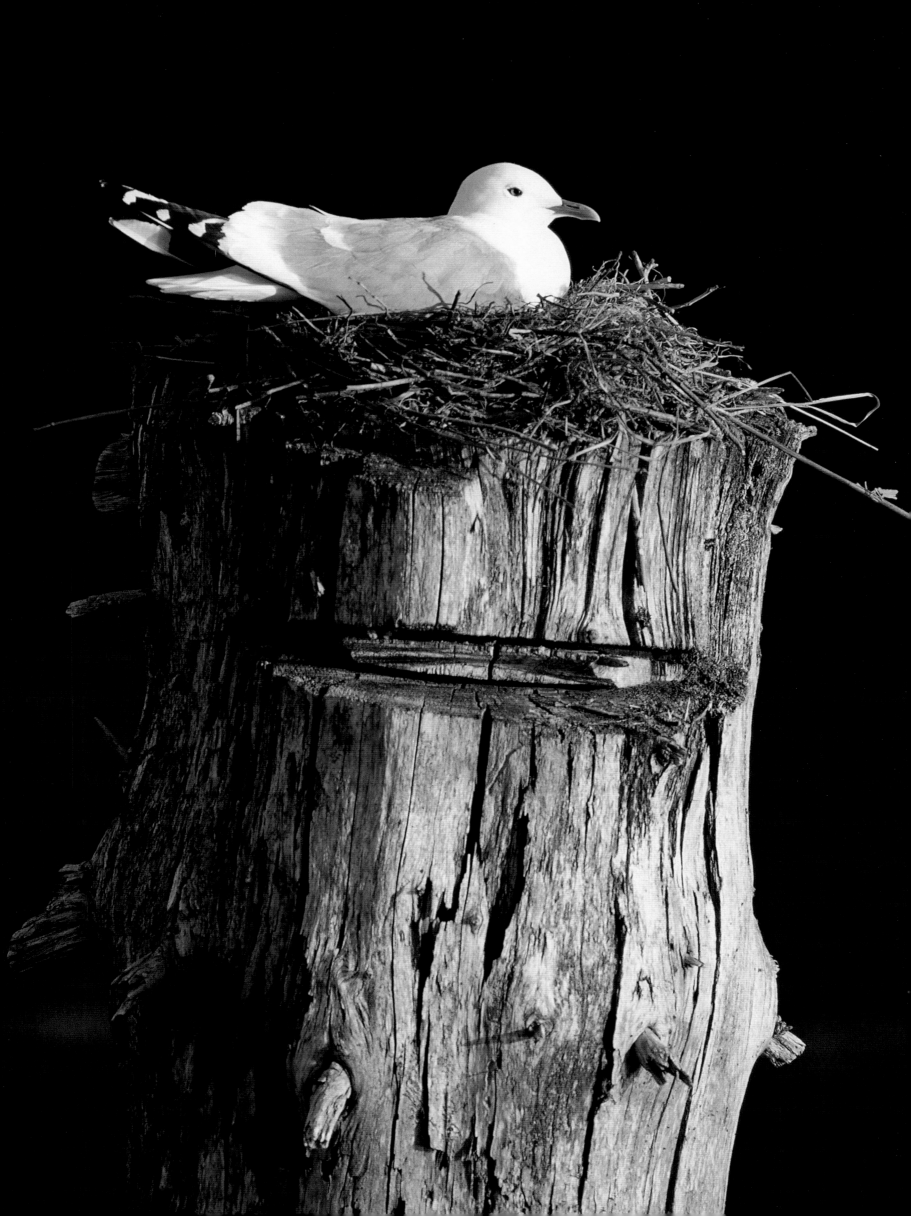

of pregnant females, remain active, hunting throughout the winter, consuming an average of one seal every four or five days. Grizzly bears that live in northern Alaska may spend up to half the year in their dens, while those in the south may not enter dens until December, and emerge as early as March. This difference in annual activity, along with differences in diet, translates into size; grizzlies along the southern coast can reach 1,500 pounds, making them the largest land carnivores, whereas those in the Far North are considered large at 350 pounds.

At Pump Station 4, just north of Atigun Pass in the Brooks Range, Alyeska personnel have become well acquainted with one grizzly bear they have christened "Blondie." This light-colored bear has been watched by regular shift workers for the past twelve years. She has raised three sets of cubs amid the towering peaks of the northern mountains, occasionally heading north onto the tundra or following rivers into their valleys. Each spring, employees keep an eye out for "Blondie" and any cubs she may have with her. The people who work here know enough to keep a respectful distance, but they thrill at the sight of this enduring resident of the Arctic.

Species that brave the winter, rather than sleeping through it or fleeing from its onset, are masters of the snow and ice. They are the white predators: the polar bear, the arctic fox, and the ermine. Other predators, like lynx and wolf, negotiate deep snow by having feet like snowshoes. Herbivores either take to the snow with their own snowshoe-sized feet, as does the aptly named snowshoe hare, or descend beneath the snow to a maze of tunnels. Larger browsers and grazers, such as moose and caribou, use their splayed hooves to tame deep drifts, but avoid the deepest snowpack and icy ponds.

Just as plants, insects, birds, and mammals adapt, so do people. The first people to set foot in Alaska changed the land, but those changes were subtle. It was the later arrivals who began the transformations that would come in decades rather than millennia. We don't tend to think of our own history in terms of the natural history of a species, but as our evolution becomes more cultural than biological, we should not forget that we, too, are the product of natural selection.

Humans began arriving in what is now Alaska more than forty thousand years ago. Today, about 16 percent of the state's population consists of Native Alaskans. The Aleutian and Pribilof Islands are home to marine-oriented Aleuts, while the Inupiat and Yupik live in northern and western coastal areas. The Interior is home to the Athabaskans, originally a nomadic people who followed caribou herds and settled along the major rivers. And in the Southeast live the Tlingit, Haida, and Tsimshian people. By the time Vitus Bering's ship made landfall in 1741, Alaska's Native peoples were already living in well-defined regions and for thousands of years had been subsisting off the land and waters by hunting and gathering.

Bering "discovered" a land rich in furs, and promptly claimed it for the Russian Empire. British interest in the region was also high, and in 1776 Captain James Cook came in search of the Northwest Passage. Citizens of the still-young United States were introduced to the Great Land through the Treaty of Cession in 1867 at a cost of $7.2 million.

It was not until the Klondike gold rush of 1896 that Alaska began to lose the derisive nicknames of "Walrussia" and "Icebergia," received from a cynical American press. With discovery of gold, Alaska's price—about two cents an acre—seemed

◁ An Alyeska employee enjoys a quiet moment on the Yukon River with a resident of Stevens Village. ◁ ◁ A black-legged kittiwake (Rissa tridactyla) sits snug on its nest in Valdez harbor. These small gulls fill the cliffs in Prince William Sound, nesting in raucous colonies and laying their eggs on precarious rocky ledges.

like a steal. By 1900, $17.3 million in gold had been mined from the territory. But within two decades, the gold rush was over and the population began to decline.

It seemed as though Alaska would forever be on the fringes of global activity, but World War II catapulted the region into the forefront. In only eight months in 1942, the U.S. Army Corps of Engineers, with the agreement of the Canadian government, built the Alaska-Canada, or "Alcan," Highway, to link the territory to the Lower 48. Alaska was soon flooded with military projects: more than a billion dollars were spent on airfields and military installations—growth that continued as the Cold War maintained the territory's position against the neighboring Soviet Union. Alaska's population swelled from 59,278 in 1930 to 128,643 by 1950.

The growing postwar economy of the United States needed domestic energy sources, and the 1950s saw the start of modern oil exploration in Alaska. Long before European explorers ever set foot here, the Inupiat used oil-soaked tundra from natural oil seeps as fuel. It may have been tales of these "oil lakes" that encouraged the U.S. Geological Survey to head north around the turn of the century.

Alaska's first oil production, beginning in 1902, was from the Katalla field south of Cordova on the shores of the Gulf of Alaska, but as early as the 1920s, some explorers were looking northward. In 1923, on the basis of preliminary surveys by geologists, President Harding designated thirty-seven thousand square miles in the western part of the North Slope as Naval Petroleum Reserve No. 4. Drilling in the reserve proved disappointing, but by 1957 the Richfield Oil Company had begun developing the Swanson River oil field on the Kenai Peninsula and was also moving offshore into Cook Inlet, both fields near Anchorage in Southcentral Alaska.

Statehood came to Alaska's 211,000 residents in January 1959, and oil was to become central to the new state's identity. By the late 1960s, five fields were producing oil, and nine were producing natural gas. Under the Statehood Act, Alaska would assume ownership of 104 million acres of previously federal land, to be selected by the state. The potential for oil would drive much of that selection.

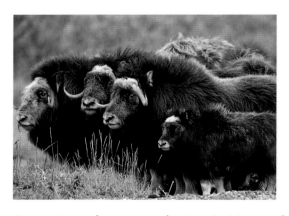

▷ *Musk ox* (Ovibos moschatus) *were once hunted to extinction in Alaska. Today they are making a slow but steady recovery following their reintroduction from Greenland.*
▷ ▷ *The tundra swan* (Cygnus columbianus), *identified by a distinctive yellow spot on its bill, has a six- to seven-foot wingspan. When swans leave arctic Alaska in the fall, they migrate to more temperate wintering grounds in California, Maryland, Virginia, and North Carolina.*

In 1964, the state selected, on the basis of geological surveys, a 125-mile coastal stretch between the newly renamed National Petroleum Reserve in Alaska (NPRA) to the west, and the Arctic National Wildlife Range (now known as the Arctic National Wildlife Refuge) to the east. That same year, competitive lease sales were conducted in the Colville River delta and around Prudhoe Bay. After ten dry holes, most oil companies had given up hope of finding commercially viable deposits, but on March 13, 1968, after a series of tests, ARCO and Humble Oil and Refining Company (now Exxon Company, USA) announced an oil strike.

The location of the strike was the Prudhoe Bay State No. 1 well, just three miles from the edge of the Beaufort Sea on the flat expanse of the Arctic Coastal Plain. It was undoubtedly one of the most remote exploration wells ever drilled. The flow rate was 2,415 barrels of oil and forty million cubic feet of natural gas per day, providing an initial estimated field size of five to ten billion barrels of oil. Estimates of total reserves were later increased to twenty-three billion barrels of oil and twenty-six trillion cubic feet of natural gas. The Prudhoe Bay oil field was, and still is, the largest oil and natural gas discovery in the history of North American exploration. In oil industry jargon, they had found an "elephant" in the Arctic.

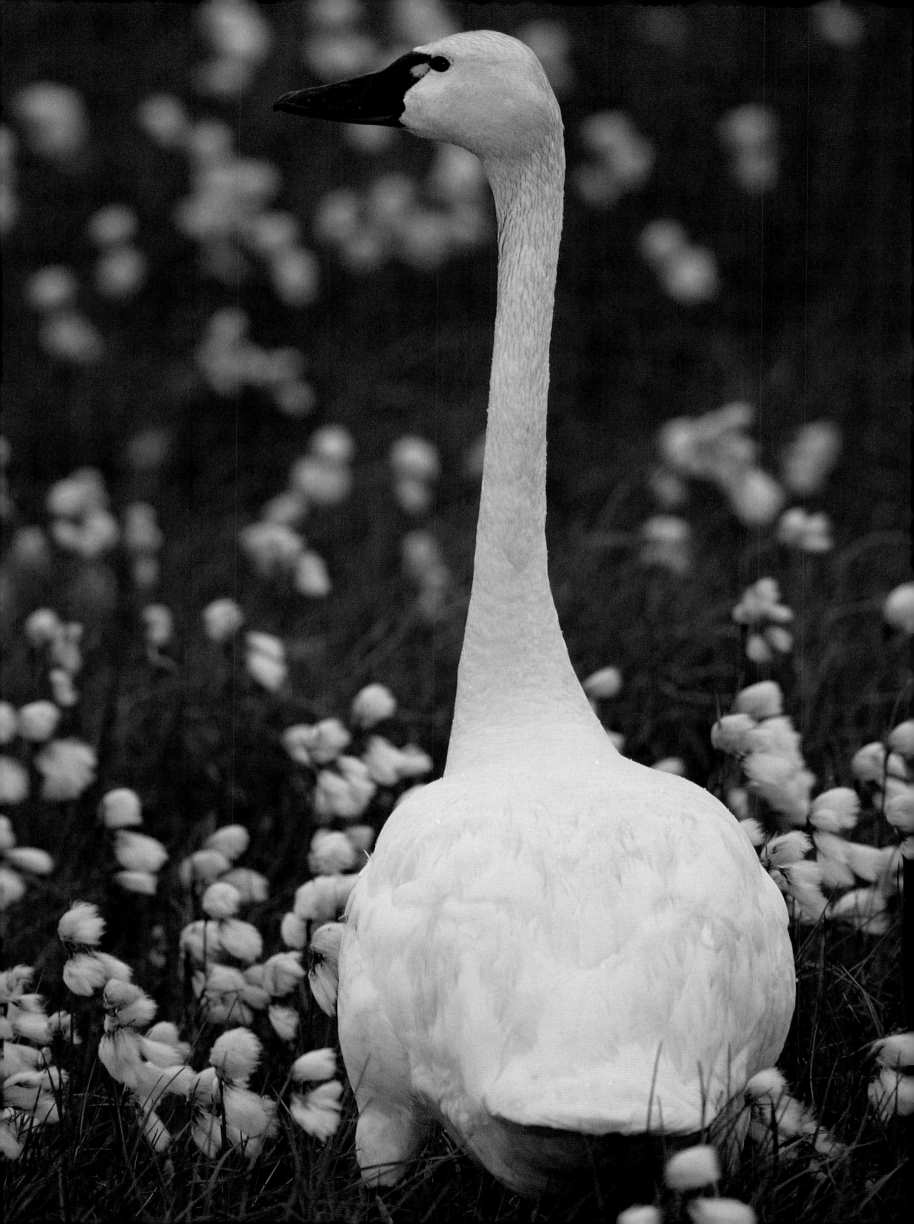

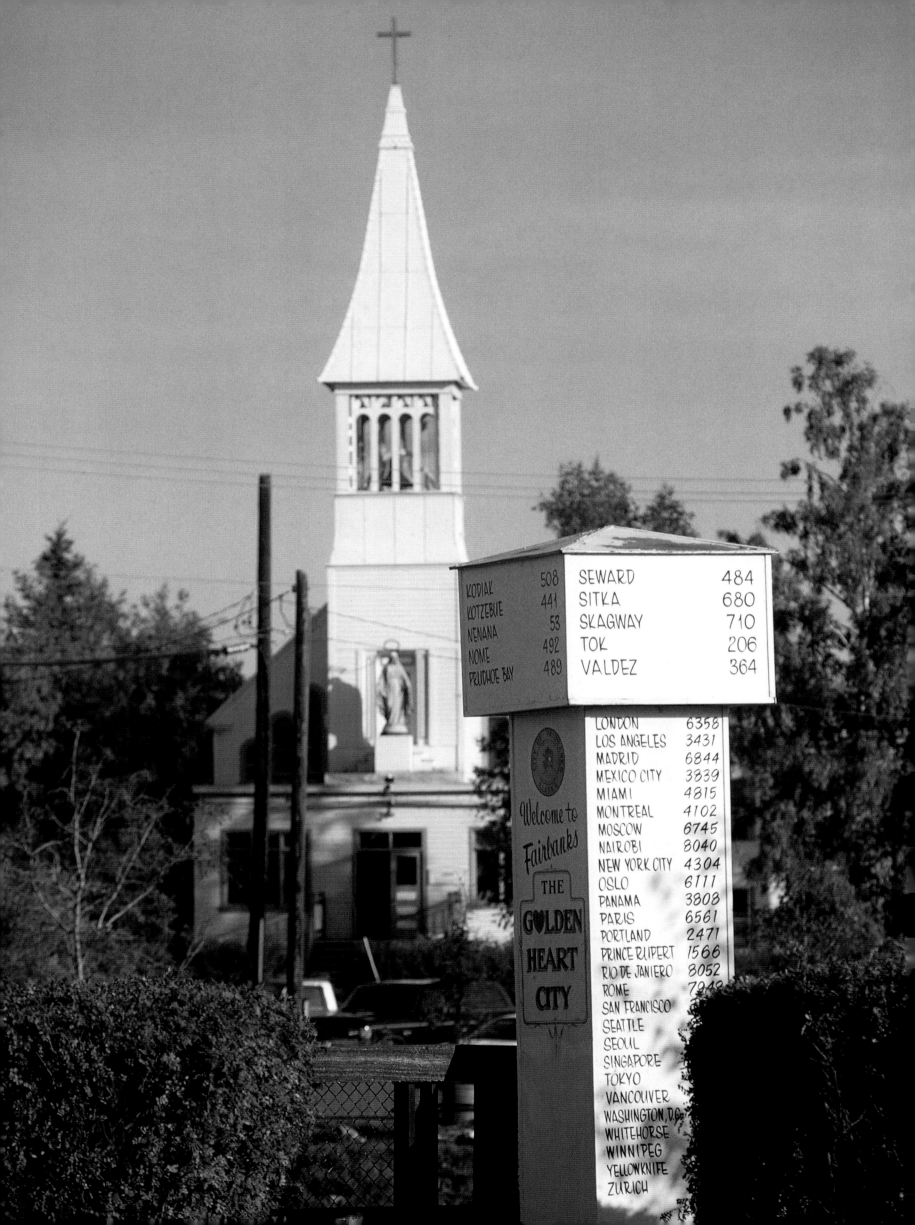

The discovery and development of the Prudhoe Bay and surrounding oil fields changed every community in Alaska. Even the most remote villages were touched by the rapid expansion in the state's resources, as schools, hospitals, new housing, communication systems, and—in a few cases—even roads reached into the heart of rural Alaska. The transition from a small economic base sustained by a strategic military position, commercial fishing, and sporadic timber harvesting to a globally significant economy fueled by oil occurred with tremendous speed.

Communities along the trans-Alaska pipeline route found themselves intimately associated with construction and subsequent operations. Valdez, the gateway to Prince William Sound, has come a long way from its inception in 1897 as a port for gold miners heading to the Klondike and the devastation the town suffered from the 1964 earthquake. This town of just over four thousand people is filled with seasonal activity. Tourists come to the region to marvel at Columbia Glacier and to watch for sea otters, whales, and seabirds, or to try their hand at salmon fishing, Alaska-style. Commercial fishing boats share the harbor with sea kayaks. As home to the Valdez Marine Terminal at the southern end of the pipeline, Valdez also sees an average of two tankers a day leave the terminal— each tanker, over a twenty-two-hour period, filled with up to 1.8 million barrels of oil.

Farther down the coast, Cordova is home to approximately twenty-five hundred people, and commercial fishing is the mainstay of the community. The town is located on Orca Inlet near the Copper River delta, site of a phenomenal annual migration of shorebirds. Every May, millions of sandpipers and other shorebirds descend on the delta, feeding voraciously in a brief respite before heading farther north to breed.

North of Valdez, the Richardson Highway links the communities of Copper Center, Glennallen, Delta Junction, North Pole, and Fairbanks. These communities developed along the roads and waterways to Alaska's Interior. In the past, they promised riches in gold and copper from the surrounding rivers, hills, and mountains; today, they vie for the tourist trade. They are small: Copper Center is home to 449; Glennallen, to 928; Delta Junction, to less than 800; and North Pole, to 1,456. Each one carries its unique history quietly, hidden in the decaying logs of prospectors' cabins or in the unmarked graves of remote cemeteries.

◁ Thrill-seekers ride the rapids through Keystone Canyon on the Lowe River, twelve miles east of Valdez. The buried pipeline passes nearby.
◁ ◁ In Fairbanks, the twelve-foot-high milepost at Golden Heart Park shows distances to seventy-six destinations in Alaska, the Lower 48 states, and abroad. The hub of Alaska's Interior, Fairbanks was founded in 1901 and has a population of eighty-five thousand. The Church of the Immaculate Conception overlooks the park. The church was moved here by horses in 1911.

Fairbanks, Alaska's second-largest city, has grown to more than eighty thousand. The town was founded in 1901 by Captain E. T. Barnette, who established a trading post on the Chena River following the discovery of gold by an Italian prospector named Felix Pedro. The area soon attracted miners and trappers, and even today it remains an important mining center. The city is home to the University of Alaska Fairbanks, the army's Fort Wainwright, and nearby Eielson Air Force Base. A burgeoning tourist industry promises to take visitors back to the days of sternwheelers and gold panning and introduce them to Athabaskan culture and customs.

In recent years, the people and the economy of Fairbanks have become closely linked to the pipeline. Fairbanks was the main staging point during pipeline construction, and the city grew under the weight of workers who arrived for a chance at high wages. Fairbanks has always attracted independent and adventuresome personalities. Today, residents delight in their eclectic city, where record cold can take the thermometer to -62°F and record heat can hit +99°F.

The Dalton Highway, north of Fairbanks, does not pass many settlements. In the Interior, it is still the rivers, not the single road north, that determine where communities will locate. Stevens Village and Rampart, two Athabaskan communities in the Interior, make full use of the Yukon River as their highway, whereas for Coldfoot and Wiseman in the southern foothills of the Brooks Range, it was the Koyukuk River that provided passage south before the arrival of the road. During pipeline construction, these remote communities suddenly had thousands of neighbors in the temporary construction camps built along the pipeline corridor. When construction was completed, the camps were removed, and only the small pump station crews remained.

Coldfoot and Wiseman are contrasting villages, where once they were twins. Coldfoot (apparently named for miners who got "cold feet" about their claims and left the area) was founded in 1898 by gold prospectors, as was Wiseman, a few miles farther north. Coldfoot, a bawdy town at the turn of the century, once housed a gambling hall, two roadhouses, seven saloons, and a flourishing prostitution trade—immortalized by a series of streams named after some particularly memorable residents. The settlement is now a truckstop and jumping-off point for hikers and rafters heading into the Brooks Range or Gates of the Arctic National Park and Preserve. Among the few remnants of Coldfoot's colorful past are the burial mounds in the old cemetery.

Wiseman, on the other hand, is still the epitome of the rural Alaska village. Until the Haul Road was built, the only ways in or out of Wiseman or Coldfoot were by air, boat, or dog sled. In *Arctic Village*, Robert Marshall wrote in 1933 that Wiseman was "two hundred years north of civilization." In many ways, his description of a frontier community living off the land still stands, with one exception: civilization's signature is now visible from Wiseman as the trans-Alaska pipeline crosses beneath the middle fork of the Koyukuk and heads south, accompanied by the Haul Road. This village of twenty-seven souls may still be two hundred years north of civilization, but today you can see civilization from Wiseman.

▷ The arctic tern (Sterna paradisaea) makes the longest migration of any bird, from the Arctic to the Antarctic, a round trip of roughly twenty thousand miles.
▷ ▷ In Prince William Sound, the moist coastal rainforest of Sitka spruce (Picea sitchensis) and western hemlock (Tsuga heterophylla) is draped in arboreal lichens. The trees do not suffer from these hanging epiphytes, but simply provide them with a place to grow.

Certainly the pro-development attitude of the state of Alaska during the early boom days of oil discovery divided Alaskans. Those who had come to Alaska to escape the twentieth century suddenly found it marching north to meet them, while others welcomed its arrival. Oil development has done a great deal for Alaska. It has provided jobs and opportunities, not the least of which is the Permanent Fund, an innovative "savings account" established by the state to ensure that Alaska would have a source of income in a post-oil economy.

In the few communities along the pipeline corridor, it is sometimes hard to see the link between a frontier past and a present built on oil, but it is there, in the generators and snowmobiles ("snowmachines" to Alaskans), the schools and hospitals, and in the modern communication networks across the state.

Alaskans are fortunate in having benefited from hindsight in a way other Americans could not: large-scale development has come late to Alaska, and many of the technological innovations and regulatory safeguards of recent years are already in place to protect the air, water, land, and wildlife. No development can go forward in the state without passionate debate and extensive analysis, for Alaskans want to keep their wilderness and live on its edge. It is this delicate balance that the citizens of the state view as their special challenge and personal responsibility. Alaskans do not intend to lose sight of the immense beauty embodied by the land of the Raven.

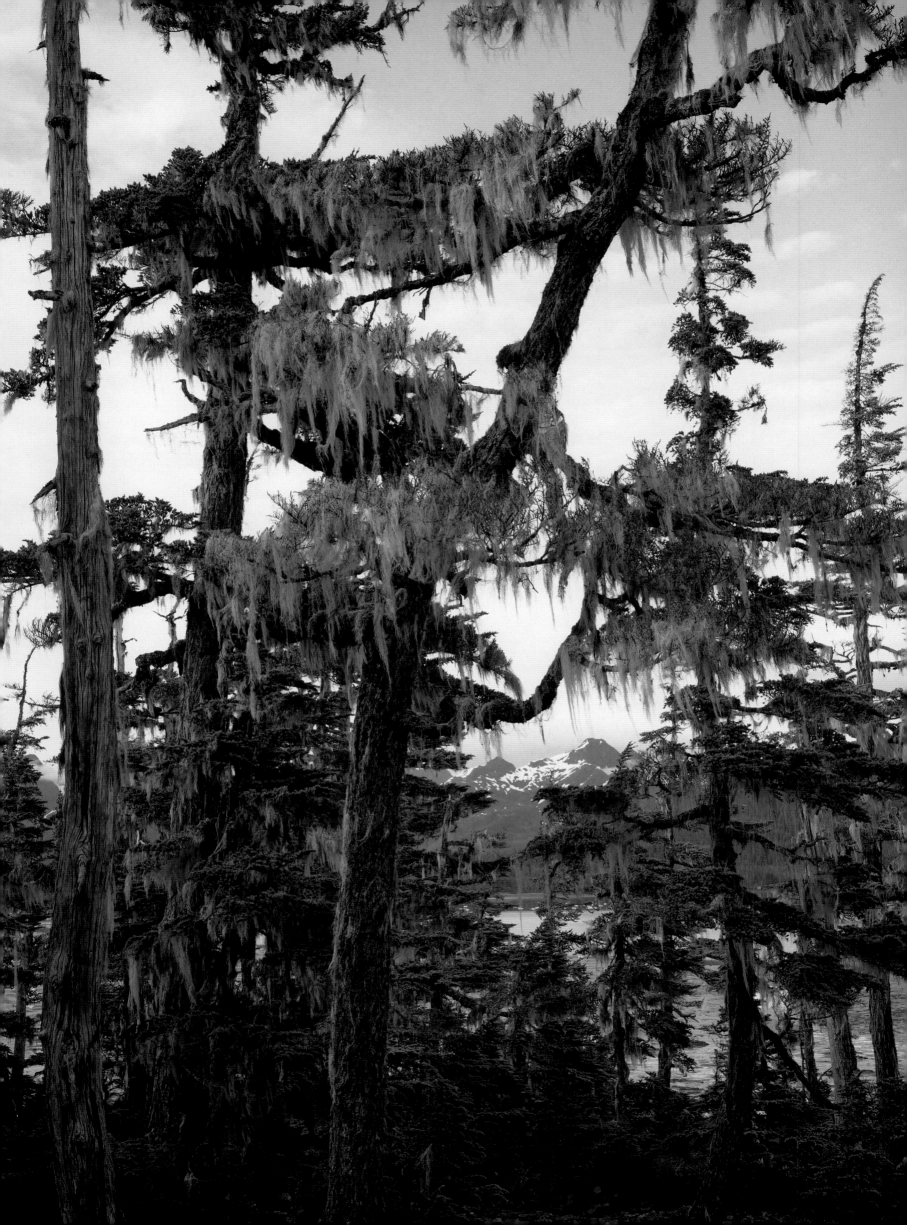

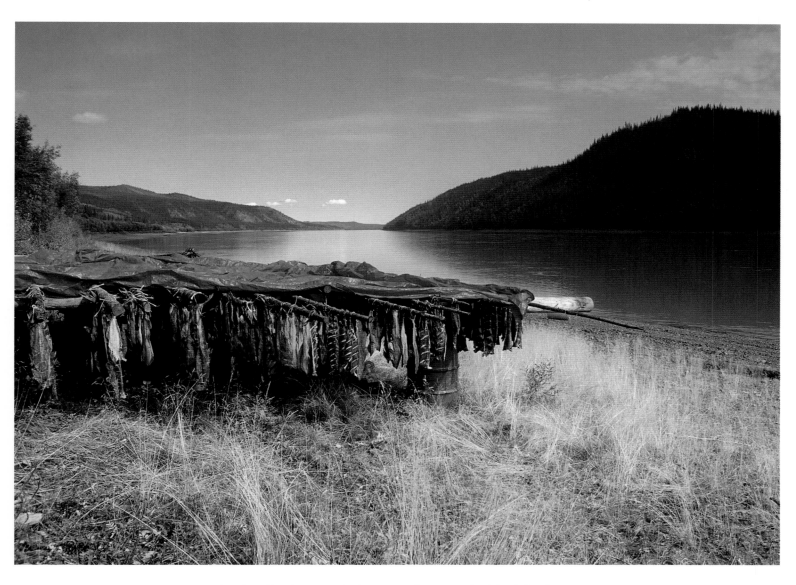

◁ Lupine *(Lupinus* species) carpets the ground with violet flowers during early summer. Members of the pea family, lupines are actually poisonous and have not been widely used by Alaska Natives. However, the Dena'ina people who called Southcentral Alaska home did use old, dry lupine pods as baby rattles. △ In summer, Alaska Natives establish fish camps like this one along the Yukon River, maintaining the traditional subsistence culture that still sustains them throughout the year.

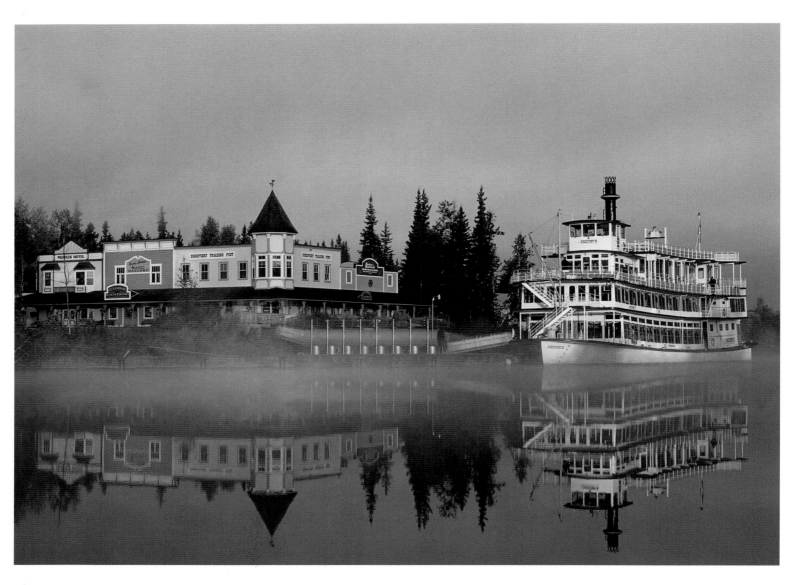

△ The Riverboat *Discovery III* and Steamboat Landing are reflected in the Chena River at Fairbanks. Owned by the Binkley family, the fully operational sternwheeler, built in 1987, takes Fairbanks visitors into a scenic past filled with fur traders and sourdoughs, Alaska Native culture, and gold strikes. ▷ In Alaska, roads are few and far between. With ample places to land, float-planes are the preferred method of transportation to and from the wilderness. During winter, skis often replace the floats.

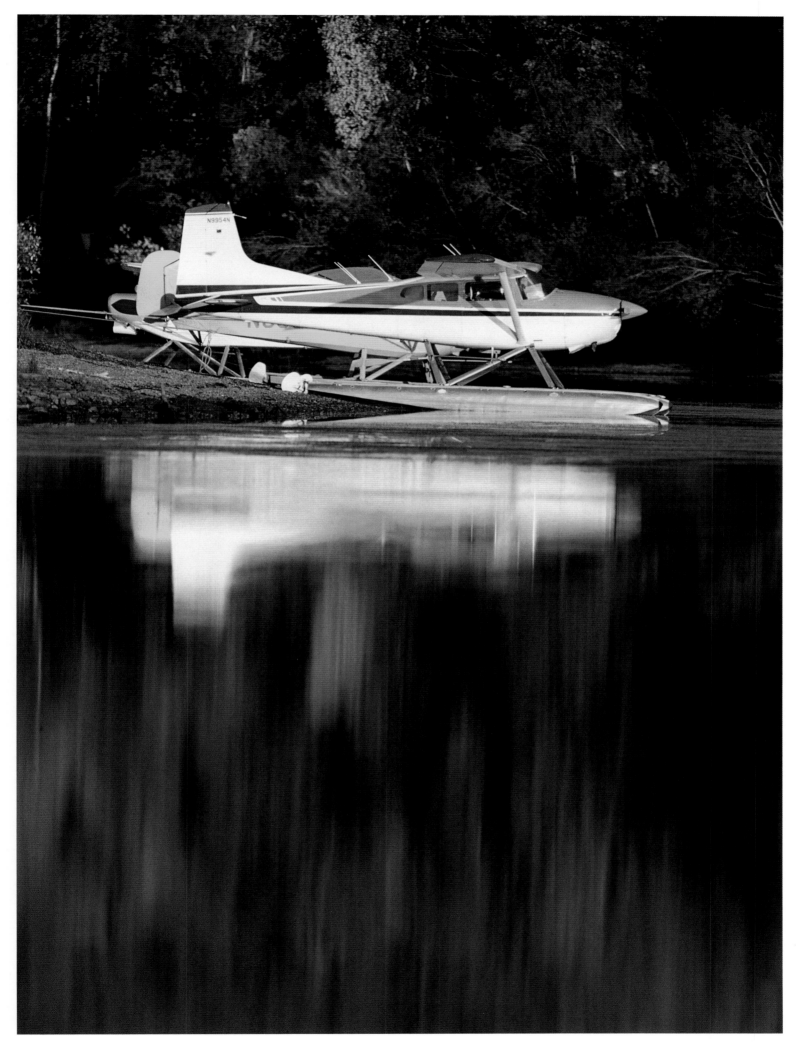

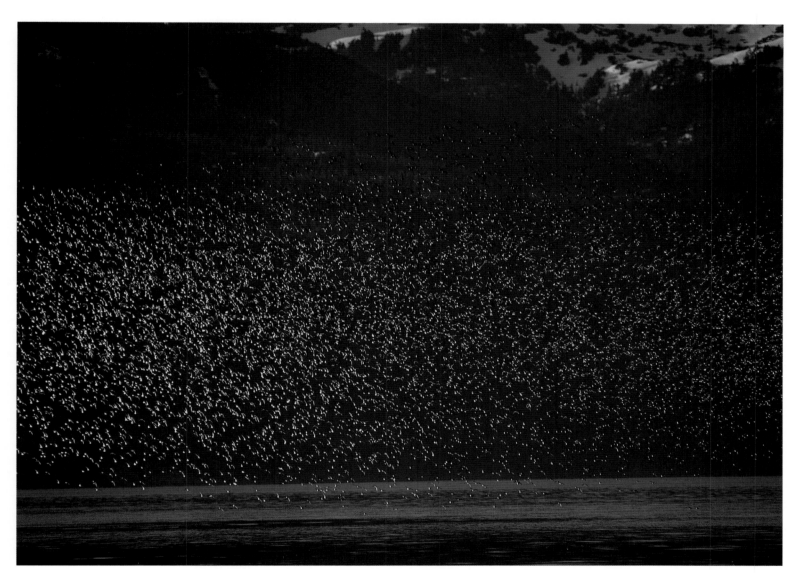

◁ Alaska produces more seafood than is supplied by the entire rest of the United States. If Alaska were a nation, it would rank among the top ten seafood producers in the world. Nearly six billion pounds of fish, shrimp, crabs, and shellfish are harvested yearly from Alaska waters, bringing an annual business income of over three billion dollars, of which salmon accounts for more than one-third. △ Every May, Alaska is host to millions of shore-birds. The sky over the Copper River delta is darkened by flocks of sandpipers and phalaropes, feeding voraciously before resuming their migration to arctic breeding grounds.

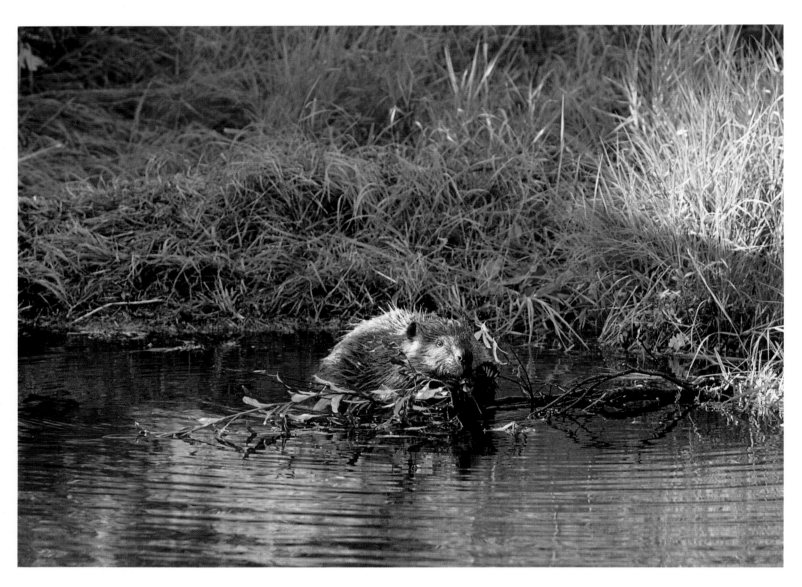

△ An industrious beaver *(Castor canadensis)* cuts willow *(Salix species)* branches for its winter store. Beavers, North America's largest rodents, are found in lakes and ponds throughout forested regions of Alaska. ▷ Quaking aspen *(Populus tremuloides)* reach skyward, their round leaves moving in the slightest breeze. This tree often occurs in dense stands, especially after forest fires. ▷ ▷ Remote gate valves like this one north of the Brooks Range can be activated electronically by operators at the Valdez Marine Terminal to isolate sections of the pipeline and stop oil flow in case of a problem. Castle Mountain looms in the background.

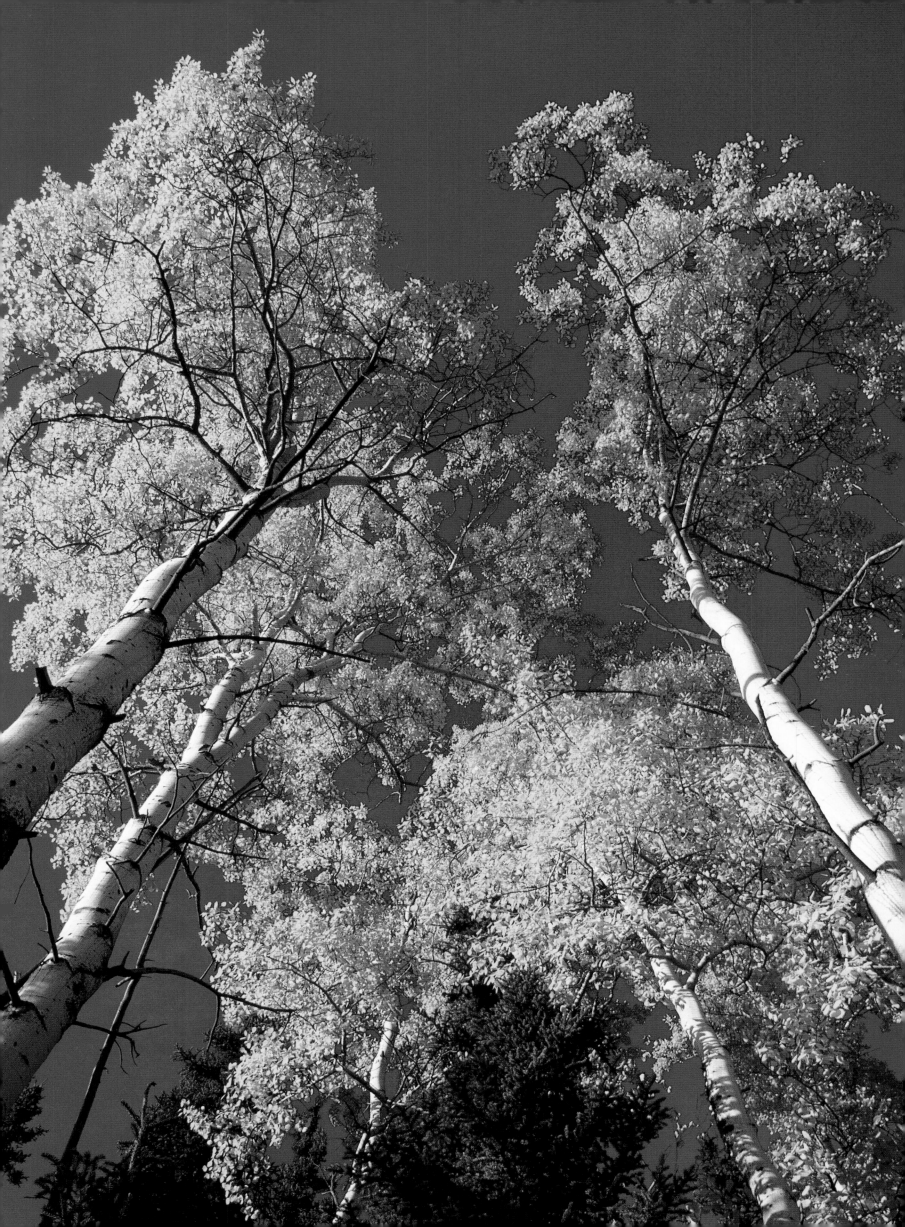

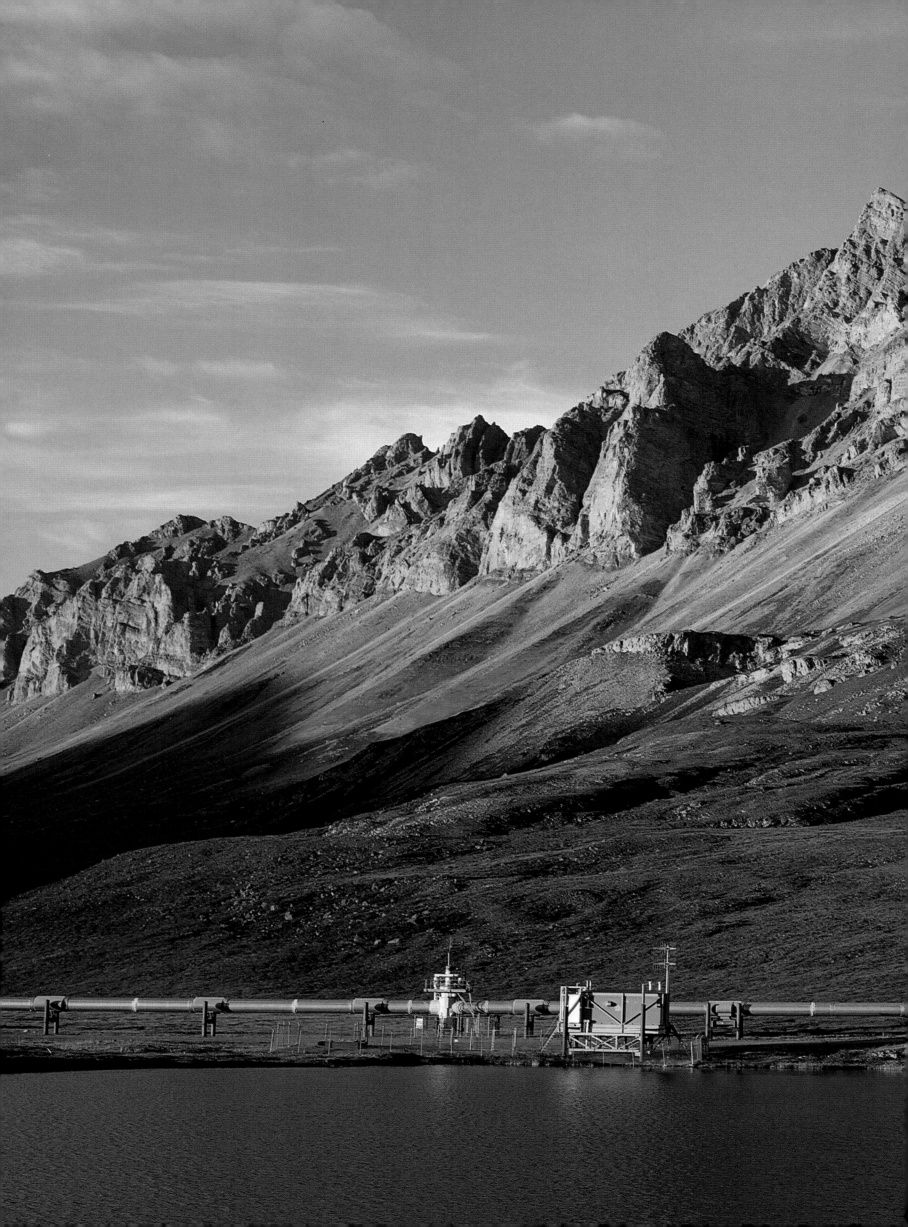

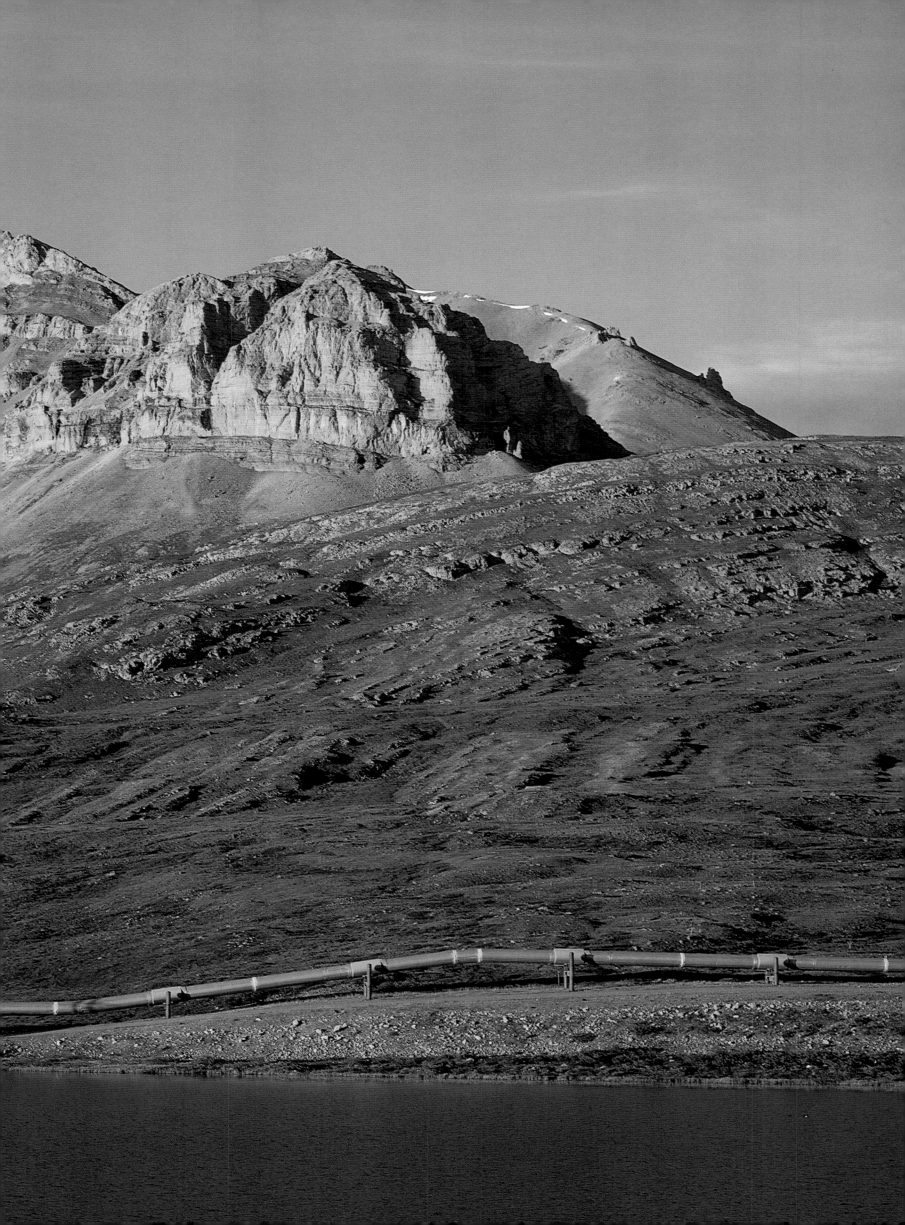

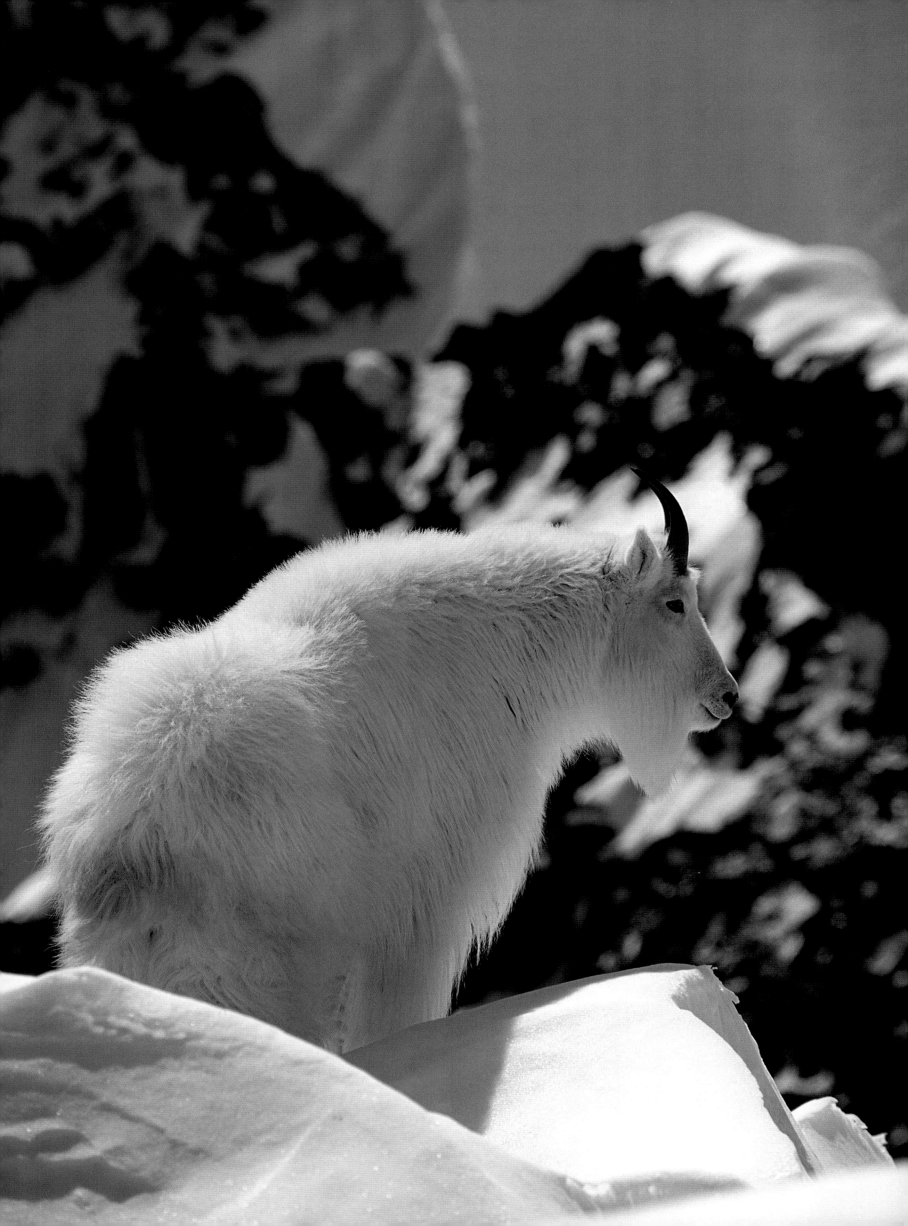

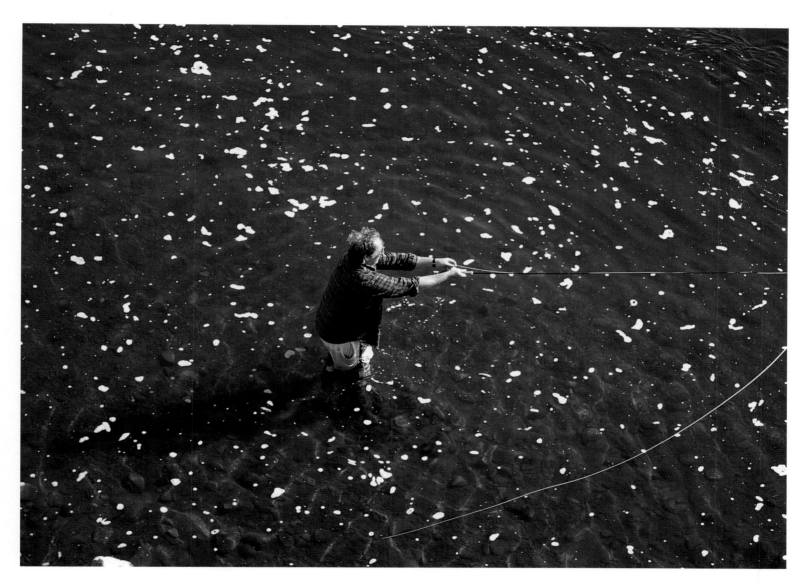

◁ A mountain goat *(Oreamnos americanus)* cuts an imposing fig-
ure against the rocks and ice of Thompson Pass in the Chugach
Mountains. Like Atigun Pass more than five hundred miles to the
north, the formidable Thompson Pass was crossed only through
the skill and tenacity of the pipeline builders. △ Approximately
twenty-five species of fish are known to inhabit the streams and
rivers crossed by the trans-Alaska pipeline. Some recreational
favorites are arctic grayling *(Thymallus arcticus)*, steelhead and
rainbow trout *(Oncorhynchus mykiss)*, Dolly Varden char
(Salvelinus malma), and all five Alaska species of salmon.

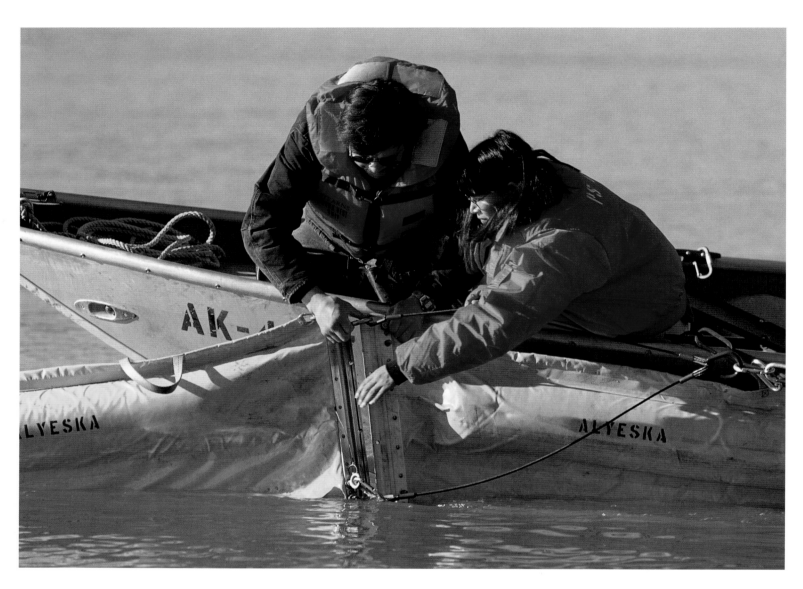

△ Emergency response training on the Yukon River involves Alyeska employees and contractors, federal and state agencies, and the communities of Stevens Village and Rampart. Here, two of the responders practice deploying oil spill containment boom.
▷ Sea kayaks in Valdez harbor attest to the growing popularity of Prince William Sound as a recreational resource.

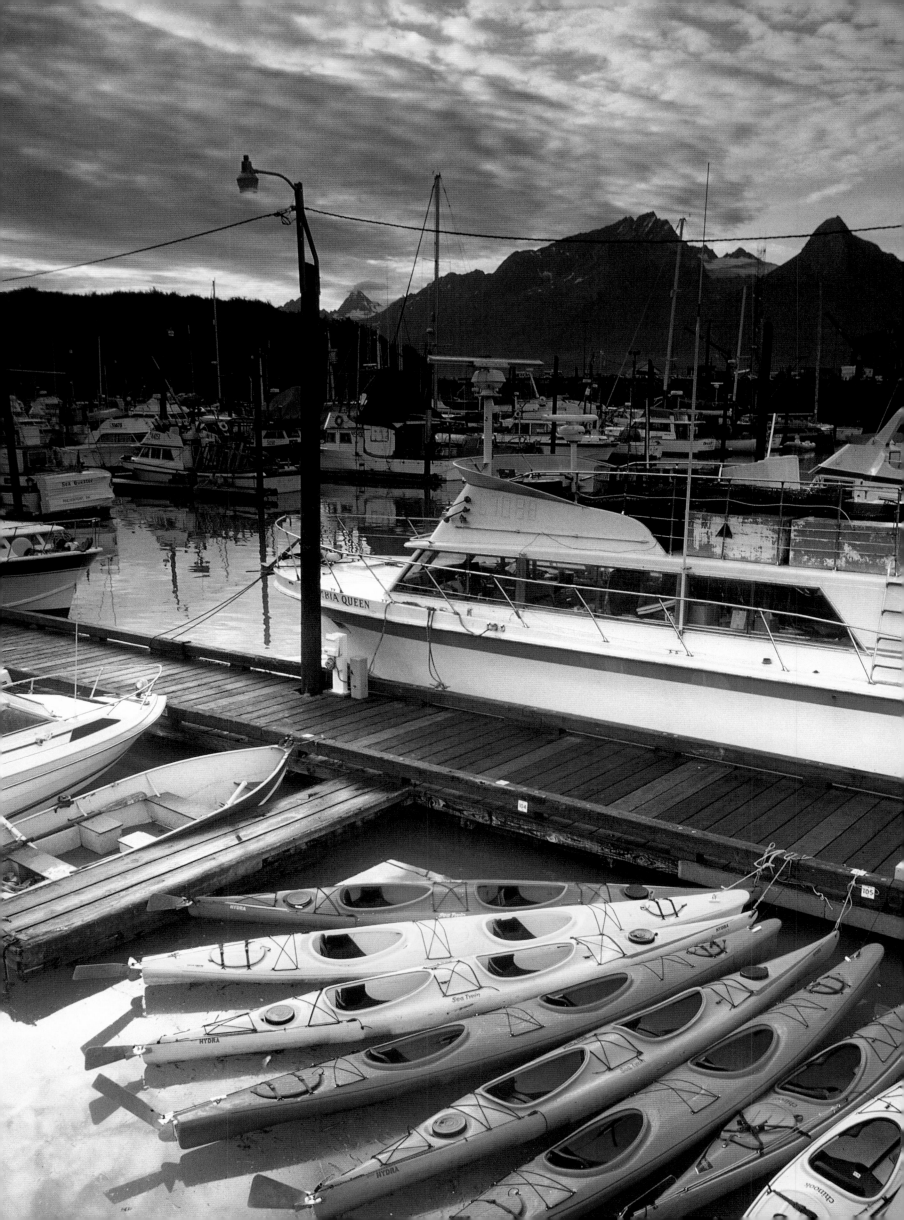

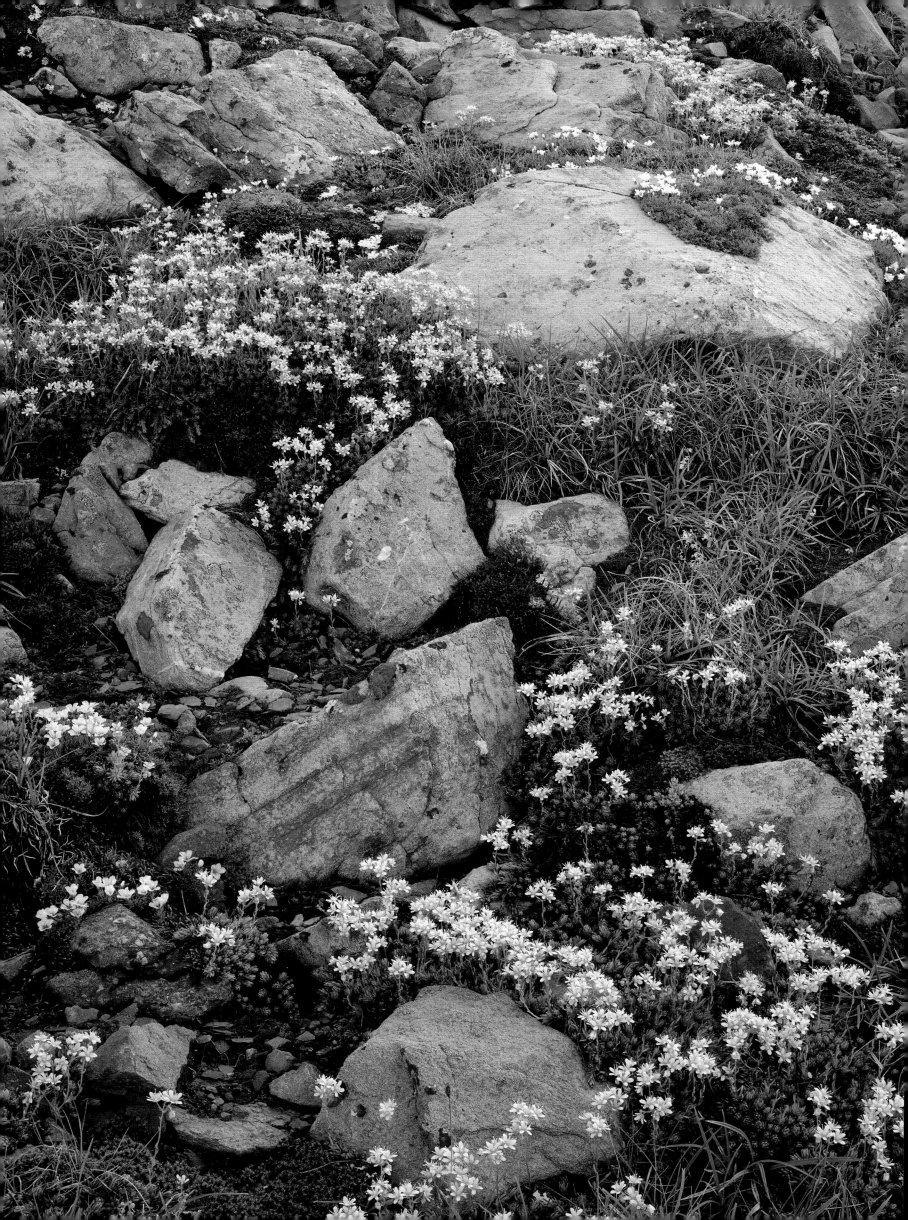

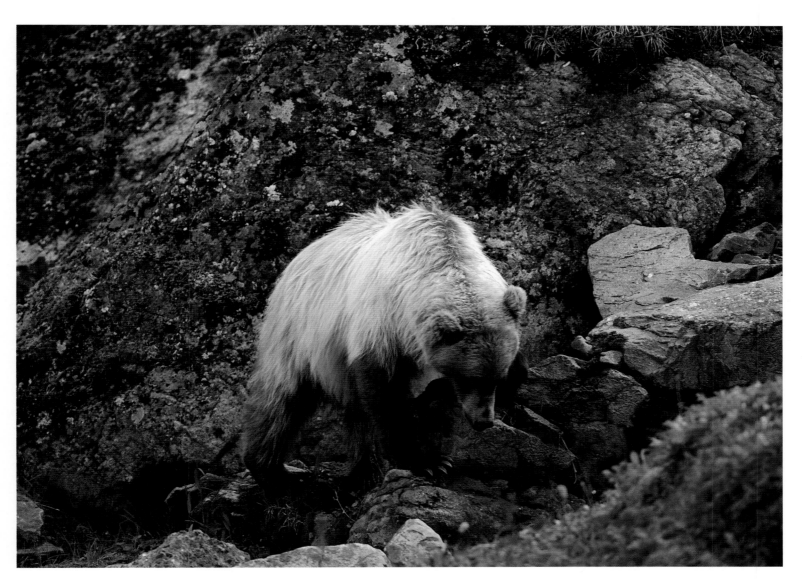

◁ Yellow spotted saxifrage *(Saxifraga bronchialis)* and alpine
spirea *(Luetkea pectinata)* fill rocky crevices high in the Brooks
Range. In summer, the splendor of wildflowers along the pipeline
is always memorable. △ The grizzly, or brown bear *(Ursus arctos)*,
ranges from blond to dark brown or almost black. Grizzlies also
range widely in size, with the largest, up to 1,500 pounds, inhab-
iting Alaska's southern coastal regions. In the Arctic, a grizzly
is considered large at 350 pounds. This bear, dubbed "Blondie"
by Alyeska employees, has been observed near Atigun Pass for
about twelve years and has raised several generations of cubs.

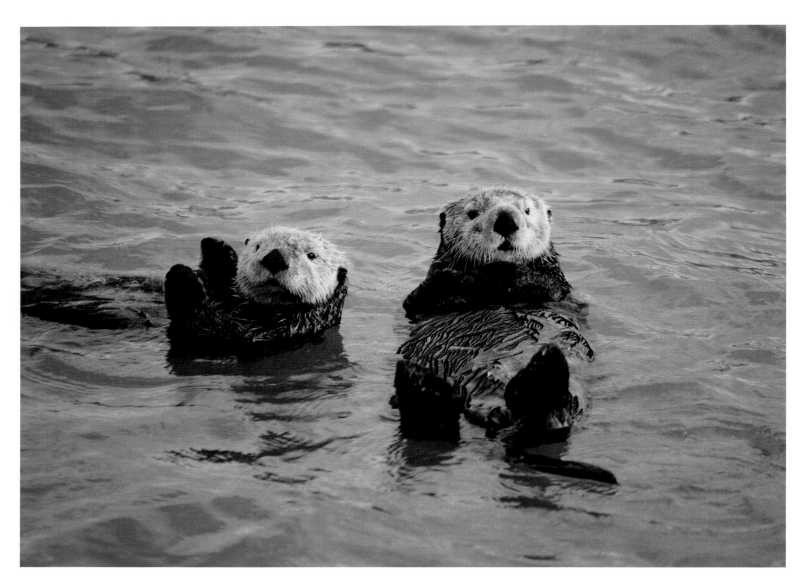

△ It is hard to resist the face of a sea otter *(Enhydra lutris)*. These largest members of the weasel family weigh up to eighty pounds, and their fur is considered the world's finest. Once hunted almost to extinction by Russian fur traders, sea otters are now protected; their populations, growing. ▷ The willow ptarmigan *(Lagopus lagopus),* Alaska's state bird, is a grouse that lives in tundra and shrubland habitats. This female's plumage camouflages her in summer, while breeding males have a russet head and neck, and a white body. Both sexes turn white in winter and have a layer of insulating feathers that covers their legs and feet.

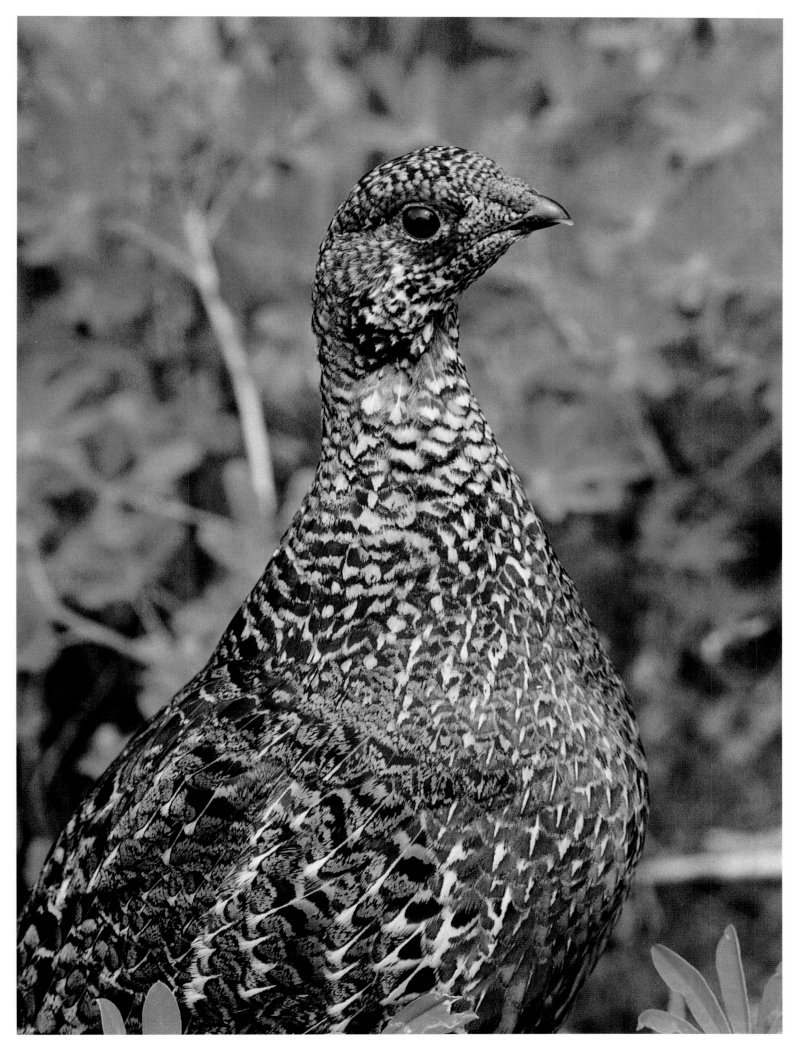

◁ With her books spread out across the kitchen table, a young Wiseman resident gets down to the business of schoolwork. The remoteness of some Alaska communities means that many children are home-schooled. Some can participate in class and talk with teachers by short-wave radios linking them to larger communities. △ Every May in Delta Junction, the Buffalo Wallow marks the beginning of summer. Named for the introduced Delta bison herd that roams the area, this all-day festival is attended by everyone from miles around, including the staff of Pump Station 9 and their families, most of whom live in the community.

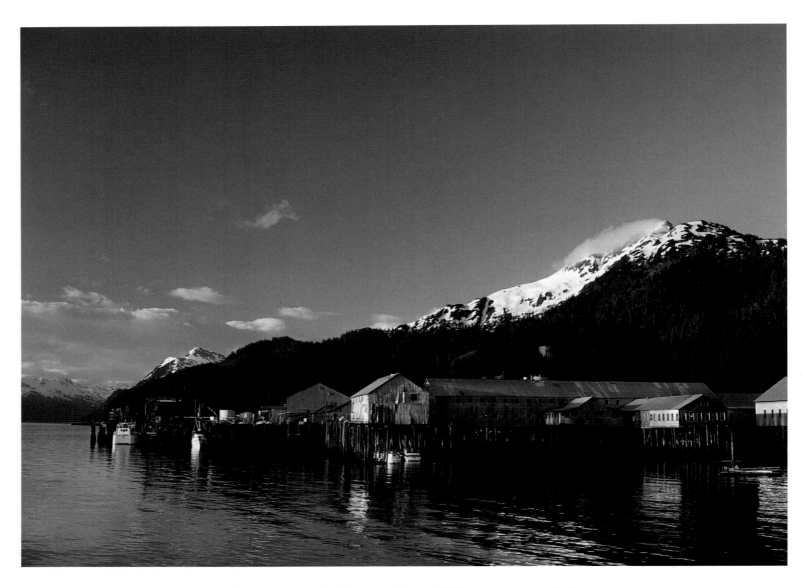

△ The cannery at Cordova, on Prince William Sound, symbolizes the importance of commercial fishing to Alaska's economy. The seafood industry generates a business volume and revenue second only to the oil industry. Salmon, crab, and halibut form the majority of the harvest. ▷ The sight of a Steller's jay *(Cyanocitta stelleri)*, named for ship's naturalist Georg Steller, confirmed Alaska as part of the New World during Vitus Bering's voyage in 1741. Steller identified this jay as the same species already known on the Pacific Coast farther south.

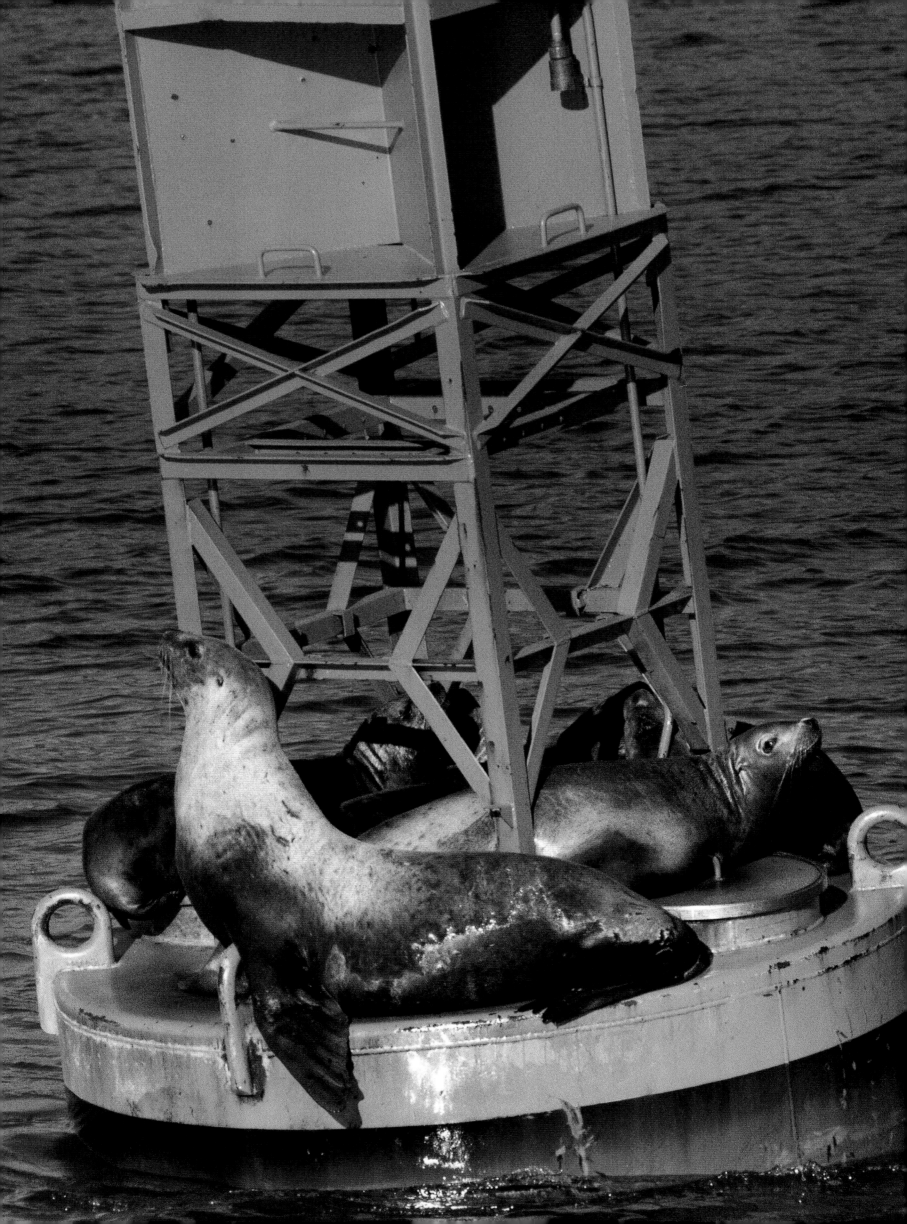

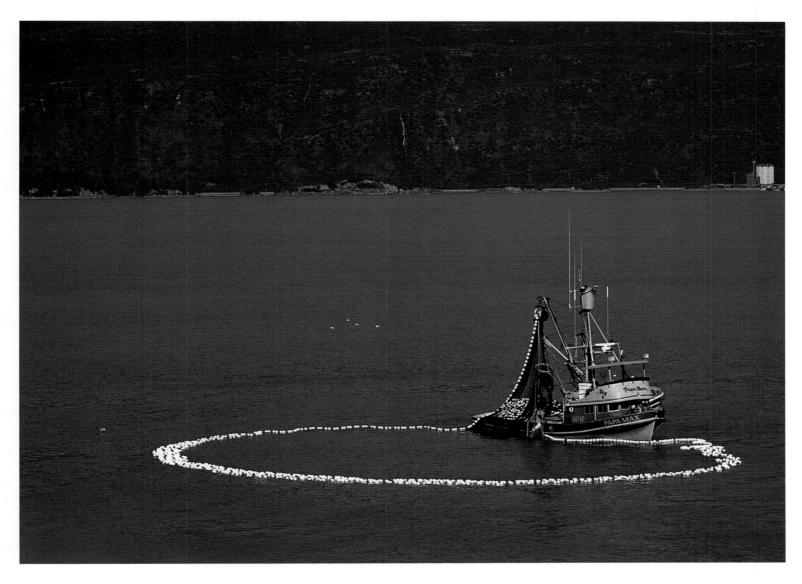

◁ Steller's sea lions *(Eumetopias jubatus)* crowd a buoy in Valdez Arm. These noisy, gregarious pinnipeds have been steadily declining throughout their range and have recently been designated as threatened under the Endangered Species Act. The reason for their decline is not known. △ Commercial fishermen retrieve a purse seine net in the productive waters of Port Valdez, near the pipeline terminal. ▷ ▷ Sandhill cranes *(Grus canadensis),* like these over Delta Junction, are a favorite among birders in Alaska. These elegant four-foot birds have wingspans of up to seven feet. Cranes migrate to and from as far away as Mexico.

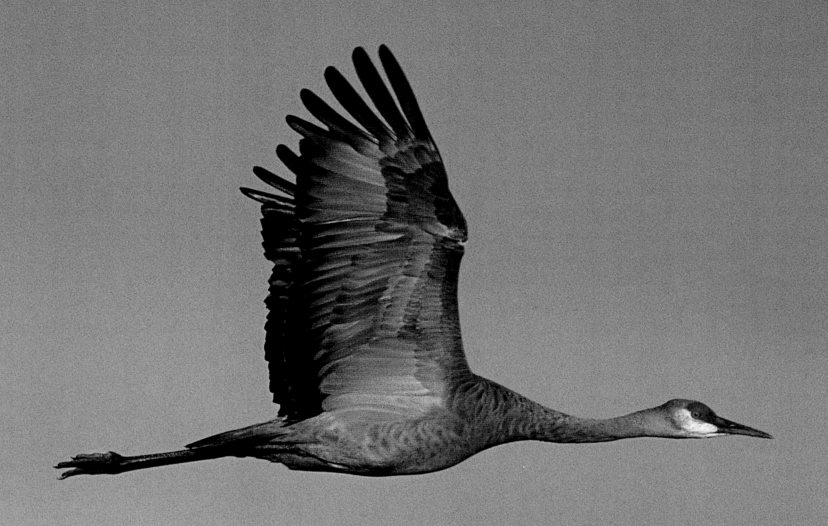

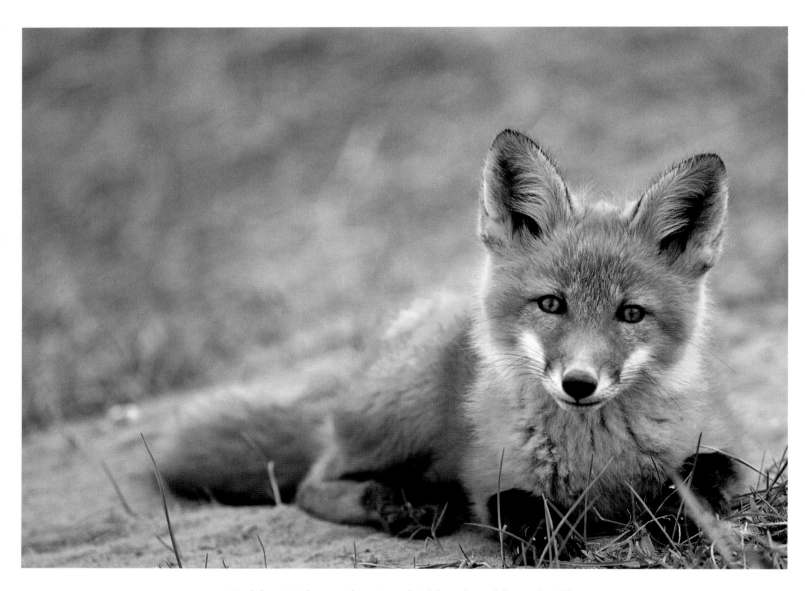

△ Red fox *(Vulpes vulpes)* are highly adaptable and will eat almost anything, including carrion, eggs, mice, hares, berries, and grasses. These wild canines live throughout Alaska and, like this one, are sometimes seen in the Prudhoe Bay oil fields, where they coexist with the smaller arctic fox *(Alopex lagopus)*.
▷ A female short-eared owl *(Asio flammeus)* stays well hidden in the tundra. These owls typically lay five to seven eggs in a nest on the ground and feed their young on lemmings, squirrels, and other small mammals, which they hunt chiefly at dawn and dusk.

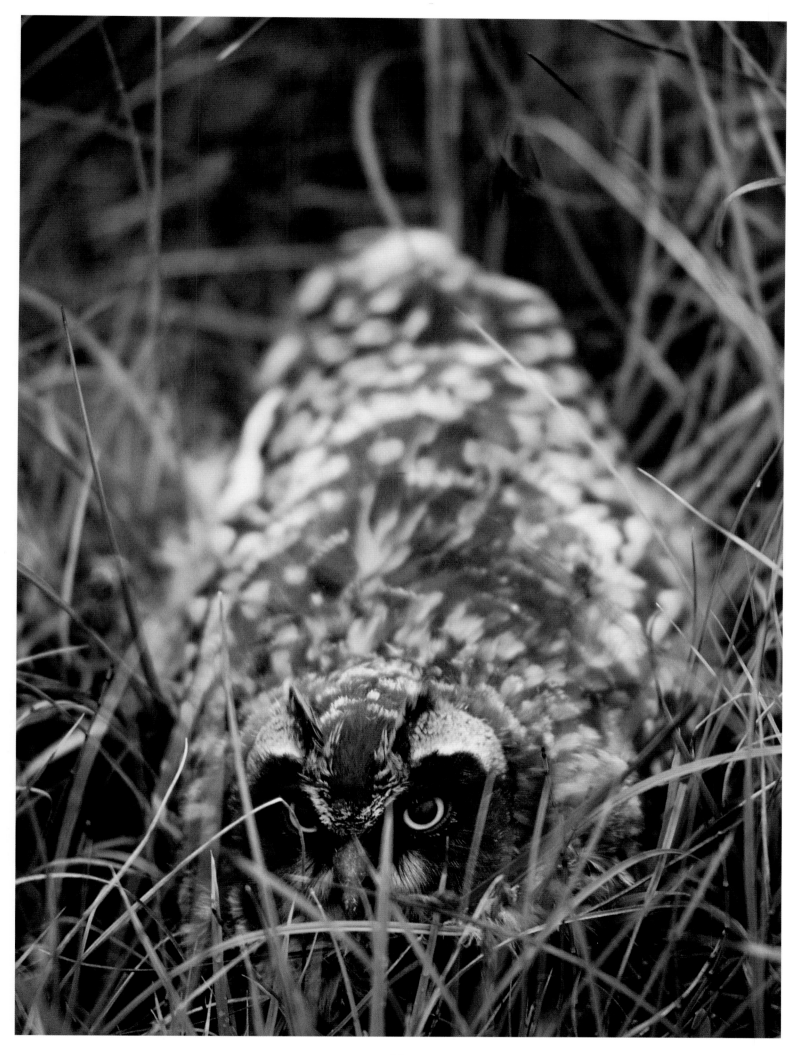

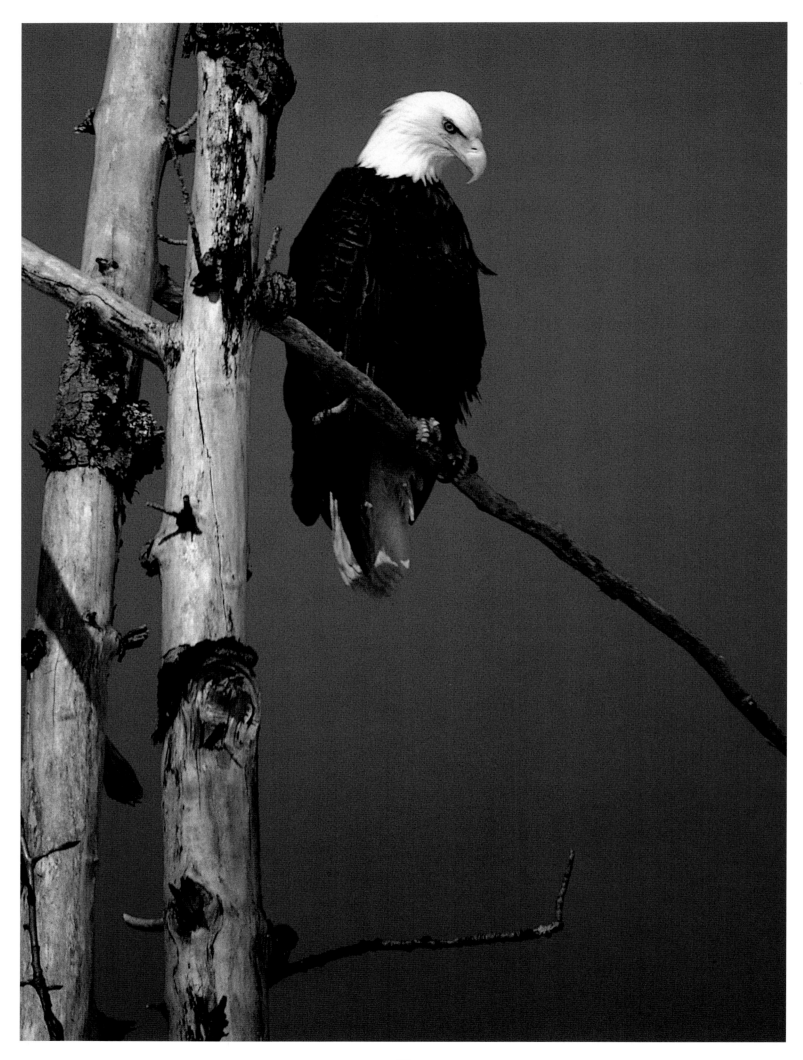

◁ The bald eagle *(Haliaeetus leucocephalus)* is a vibrant emblem of the state of Alaska. The distinctive white head and white tail feathers of the adult contrast dramatically with its brown body and wings. Bald eagles mate for life and build large nests in cottonwoods and spruce, returning to them year after year.
△ A snowshoe hare *(Lepus americanus)* crouches in the under-growth. In summer, snowshoe hares are gray-brown, but in winter they turn pure white, except for the dark tips of their ears. As their name implies, snowshoe hares have large feet that enable them to travel with ease over deep snow.

△ North of the Yukon River, on the site of the former Five Mile pipeline construction camp, a small business is open during the summer months. This store is located on one of the very few tracts of private land along the northern portion of the pipeline corridor.
▷ A cow moose *(Alces alces)* and two yearling calves stroll along the pipeline corridor. Calves are born in late May and early June, and twins are common. Only bull moose sport the large, familiar racks, which they shed in November and regrow each spring.

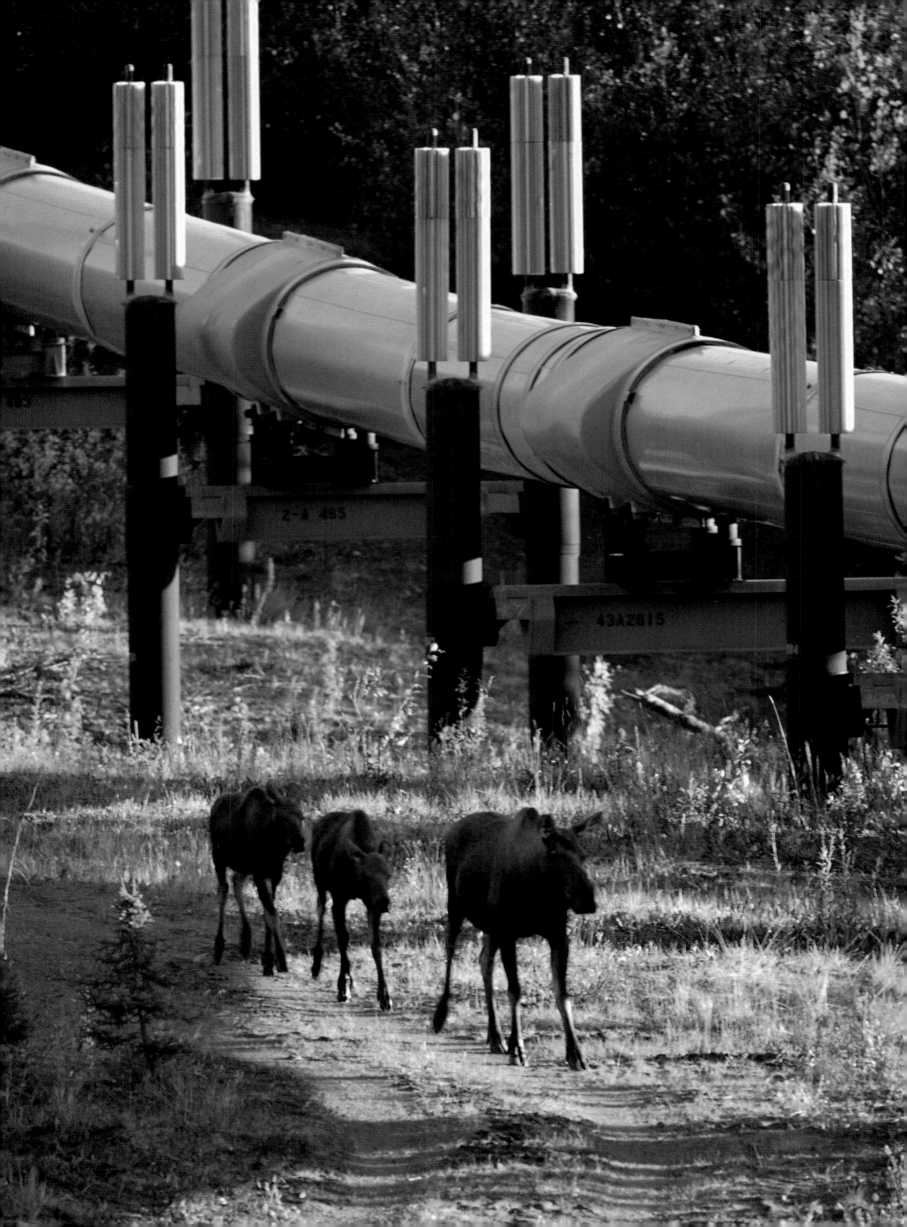

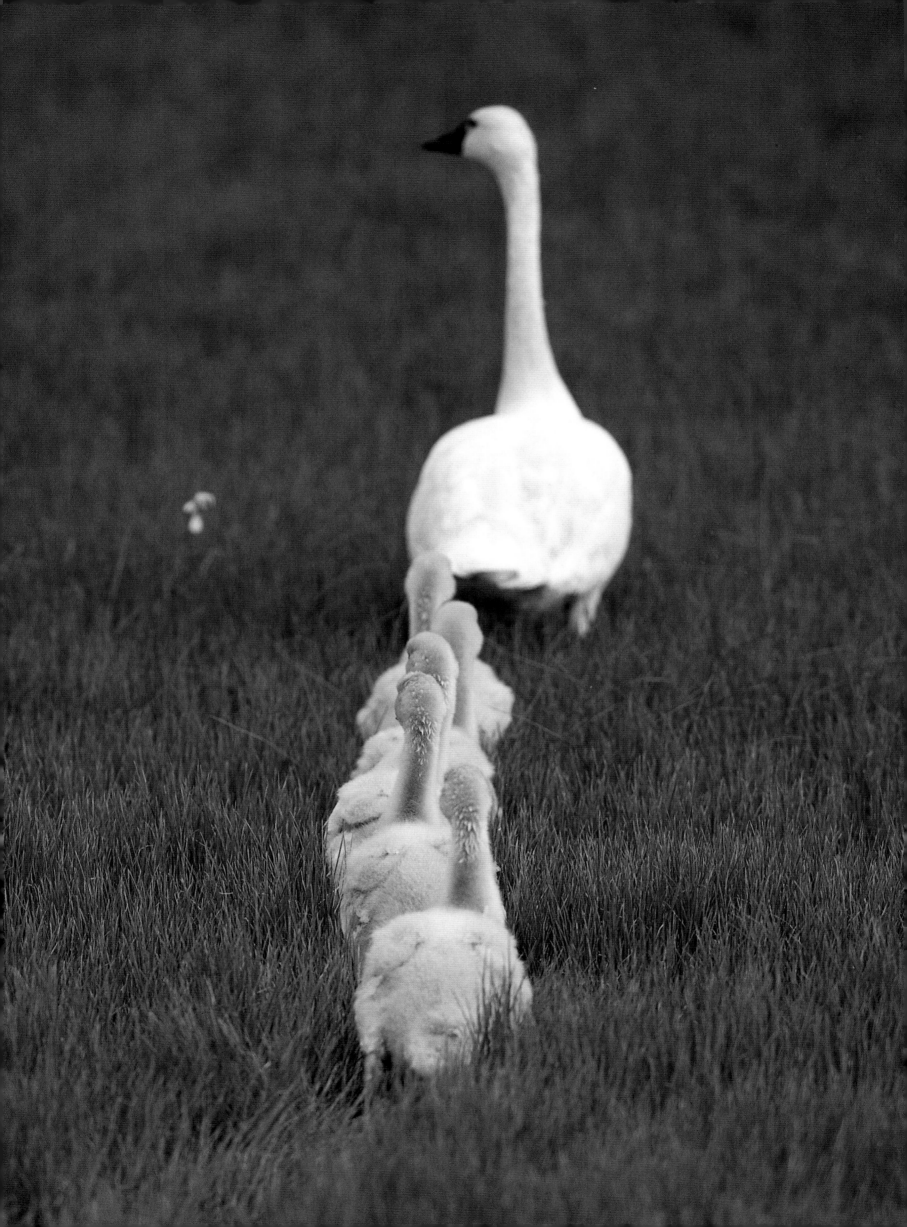

◁ Follow-the-leader is the name of the game for this tundra swan *(Cygnus columbianus)* and five cygnets. Swans aggressively protect their young from predators and other intruders. △ Every year, some 175,000 people visit Alyeska's information centers, such as this one just north of Fairbanks, to learn about the pipeline and the role oil has played in Alaska's communities. Oil revenues account for up to 85 percent of the state's annual operating budget, bringing schools, hospitals, community centers, libraries, museums, roads, and utilities to cities and remote villages alike.

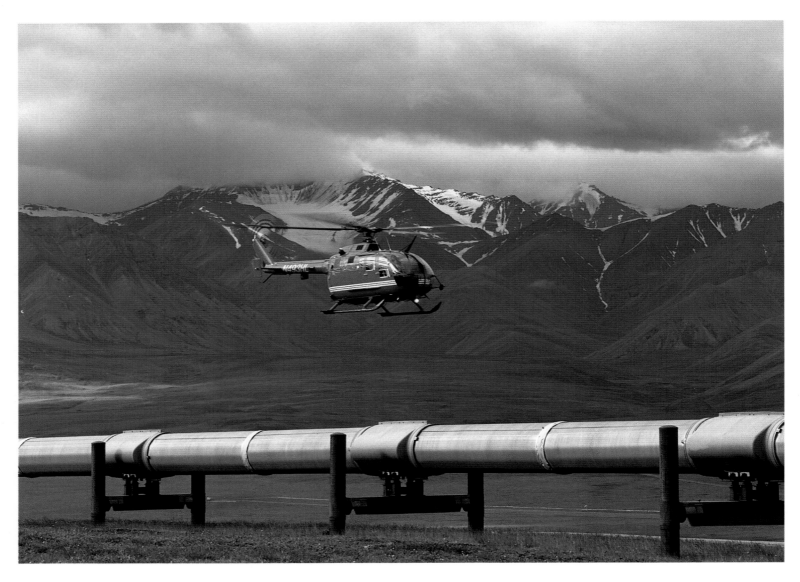

△ Alyeska conducts one of its frequent surveillance flights along a remote section of the pipeline near Galbraith Lake. One of the few public camping areas to be opened along the Dalton Highway north of the Yukon River, this site was a former pipeline construction camp. ▷ The gyrfalcon *(Falco rusticolus),* North America's largest falcon, can vary in color from almost white to dark brown, although the gray phase is most common. This falcon is sitting above a radiator designed to keep the permafrost from melting. Approximately 80 percent of the pipeline's vertical support members are equipped with these heat dissipaters.

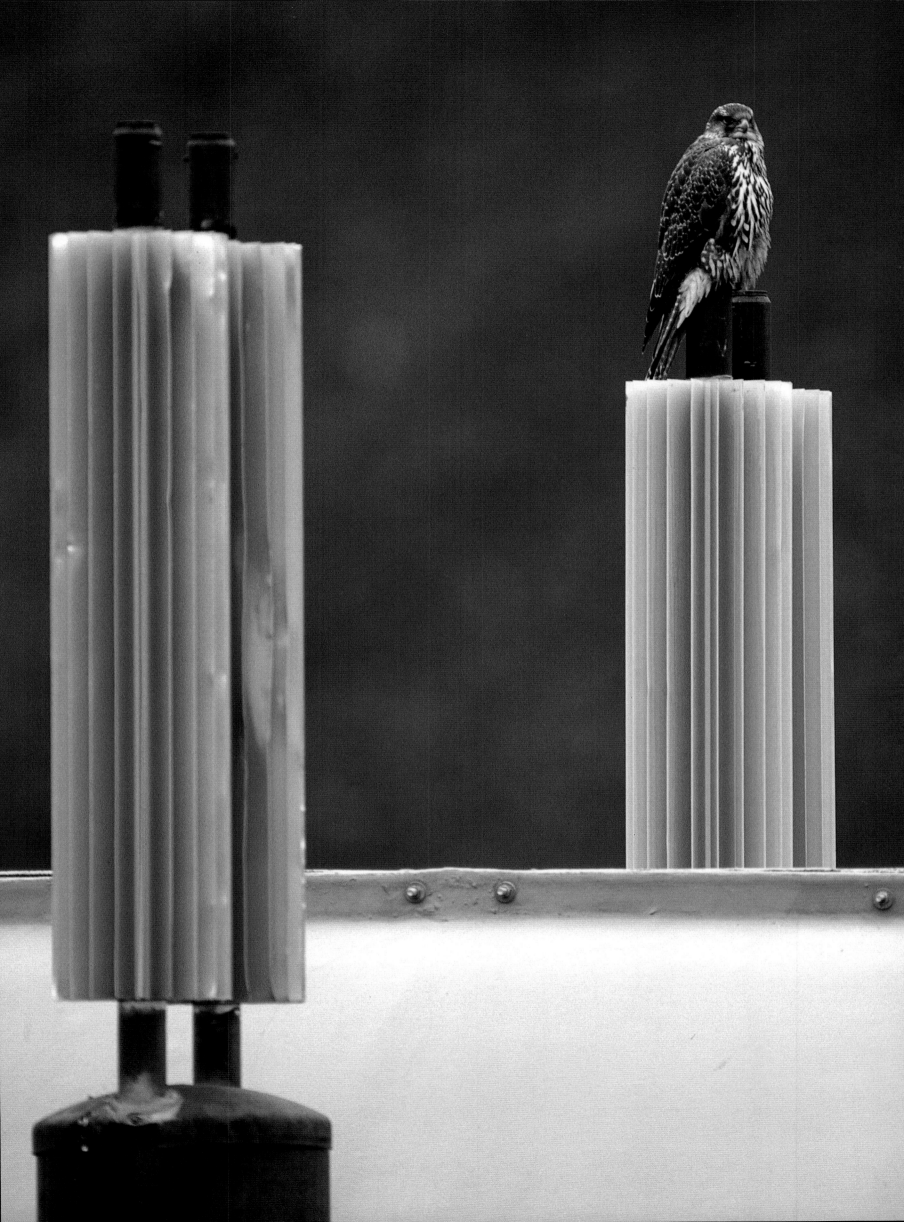

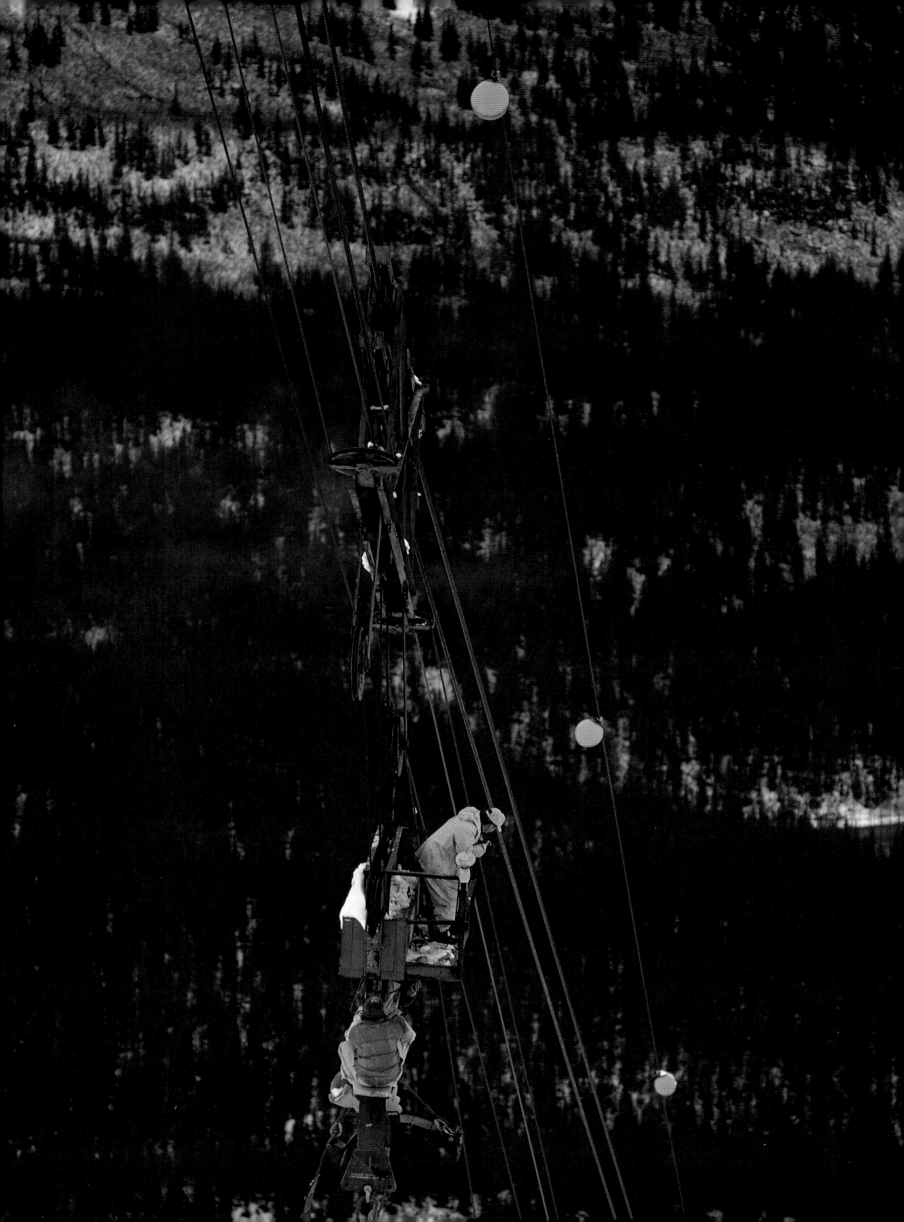

History is more than the sum of its parts. We record it as a series of dates—defining points in time to which we ascribe significance. Volcanic eruptions. Earthquakes. Wars. Elections. Victories and defeats. We all remember dates from our history lessons: 1066, 1492, 1776, 1812, 1941, 1963. In Alaska, history assumes a more personal aspect. Ask any non-native Alaskan when they arrived, and you don't just get a year, you get a specific date. January 12, 1974. June 16, 1984.

There is one date that many who were associated with the trans-Alaska pipeline will never forget. It is the day, in pipeline jargon, of "oil-in"—the day crude oil began to flow southward from Pump Station 1: June 20, 1977. Dave Schmidt, an environmental specialist with Alyeska, tells of being a graduate student in 1977 at the National Science Foundation's Toolik Lake research site north of the Brooks Range: "We heard that June 20 would be the day oil would start flowing through the line. On June 24 we listened, ears to the pipe, as oil passed through the pipeline at our location. It was a big deal. We were there as history happened."

The road to "oil-in" was long and sometimes bumpy. The March 1968 oil discovery at Prudhoe Bay thrust Alaska into heated debates that ranged from Native Alaskan land claims, to the status of wilderness lands, to international oil trade. Certainly there were, and still are, diverse opinions about the desirability of development and the appropriate balance that should be struck. But on the whole, Alaskans seem determined to achieve what many elsewhere have tried and failed to do: develop their natural resources while preserving the integrity of their wilderness. The trans-Alaska pipeline is a paramount symbol of this philosophy. Although its footprint on Alaska's landscape is small, it hides a mammoth project. It has contributed significantly to the nation in terms of economic benefits, technological innovation, and new standards for environmental safeguards.

In the days following oil discovery, a team of petroleum companies considered every conceivable method of transporting the oil to markets, from the practical to the fanciful. They considered ship-ping the oil by ice-breaking, double-hulled tankers eastward through the Northwest Passage; extending the Alaska Railroad north from Fairbanks; and building a road to Prudhoe Bay so that the oil could be carried south-ward by tanker trucks. They even considered a fleet of under-ice submarines. But if the oil at Prudhoe Bay was going to compete with imported oil, its transport had to be cost-effective and reliable. After extensive research and analysis, it was concluded that Alaska's North Slope oil could be moved economically, safely, and realistically only through a pipeline.

Less than a year after the Prudhoe Bay discovery, a consortium of oil companies conceived the Trans Alaska Pipeline System and announced plans to build a forty-eight-inch-diameter, all-buried pipeline from Prudhoe Bay to the year-round ice-free waters of Valdez, eight hundred miles to the south. Construction, slated to begin in spring 1970, would be completed by 1972. It was estimated that the pipeline and Valdez Marine Terminal would cost $900 million to build.

It sounds like a simple project: to build a pipeline to transport oil. But the infrastructure we take for granted today was not there three decades ago. There were no roads north of Livengood, yet the giant oil field was 250 miles north of the Arctic Circle. This new state, not yet ten years old, was suddenly the energy storehouse for a nation. It would overtake Texas, California, and every other oil-producing state—but only if it could get its oil to market.

The Merging *of* a Land & Its People

◁ *During construction, each section of pipe had to be heated before welding.*
△ *Radiators were stockpiled prior to installation on heat pipes that are inserted inside vertical support members.*
◁ ◁ *Crossing precipitous terrain demanded ingenuity and perseverance during construction (1974-1977). In 2,812-foot Thompson Pass, a tramway was installed to transport pipe, personnel, and equipment. Here, workers lift sections of pipe into position on a 45° slope.*

To many Americans in 1970, Alaska was more than the fading memory of a last frontier; it was seen as sacrosanct and inviolable: the nation's last remaining fragment that could represent the continent before European settlement. To some Alaskans, the coming pipeline was the essential link to an economically secure future and to personal opportunity, whereas to others the pipeline would be an incision that would irrevocably cut the wilderness in two, scarring it forever. Because the Trans Alaska Pipeline System proposed crossing eight hundred miles of wildlands—most of them unprotected by specific federal legislation and many in an unresolved ownership status—the project immediately became the focus of industry, government, and special-interest groups, precipitating a period of national debate.

The eventual construction of the pipeline was influenced by a remarkable sequence of landmark legislation. The National Environmental Policy Act of 1970 (NEPA) had a significant impact on the pipeline project. NEPA was passed on a tide of rising environmental concern, and its regulatory consequences would be far reaching. The act required that an environmental impact statement be prepared for major activities requiring federal approval or funding, and that all reasonable alternatives be adequately studied. The act's intent was to seek a balance between protection and development and to ensure that environmental concerns were not ignored.

The trans-Alaska pipeline was the first significant project reviewed under NEPA, and it was clear to all the stakeholders that regulatory precedents would be set. The result was an extended period of controversy, lawsuits, and technical reevaluations as industry and government officials alike sought a way through the unmapped territory of new regulation.

A year after NEPA was passed, the Alaska Native Claims Settlement Act of 1971 created Alaskan Native regional corporations and provided almost one billion dollars and forty-four million acres to Native Alaskans. As part of this legislation, Native land claims along the proposed pipeline right-of-way were resolved, making it possible for the federal and state governments to grant essential licenses and permits.

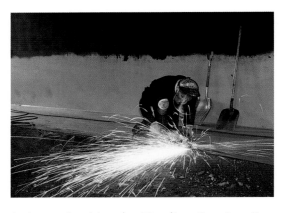

> *Maintenance is an unending responsibility on the pipeline system. Here, a welder's assistant works on a twenty-one-million-gallon crude oil storage tank, one of eighteen at the Valdez Marine Terminal. Altogether, these tanks are capable of holding up to nine million barrels of crude oil.*
> ▷ ▷ *The pipeline crosses tundra just north of the Brooks Range. The distinctive zigzag pattern in the pipeline allows for the linear expansion or contraction of the pipe from temperature changes in the oil, as well as pipeline movement caused by earthquakes.*

While Congress and the regulatory agencies worked on the finer points of land claims, right-of-way restrictions, and environmental stipulations, the Alyeska Pipeline Service Company was established by its owner companies as the nonprofit corporation to build, operate, and maintain the pipeline.

Through all of the delays, Alyeska's engineers continued to work on the design and specifications of the pipeline. This work was performed in coordination with experts of the U.S. Geological Survey, the U.S. Bureau of Land Management, the U.S. Army Corps of Engineers, the Alaska Department of Fish and Game, and other federal and state agencies. Data from pipeline field tests, simulation modeling, and an unprecedentedly detailed study of permafrost were slowly beginning to alter the shape of the project. Where permafrost was mapped as not thaw-stable and in earthquake zones—both regions mainly south of the Brooks Range—plans for the buried pipeline were changing to an aboveground mode in which the pipeline would be supported on vertical support members.

As controversies were resolved, land claims settled, and engineering refinements made, the debate on the pipeline was further complicated by the emerging energy crisis of mid-1973. Under the impetus of this international development, the

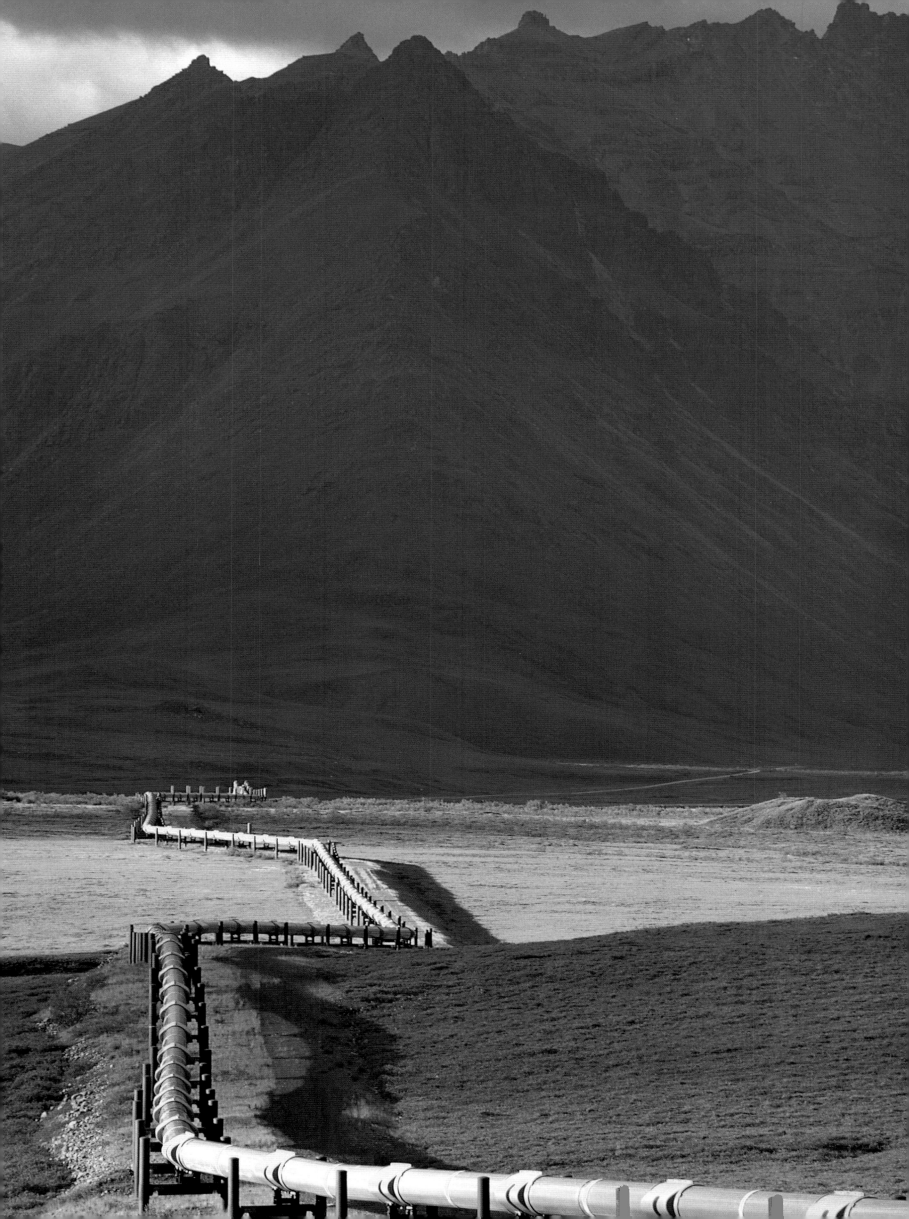

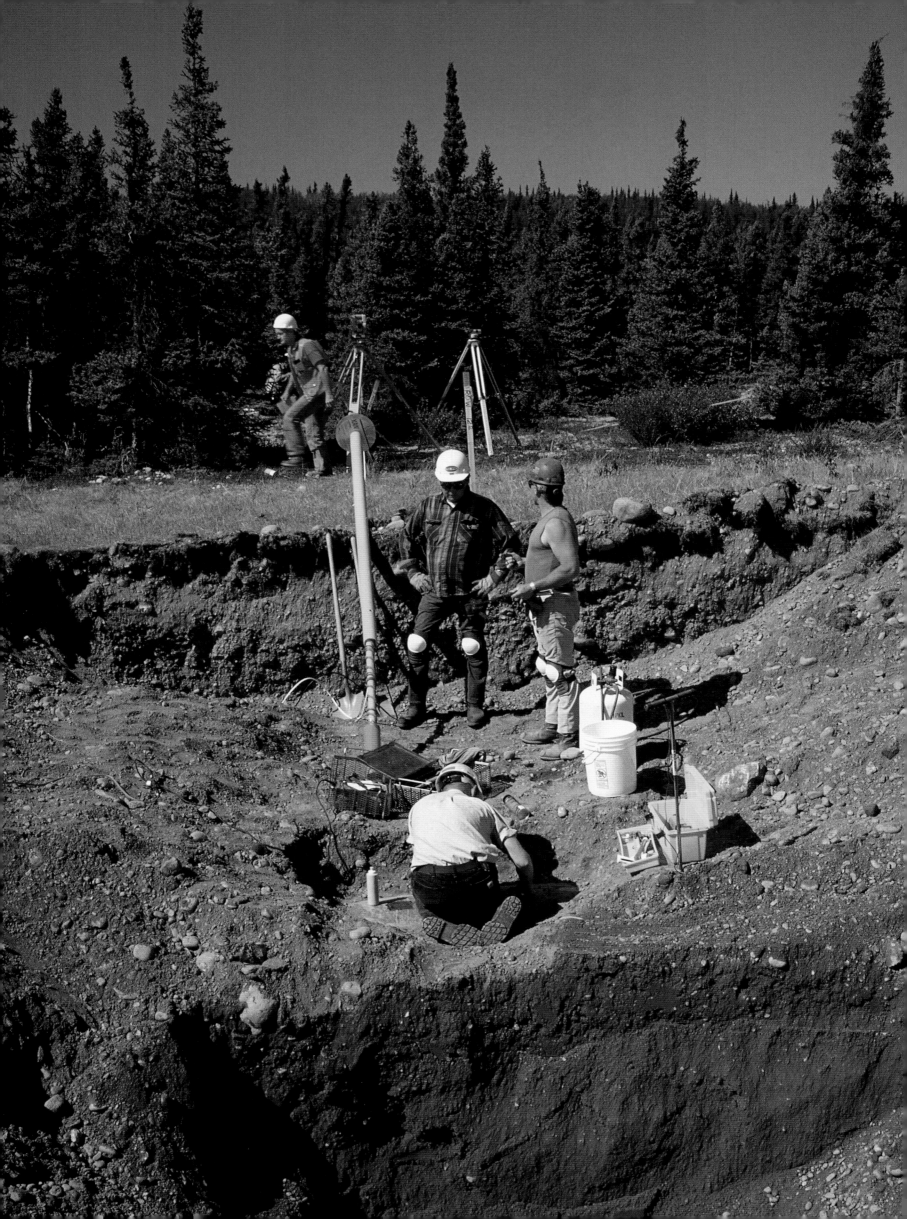

Trans Alaska Pipeline Authorization Act was passed by Congress and signed by President Nixon on November 16, 1973.

Early in 1974, Alyeska began moving 37,500 tons of equipment by air and truck to the Yukon River, then north by ice road. Construction of the Trans Alaska Pipeline System required that seventy-three million cubic yards of gravel be mined, stockpiled, hauled, and laid down. This meant designing and permitting hundreds of detailed gravel mining plans. Construction was finally underway, six years after the discovery of oil at Prudhoe Bay.

The construction of the permanent Haul Road was started on April 29, 1974, and completed on September 29 of that year. The first pipe was laid at the Tonsina River crossing of the Richardson Highway, seventy-five road miles north of Valdez, on March 27, 1975; the final pipeline weld was finished on May 31, 1977. Oil began flowing down the pipeline on June 20, 1977, and on August 1, the *ARCO Juneau* was the first tanker to leave Valdez carrying North Slope crude oil. After six years of controversy, an additional three years of construction, a workforce that ultimately totaled seventy thousand people, and eight billion dollars, Alaska's oil was on its way to market.

Few people are aware that what they are doing will one day be history, but the men and women working on the pipeline knew they were part of a project like no other. People who were in Alaska in those days speak of "intense excitement," "the thrill of being involved in something so vast," and "the sense of being caught up in something larger than life, something important." Alyeska's engineers dealt with major challenges wrought by a climate and landscape as harsh and remote as it was beautiful. They faced permafrost, earthquake faults, wide rivers, and steep mountain passes. The winters were dark, with temperatures approaching -60°F, while summer heralded near-continuous daylight, temperatures near 100°F in the Interior, and mosquito swarms that could stampede entire herds of caribou.

The construction of the pipeline was a combination of state-of-the-art technology and bootstrap improvisation. As one engineer put it: "We had no fax machine, no e-mail. We had a mail drop every day and a telex, but very few phone lines. During the Atigun reroute in 1991, we replaced over eight miles of pipe to forestall corrosion problems. To do that, we had to go back and find the original 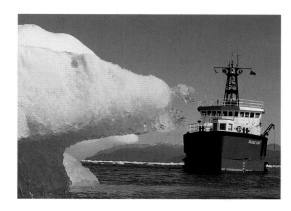 program for the aboveground alignment, and it was still on punch cards! We had to find a punch card reader and have the cards converted to a regular diskette. But those punch cards were the state of the art back in 1974."

Any gathering of Alyeska employees who were in Alaska during the seventies ends up with a roll call of names, people remembered from the frantic, exhilarating days of construction. There is an intense pride in their memories and in their accomplishments. For many, the pipeline has been their whole career.

"The construction of the pipeline was a triumph of the human spirit," says Bill Howitt, an Alyeska manager. He came to Alaska on March 1, 1975, and began working on the pipeline as a project engineer. "It was the people who figured out how to get the pipeline over Thompson Pass and who made the machinery run the way it was designed to. Very little equipment has had to be replaced."

Charlie Hubbard is an Athabaskan whose people were instrumental in stopping construction of the pipeline until Native Alaskan land claims could be resolved. He works in Alyeska's Human Resources Department and is involved in

◁ *The* Valdez Star, *the largest oil skimmer ever built in North America, was planned by Alyeska specifically for operation in Prince William Sound. The 123-foot vessel, launched in 1990, can collect up to eighty-four thousand gallons of oil per hour. In addition to its large-scale skimming capabilities, the* Valdez Star *can tow barges, assist in dock repairs, place containment boom, and function as a base for scientific research.*
◁ ◁ *Workers install corrosion testing devices along the southern portion of the pipeline corridor as part of Alyeska's corrosion protection program. Although the pipe is covered with a protective coating, it is still necessary to test buried sections to ensure that the corrosion protection system is working.*

the company's Native training, employment, and advancement programs. These programs support institutions and organizations that establish scholarship programs for Native Alaskan students. "I've been a superintendent of corrections," says Hubbard, "and I've swung a ten-pound hammer on a railroad. I've done all kinds of things. What has impressed me the most, of all the things I've done and all the people I've worked with, is this: When you go to work for Alyeska, all of a sudden you've got the 'I am' attitude—I am the best. That's the way we are. Whatever comes down the pipe we meet head-on."

Pipeline construction required getting in and out of places that went beyond the extreme. At Thompson Pass, crews encountered 45° slopes and still managed to lay the pipe by a combination of improvised aerial cable systems that lifted the pipe into place, and a technique known as "yo-yoing" bulldozers down the steep slopes while they were attached to strong cables and winches. These achievements are made even more remarkable in that they were done safely. Alyeska's accident rate is substantially below the national average.

Life along the pipeline corridor during construction also had its lighter moments. At one of the construction camps, a number of vertical support members disappeared, and soon afterwards some very well made, familiar-looking barbecues began making the rounds. Food was an important part of life in the field during construction, and the twenty-nine construction camps along the corridor were well known for their culinary delights. The way to construction workers' hearts was through their stomachs, and the camps held informal competitions to see who could devise the best field cuisine to tempt the palates of the hard-working residents.

Today, Alyeska's approximately one thousand employees and their contractors are charged with keeping the pipeline, pump stations, and Valdez Marine Terminal operating safely and efficiently. They work in operations, engineering,

▷ Workers must wear hard hats and safety glasses under most field conditions. Approximately seventy thousand workers have been employed in the construction, operation, and maintenance of the pipeline and related facilities since construction started in 1974.
▷ ▷ The Dalton Highway had to be in place before the pipeline could be built, and the road remains vital to the pipeline's operation and maintenance. At the peak of the road's construction, thirty-four hundred workers were deployed, and thirty-two million cubic yards of gravel were laid over 415 miles. The state of Alaska maintains the road to ensure year-round access to the Prudhoe Bay oil fields.

emergency response, safety, quality, environment, integrity and compliance, legal, human resources, corporate affairs, and administration. The different branches of Alyeska work together like the huge steel cables that hold the pipeline above the Tanana River. If any one of the cables were to break, the integrity of the suspension bridge would be compromised.

"Each of us has a job to do, and all the jobs fit together in a way that makes the whole system work," says Jim Sweeney, head of Alyeska's Environment Department. "But at the same time, very few people in the world have this sort of opportunity. We see things that other people don't get to see—like flying through Atigun Gorge, spotting Dall sheep on the mountains, seeing herds of caribou along the Haul Road—it's incredible. And I get paid to do this!"

The environmental monitoring conducted along the pipeline corridor over the past twenty years, by industry and agency researchers, has included water quality studies in Port Valdez; long-term revegetation experiments; fisheries investigations of water bodies that are crossed by or that lie near the pipeline; and surveys of caribou, moose, bear, waterfowl, and other wildlife along the pipeline corridor. The result is that the corridor is one of the most intensively studied regions in Alaska.

"Life at a pump station can be fast-paced and pretty hectic at times," says Kate Montgomery, who monitors the wildlife and environment in the northern district.

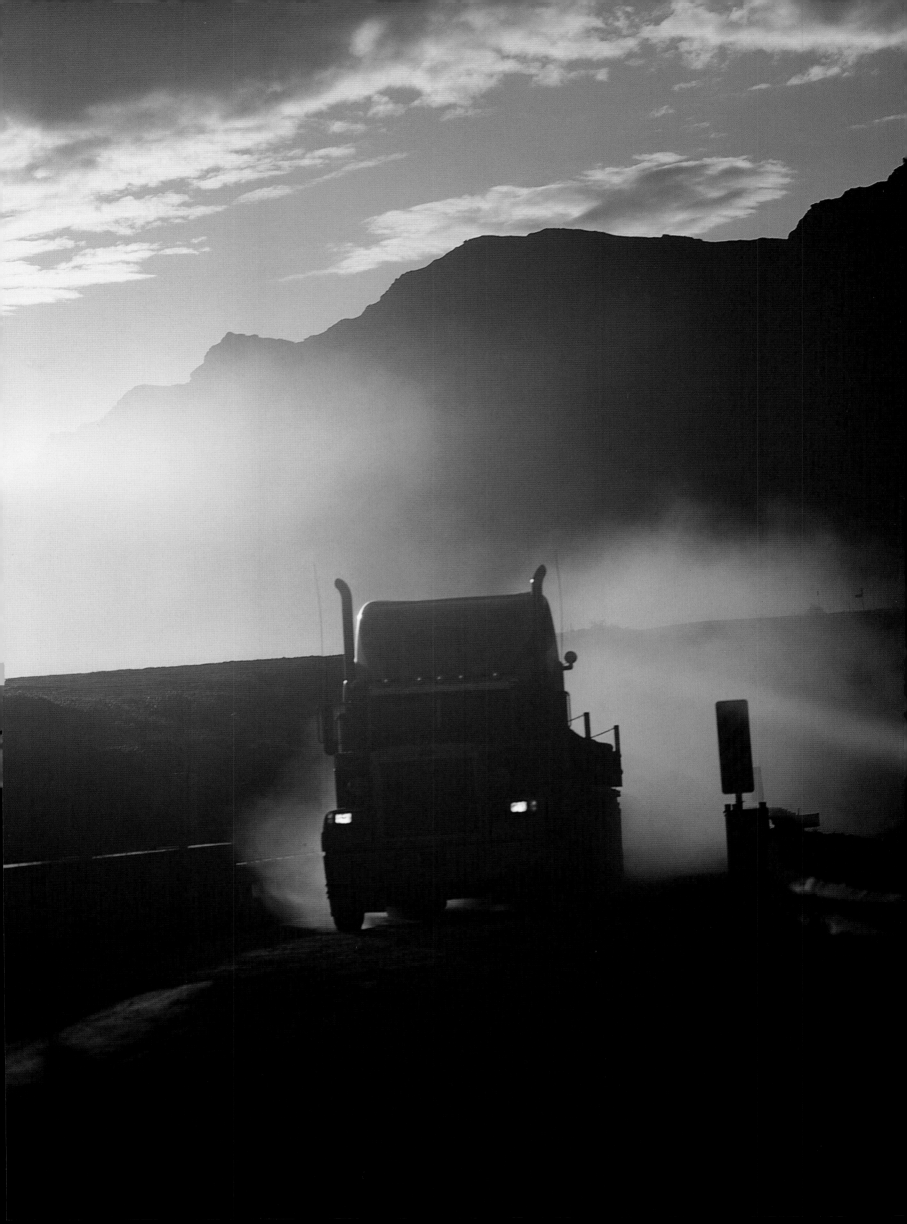

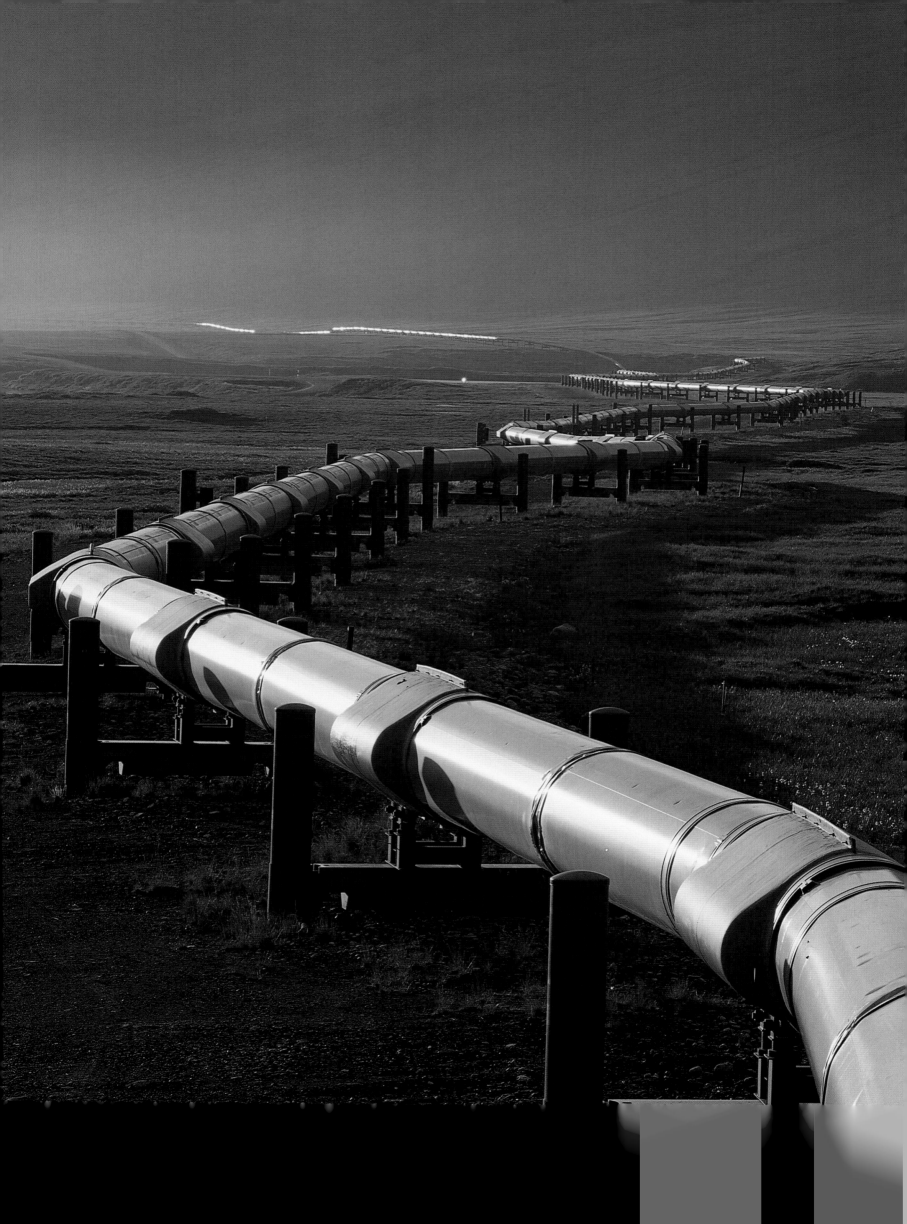

"Most of the time you hit the ground running and begin working the minute you get to the station." In contrast to the stillness of the surrounding wilderness, the environment inside the station is loud. There is even a dull roar in the living quarters: equipment running, radios, television, footsteps, conversations.

The pump stations are the driving force that keeps the oil flowing. The on-line stations never stop functioning, and they must be maintained with vigilance every minute of every day. Despite the inherent risks of working in remote areas and the isolation from family and home they endure during their one- or two-week shifts, the pump station personnel along the line take an immense pride in their work. Their profound love for Alaska and its wildlands is its own reward.

"People leave their families to work on the line," says Dave Comins, an oil spill response specialist, a twenty-seven-year Alyeska employee, and an Alaskan since 1967. "In a sense, the whole line becomes a second family for each one of us. People go out to work at 30 below, in conditions that most of us would find unendurable—here they just do it. Most people in the field work at least a twelve-hour shift. These are the top people in the world at what they do."

This is echoed by Tim Rupp, a technician on the line, who says, "pipeline technicians are the most versatile and 'can-do' people I have ever worked with. We have to have a detailed knowledge of everything, from regulations and spill response to an intimate understanding of our equipment."

"Each pump station is like a small town," says Lee Schoen, a geologist who came to work for Alyeska during construction. "Everything you need is there: offices, support staff, private bedrooms, dining room, kitchen, television. While the operators are on site, they just do their jobs, day in, day out, year after year. Nobody thinks about these people when they put gas in their cars. The world only notices when something doesn't work—and that's the way it should be."

Because most pump stations are located in remote parts of Alaska, they must be self-sufficient. Each is staffed with medics and technicians for on-site repairs; and each has its own fire-fighting equipment. Each pump station also generates its own electrical power and operates its own treatment systems for water and sewage. Advanced communication systems—microwave and satellite—connect the station to the rest of the pipeline system and to the outside world.

◁ Bob Malone, President of Alyeska Pipeline Service Company, seen here in Rampart, frequently visits with Alaskans living along the pipeline route.
◁ ◁ At each vertical support member, the pipe rests on a saddle that can slide back and forth to allow expansion or contraction of the pipe and to accommodate seismic activity. The length of the cross-member varies with seismic data for specific regions, but generally allows a twelve-foot horizontal movement and a two-foot vertical movement. The steel pipe is insulated to allow startup of the pipeline after a twenty-one day shutdown. With the insulation, oil is generally kept at 110°F during the trip to Valdez.

For the most part, the majority of personnel stay at the station for their entire shift. After a busy tour of duty along the pipeline, Alyeska's employees and contractors relax by making the most of the Great Land. They take their kids hiking, canoeing, camping, and fishing. They are fanatical skiers and snowmobilers. Some climb mountains, others climb icefalls. They dive, parachute, and mountainbike. Some write books, others photograph wildlife. They are true Alaskans, and during their time at work they get to enjoy the depths of Alaska's wildlands.

In addition to the pump stations, there is another facility critical to the functioning of the pipeline: the Valdez Marine Terminal. Across a thousand acres, the terminal meters, transfers, and directs incoming crude oil to the huge tankers moored at its berths. As the oil is prepared for loading, the terminal operators are responsible for ensuring the safety of the transfer, and the treatment of ballast water removed from incoming tankers. As the final component in the eight-hundred-mile line, the terminal is the technologically advanced facility that ultimately sends North Slope oil to its markets.

Advances in engineering and construction techniques did not end when the pipeline was built. Any large, operational system takes on an almost organic development as it evolves. A system that does not adapt will generally fail, and during the past twenty years, Alyeska's engineers have developed innovative advances in low-temperature engineering.

Drag reducing agent (DRA) was initially injected into the pipeline at Pump Station 1 in July 1979, two years after startup. It was considered experimental at the time, and Alyeska pioneered its use to reduce drag in the oil stream. A long-chain polymer with the consistency of cold molasses, DRA dissolves in crude oil and lowers the oil's frictional resistance, increasing its flow rate through the pipeline.

With any steel pipe, the potential for corrosion is a significant concern. Corrosion and stability studies are conducted along the length of the pipeline. In 1989, Alyeska began a heightened corrosion inspection program with newly developed "pigging" technology to identify problem areas. Pipeline "pigs" are mechanical devices that are passed through the oil stream—some to clean the walls of the pipeline, some to sense any deformation in the pipe, and others to detect signs of corrosion. Working with Japanese researchers, Alyeska also developed the world's first ultrasonic corrosion-inspection pig. This pig measures and records the thickness of the pipeline's walls using ultrasonic transducers, identifying areas of possible corrosion before they become problems.

As Alyeska focused on its investigation of corrosion, it was an external event that soon dominated everyone's thoughts and actions. Just after midnight on Good Friday, March 24, 1989, the *Exxon Valdez* strayed off course and ran aground on Bligh Reef in Prince William Sound. The ruptured supertanker spilled 240,000 barrels of oil: a total of over ten million gallons. The oil spill was a tragically disappointing event for all Alaskans. It had ramifications far beyond simple issues of oil transportation and precipitated a new and significant focus on preparedness.

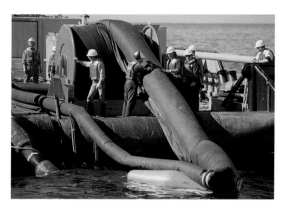

▷ *Alyeska personnel practice boom deployment during an emergency spill-response exercise in Prince William Sound.*
▷ ▷ *Connected by hawsers, a tug escorts a loaded tanker from Port Valdez. For twenty years, the North Slope oil fields have provided approximately 25 percent of the nation's domestically produced oil. Since "oil-in" in 1977, more than eleven billion barrels have made their way down the eight-hundred-mile pipeline, and more than fourteen thousand tanker trips have moved that oil from Alaska to markets.*

"I compare the *Exxon Valdez* spill to what happened with the space shuttle *Challenger*. If you're doing everything right, nobody ever hears about it. But once you have a real problem, people start asking questions. I think we ended up with a better company, because we reevaluated everything and came up with new and better ways of doing things. Now our emphasis is on prevention," commented Chuck O'Donnell, manager of the Valdez Marine Terminal during the spill. By anyone's standards, Alyeska is now better prepared to prevent and respond to oil spills, including those in the marine environment of Prince William Sound. The Ship Escort/Response Vessel System (SERVS) was established following the *Exxon Valdez* spill in response to an executive order by the Governor requiring every outbound tanker to be accompanied by two escort vessels until the tanker has left Prince William Sound.

The primary goal of SERVS is to prevent oil spills; however, it also has more oil spill response equipment than any other entity in the Western Hemisphere, and it is the cornerstone of the Prince William Sound Tanker Spill Prevention and Response Plan. With frequent drills, federal and state agencies gauge marine and shoreline response capabilities using challenging spill scenarios. Other drills are carried out along the pipeline corridor, with an emphasis on areas near rivers and streams.

As an integral part of SERVS, Alyeska has established a unique arrangement in which over fifty privately owned fishing vessels with trained personnel are on

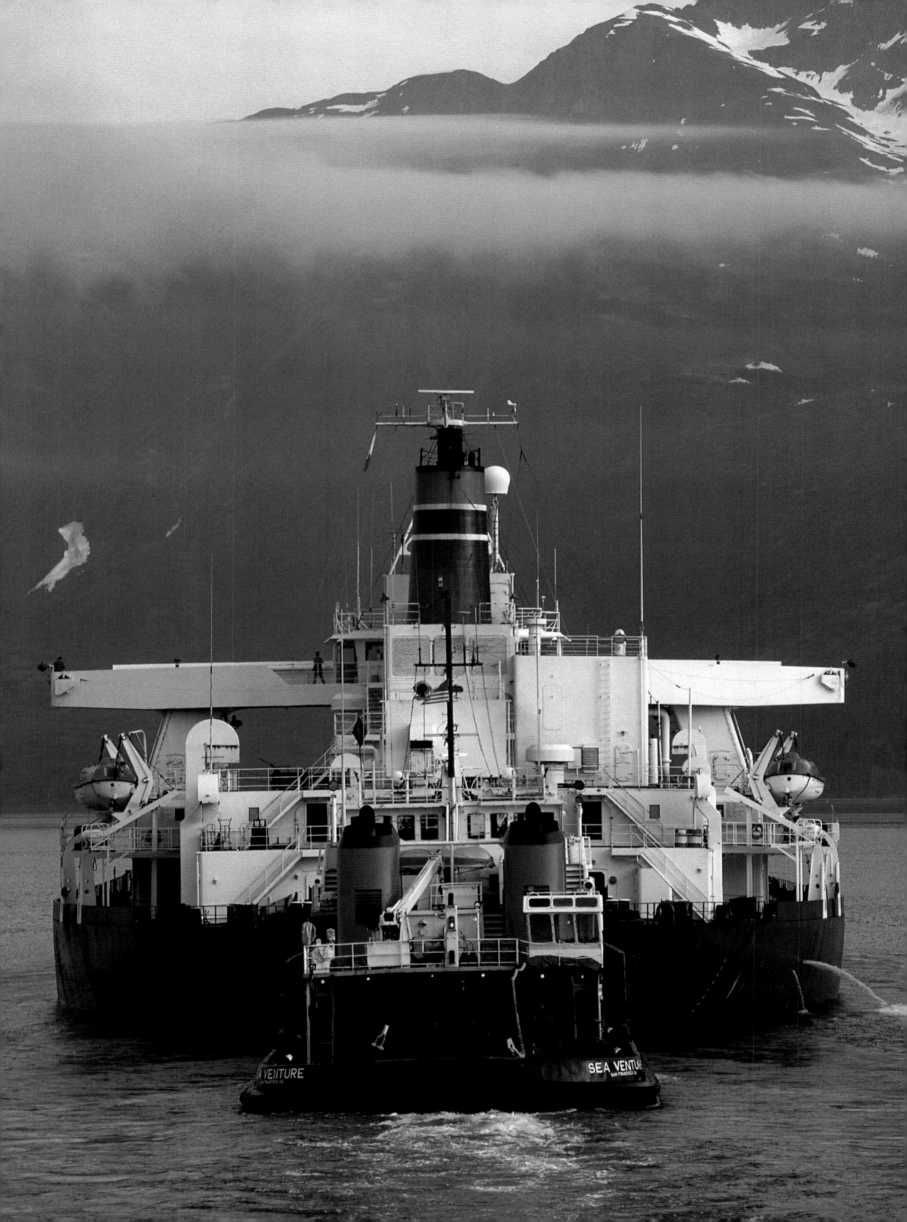

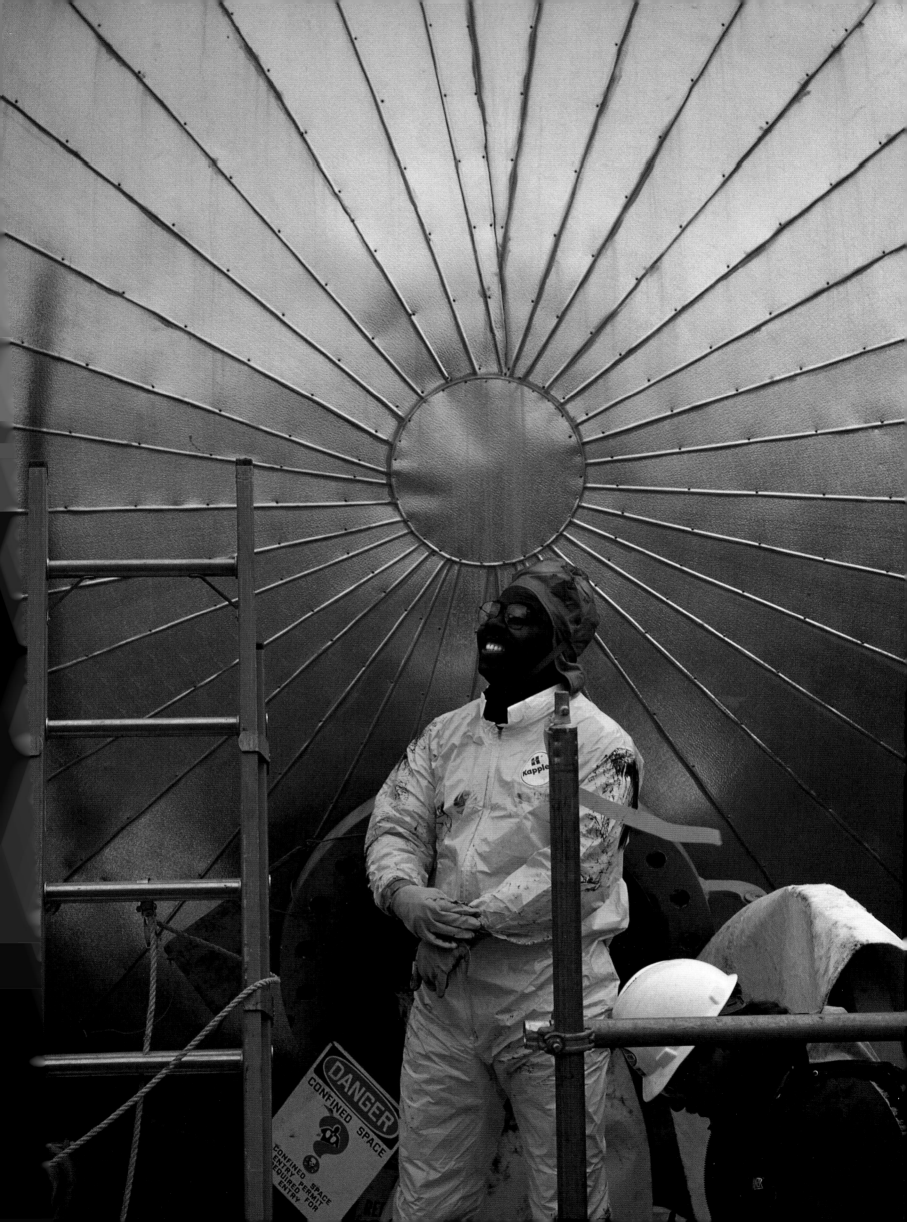

contract to provide immediate response support in case of a marine spill; several hundred additional vessels are also available to mobilize spill response equipment.

The 1989 oil spill also gave added impetus to the establishment of a coordinated regulatory body to oversee the planning, construction, operation, and maintenance of all Alaska pipelines and associated facilities. The Joint Pipeline Office (JPO) was established in 1990 and houses representatives from various federal and state agencies, including the U.S. Environmental Protection Agency, the U.S. Bureau of Land Management, the U.S. Coast Guard, the Alaska Department of Natural Resources, the Alaska Department of Environmental Conservation, and the Alaska Department of Fish and Game. Agency representatives conduct unannounced inspections of facilities, review permit applications, and oversee every aspect of pipeline operations in Alaska.

In 1991, Alyeska began what was to be the largest post-construction project in the pipeline's history: the Atigun reroute. The reroute began as a result of information supplied by smart pigs used during the first years of the ongoing corrosion investigation. It was the discovery of corrosion in the buried section of pipe running through the Atigun River valley that led to the replacement of an 8.5-mile section of pipe in record time. Planning and scheduling for the reroute started in late 1989, construction began in January 1991, and the replacement pipeline was tied in to the system in August 1991. During the tie-in, oil flow was suspended for just thirty-six minutes. It was a phenomenal achievement in project management and execution, requiring careful timing and detailed coordination of some three hundred contractor firms and twenty-five hundred personnel. The project was selected as the Project Management Institute's International Project of the Year in 1991.

While the pipeline seems to be able to continue operations almost indefinitely, the declining oil reserves on Alaska's North Slope present a more sobering future. In 1996, Alyeska ramped down two of its pump stations. The number of pump stations that pump crude oil reflects the production rate on the North Slope and pipeline economics. Despite ramp-down of pump stations, Alyeska is a long way from shutting down the line. As long as it is economical to operate, a factor dependent on the world price of oil, the pipeline will be part of Alaska's landscape and her economy.

◁ It takes about five and one-half days for one barrel (forty-two gallons) of oil, moving at an average speed of about six miles per hour, to travel from Pump Station 1 to the Valdez Marine Terminal.
◁ ◁ An Alyeska employee has just inspected and cleaned a pump station desalter tank. The "Danger" sign has been temporarily unstrung to allow access as a safety representative, in a white hard hat, records the inspection.

Reinforcing its commitment to the state, Alyeska is upgrading its communication service from microwave dishes to a new, enhanced fiber optic system. The new system will not only improve communications for the pipeline; it will also provide better communications to communities along the pipeline corridor. When fully installed, the fiber optic network will be one of the world's most advanced communication systems.

Alyeska's President Bob Malone is confident about the future and about his company's role in Alaska: "I want people to see the pipeline as it really is, to look at the care that has been taken in the way the pipeline has been designed, maintained, and operated. Alyeska has tremendous people. Look at what they've done in a safe and environmentally sound manner: they've transported over eleven billion barrels of oil—about 25 percent of the nation's domestic oil production—for twenty years."

People have always left their mark on the land. Ancient farmers and lost civilizations are remembered by their burial sites and trade routes. Pharaohs left pyramids, emperors left palaces, and dynasties left legions of stone warriors. Even subsistence hunter-gatherers set fires, cut trees, and modified wildlife populations,

changing what had been before. We are a species that alters the things around us. Today, our ability to change the earth has increased dramatically. It is an ability that brings with it great responsibility. Can we take the food, minerals, and other wealth we need from the land and waters and leave behind just a slight impression of our passing? Or will our footprints mar the land for our children and grandchildren?

Max Brewer, former Director of the Naval Arctic Research Laboratory at Point Barrow and former Commissioner of the Alaska Department of Environmental Conservation, believes that with the pipeline, Alaskans have managed to do this. The pipeline's main impacts, he believes, have been economic and social: "The pipeline has transformed Anchorage and smaller communities, strengthened the state's economy and government, enhanced Alaska's education system, and built some roads. Those, basically, are the pipeline's impacts."

The state receives over two billion dollars in petroleum-related revenues each year; up to 85 percent of the state's annual operating budget is derived from oil field royalties and severance taxes. Oil has provided Alaska with jobs, schools, hospitals, libraries, and economic security; it has also led to an appreciation of how tenuous is our stewardship of the land, and how great are the risks of human endeavors.

Alaska covers 586,412 square miles, over 375 million acres. Since its purchase from Russia in 1867, about 250 square miles, or 160,000 acres, have been cleared, settled, or otherwise developed—roughly one-twentieth of one percent of the state. By way of comparison, the city of Los Angeles covers 464 square miles, or 296,894 acres; and the metropolitan area covers 4,070 square miles, or 2.6 million acres. At about ten thousand acres total, the pipeline and its facilities have left a diminutive footprint on the Alaska landmass.

The trans-Alaska pipeline was a response to a challenge. The challenge of bringing oil south, across three mountain ranges, hundreds of rivers and streams, floodplains, and geologic faults—while preserving the splendor of Alaska—is an

▷ *Eight Prince William Sound communities—including Tatitlek, shown here—participate in a fleet of about three hundred fishing vessels with crews trained to deploy oil spill response equipment. Community Response Centers in these communities have designated fishing vessel administrators who are prepared to coordinate the mobilization of vessels and equipment, at Alyeska's direction, in the event of an emergency. ▷ ▷ Pipeline workers recoat a buried portion of the pipeline following identification of a possible problem by a "smart pig." Smart pigs are devices with on-board computer equipment that can pass through the pipeline and detect any deformation or settlement.*

amazing story. The structures people have imposed on nature have seldom been perfect. But in Alaska, there seems to be a willingness to feel small in the shadow of such grandeur. The Great Land can bring out great things in people, the greatest being humility.

Early exploration must be considered in light of the technology and communication systems of the day. At the turn of the century, geologists who scouted the North Slope were literally left in the middle of nowhere with little equipment and a notebook. Even in the 1950s explorers often relied more on luck and intuition than on science. These wildcatters and risk-takers were every bit as much explorers as Franklin, Amundsen, Bering, and Cook. As we enter the twenty-first century, we should feel privileged that there are still people willing to brave -115°F windchills in search of knowledge and for whom Terra Incognita is an attraction.

If beauty is in the eye of the beholder, some will see beauty in a pipeline through the wilderness, or at least find respect in the story of how it came to be there. Beauty can be found not only in the scenic majesty of Alaska, but also in the commitment of those who work from the shores of the Beaufort Sea to Prince William Sound. In the not-too-distant future, if we measure time in terms of mountain ranges and rivers, or even in terms of human generations, the pipeline will be gone. Alaska's mountains will continue to rise, its rivers to erode, and its volcanoes to breathe fire and ash into the air. And perhaps someday, Raven will tell of a shining silver thread that once crossed Alaska.

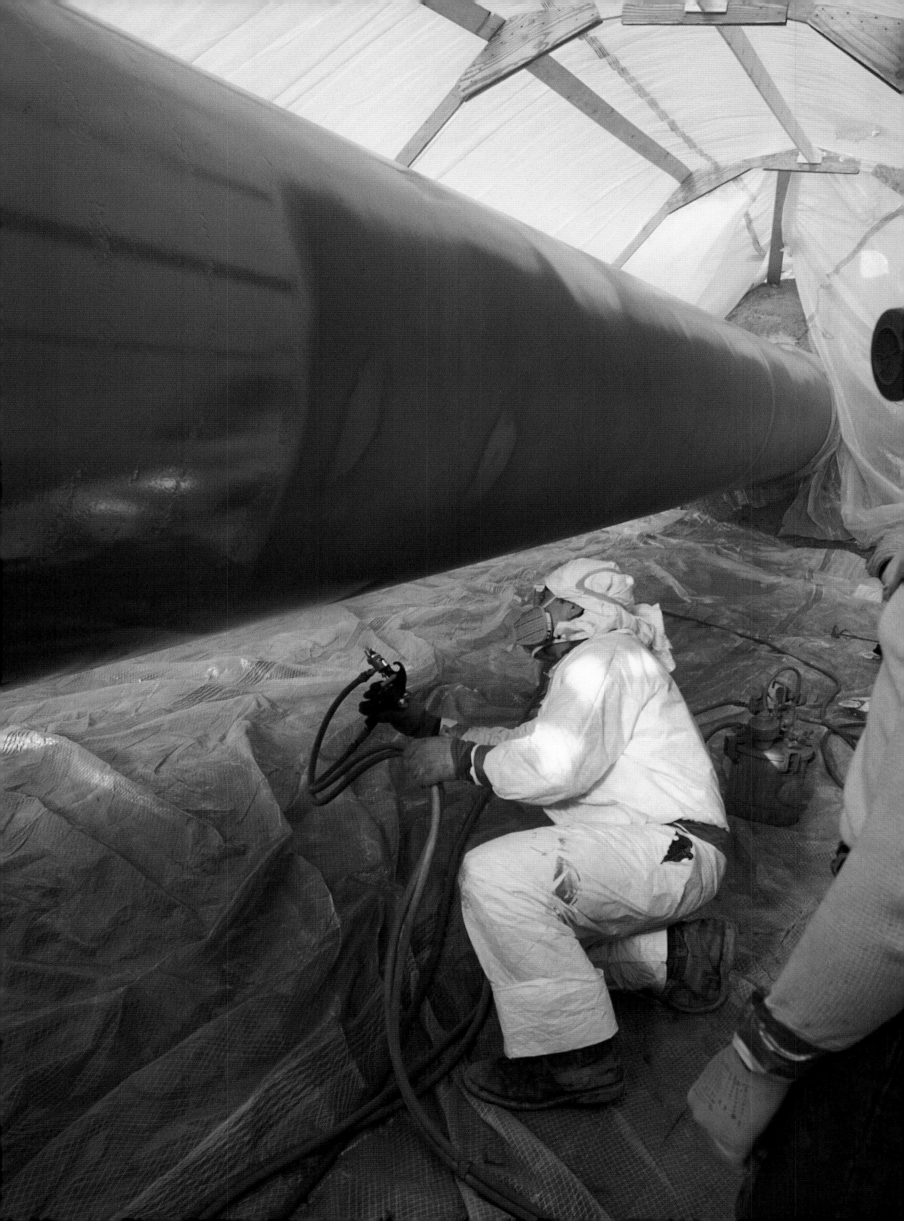

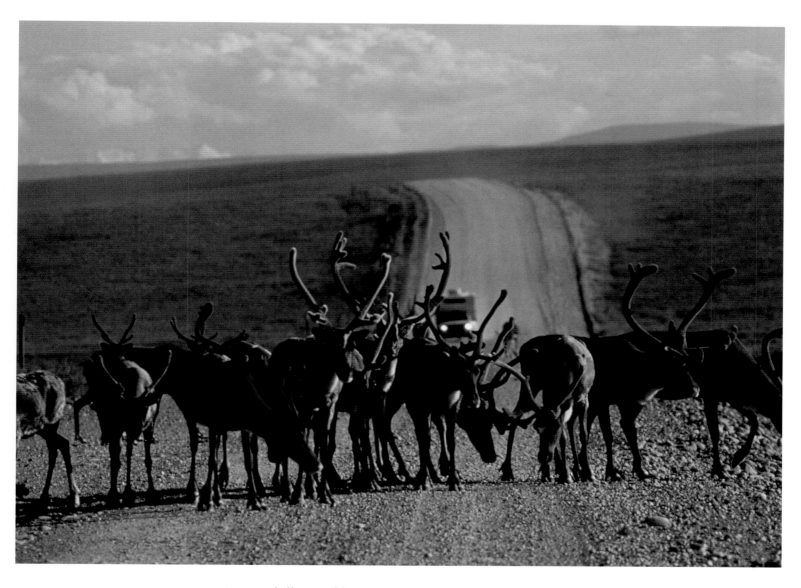

◁ A cranesbill, or wild geranium *(Geranium erianthum),* adds a touch of splendor to the undergrowth. Many of Alaska's wildflowers, such as the cranesbill and the forget-me-not *(Myosotis alpestris),* Alaska's state flower, have been adopted by local gardeners. △ Caribou *(Rangifer tarandus)* crowd onto the Dalton Highway near Pump Station 3. During the brief arctic summer, caribou often seek windswept areas to escape the irritating hordes of mosquitoes and other biting insects.

△ Large shackles are used to connect towing cables on emergency response vessels in Prince William Sound. ▷ The trans-Alaska pipeline stretches 1,299 feet over the Tanana River, ninety miles south of Fairbanks. The pipeline is suspended from steel cables anchored to massive foundations on both sides of the river. ▷ ▷ Two commercial fishing boats, part of an emergency response fleet of more than three hundred privately owned fishing vessels, practice deployment of oil spill containment boom. In the event of an actual incident, the *Valdez Star,* standing by, would remove the contained oil from the water.

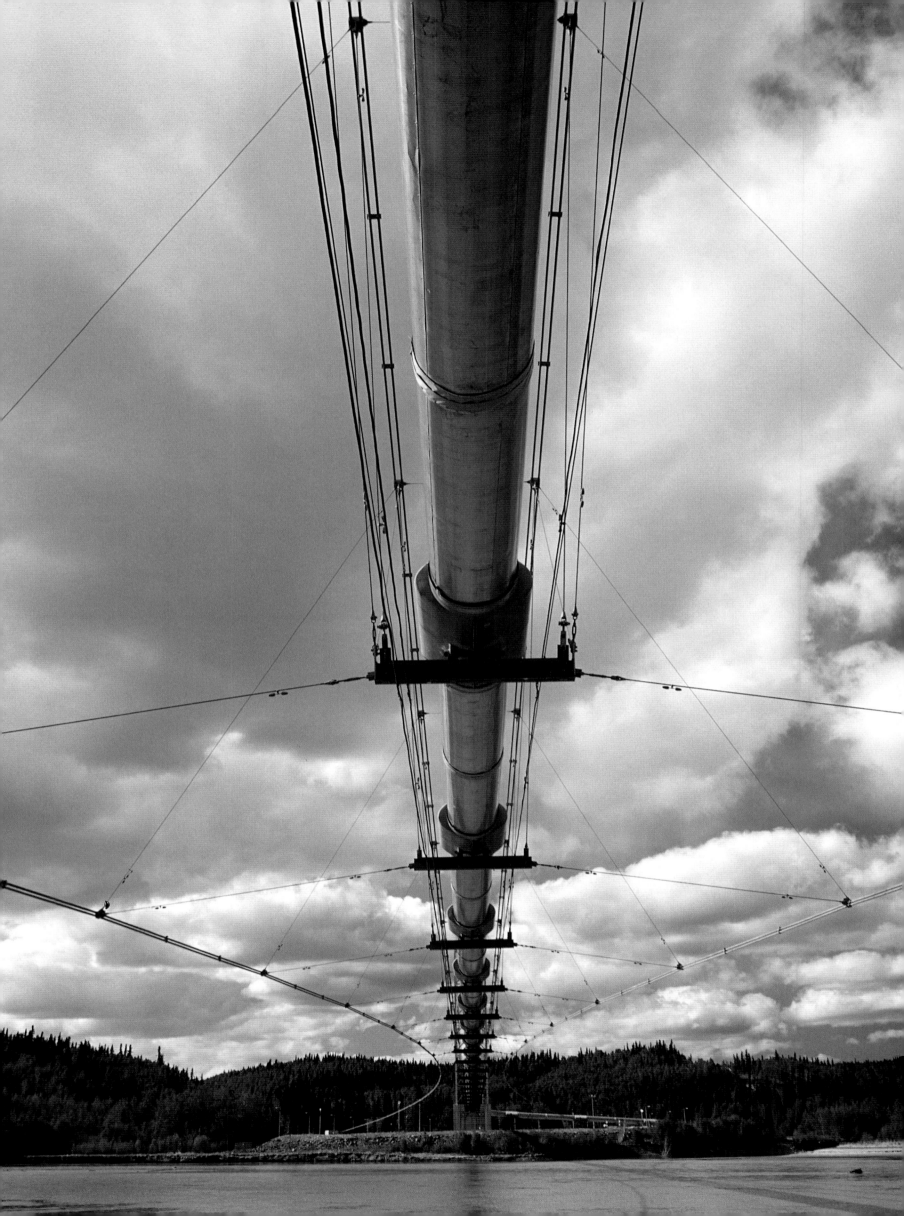

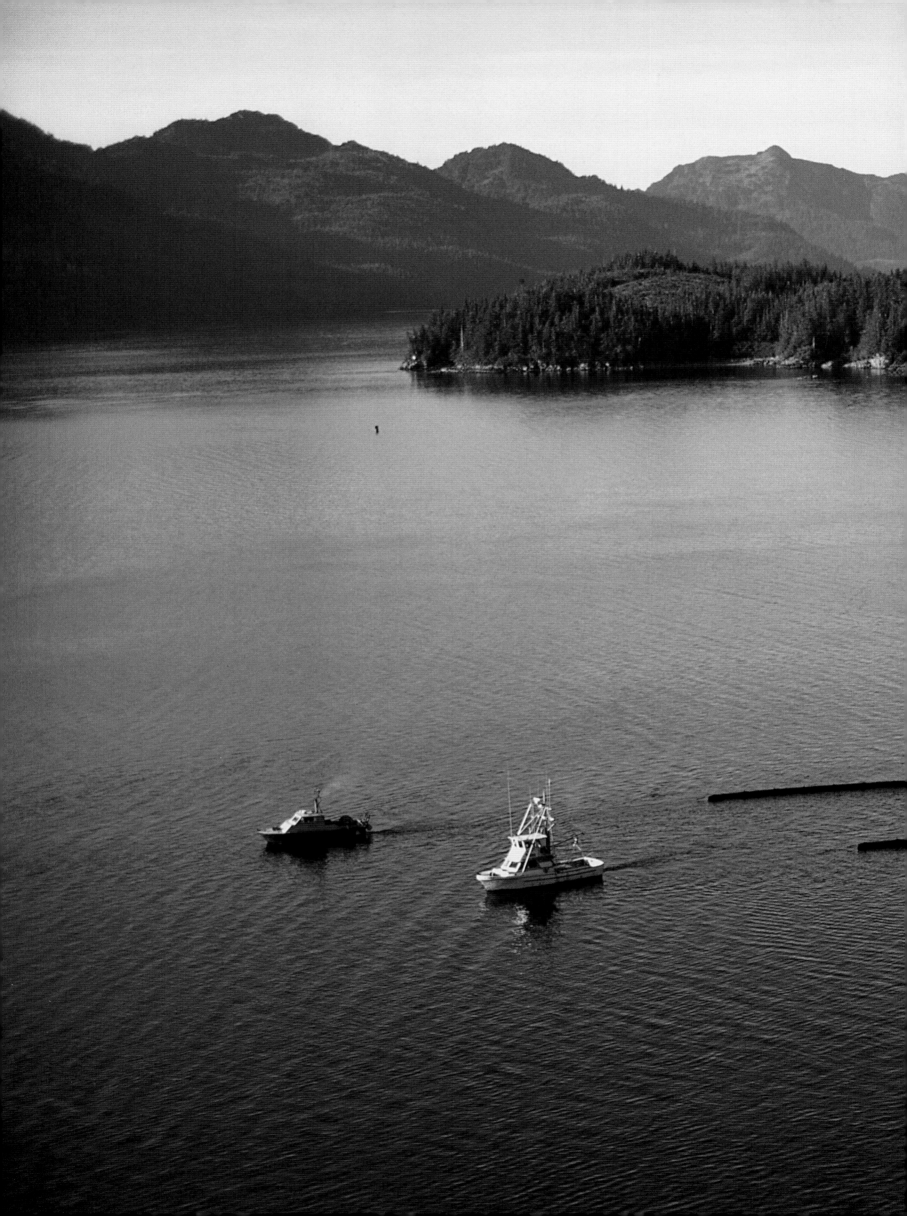

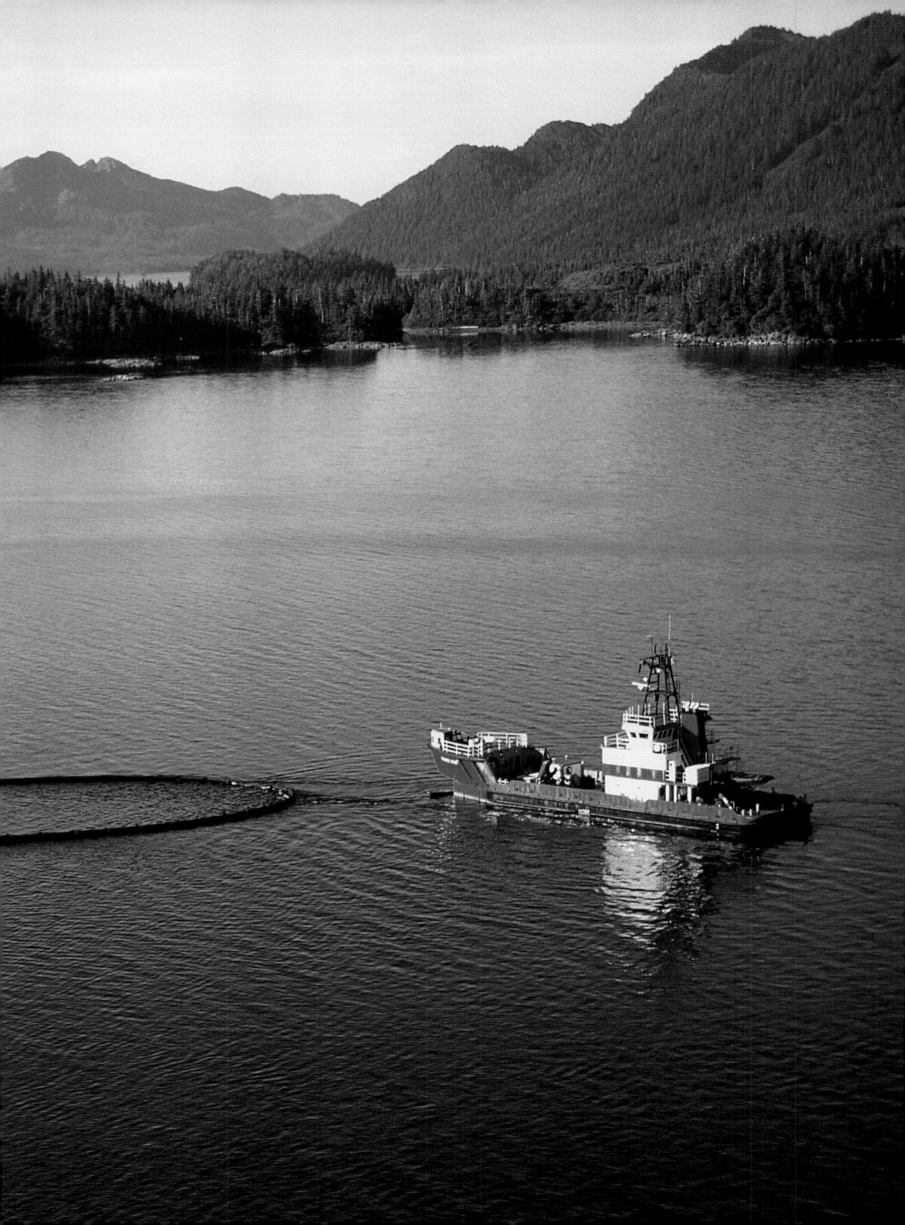

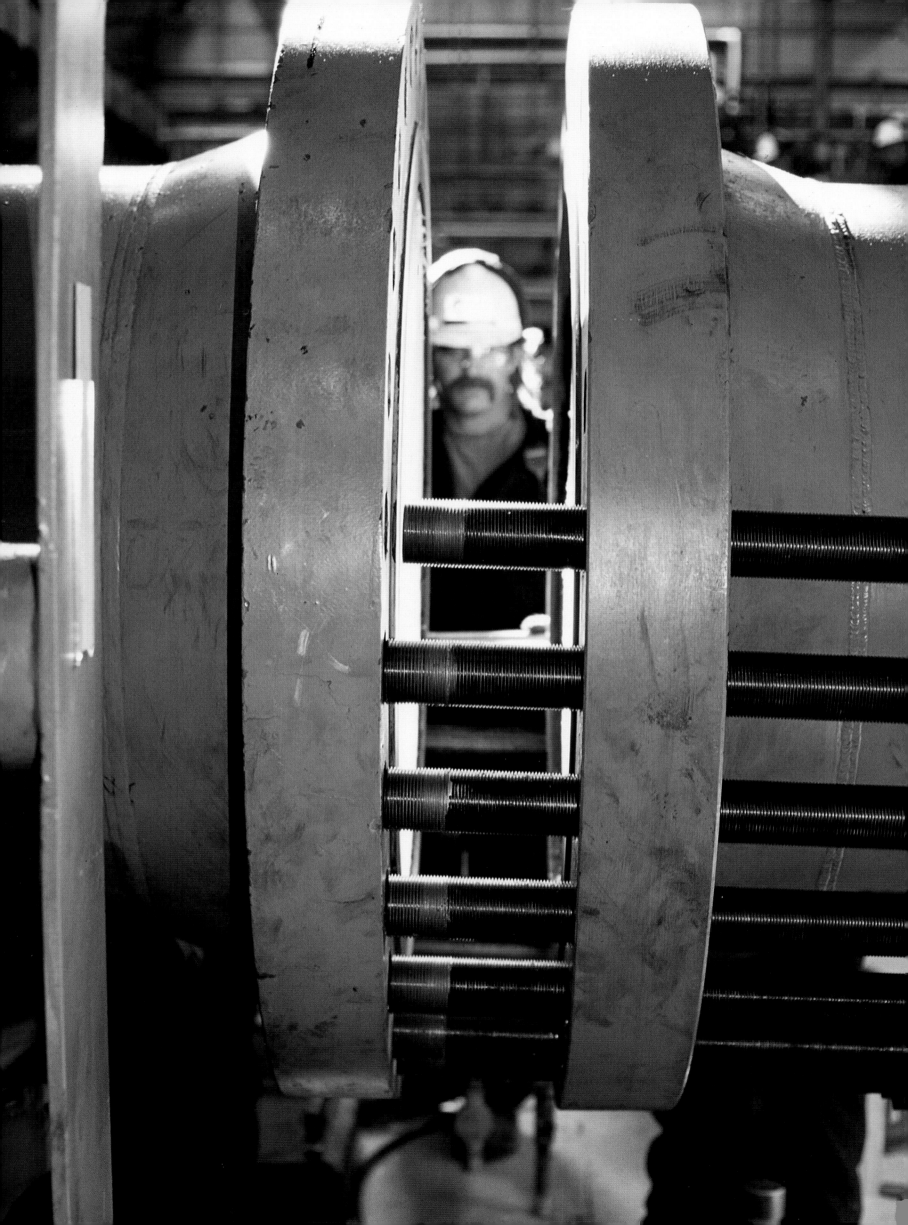

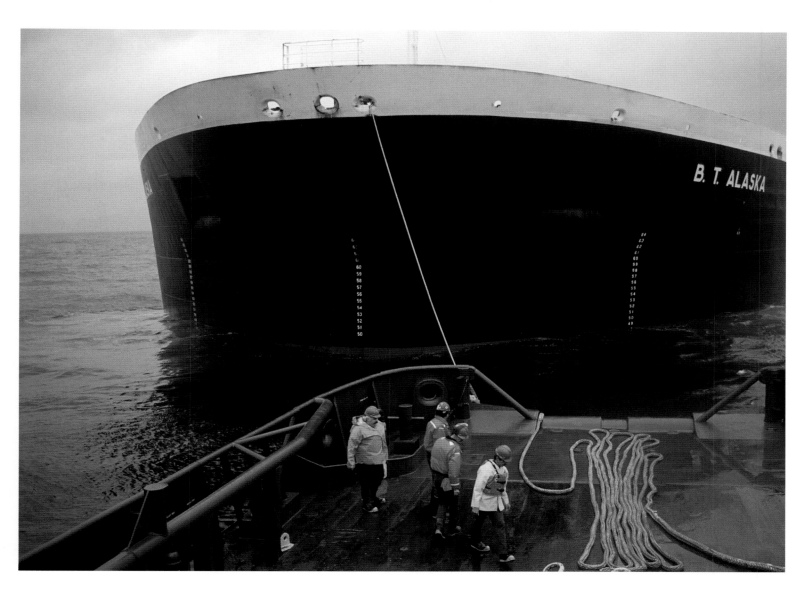

◁ At Pump Station 1, pipe is reconnected after replacement of a valve. The valve is closed during normal operations, but can be opened to allow the launching of a "pig" into the line. Constant maintenance is required to keep the pipeline functioning safely and efficiently. △ A spill response vessel prepares to tow an oil tanker as part of a routine exercise by SERVS, the Ship Escort/Response Vessel System. SERVS is equipped to tow a disabled tanker away from dangerous conditions. There is more oil spill response equipment stationed along the coast of Prince William Sound than in the entire rest of the Western Hemisphere.

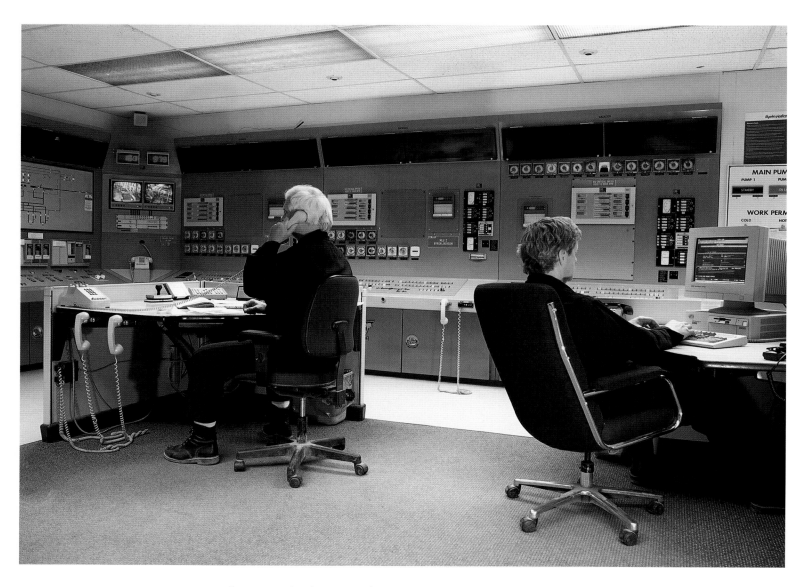

△ Operators in the control room at Pump Station 4 monitor oil flow and equipment twenty-four hours a day. They can control the flow rate of oil through the pipe, open and close valves, and even shut down the pipeline in an emergency. The Operations Control Center for the entire pipeline system is located at the Valdez Marine Terminal. ▷ Forty-one microwave towers along the pipeline have provided continuous communications since "oil-in" on June 20, 1977. If any link in this system should fail, a complete satellite backup system is in place. Alyeska will phase in a fiber optic system to replace microwave communications.

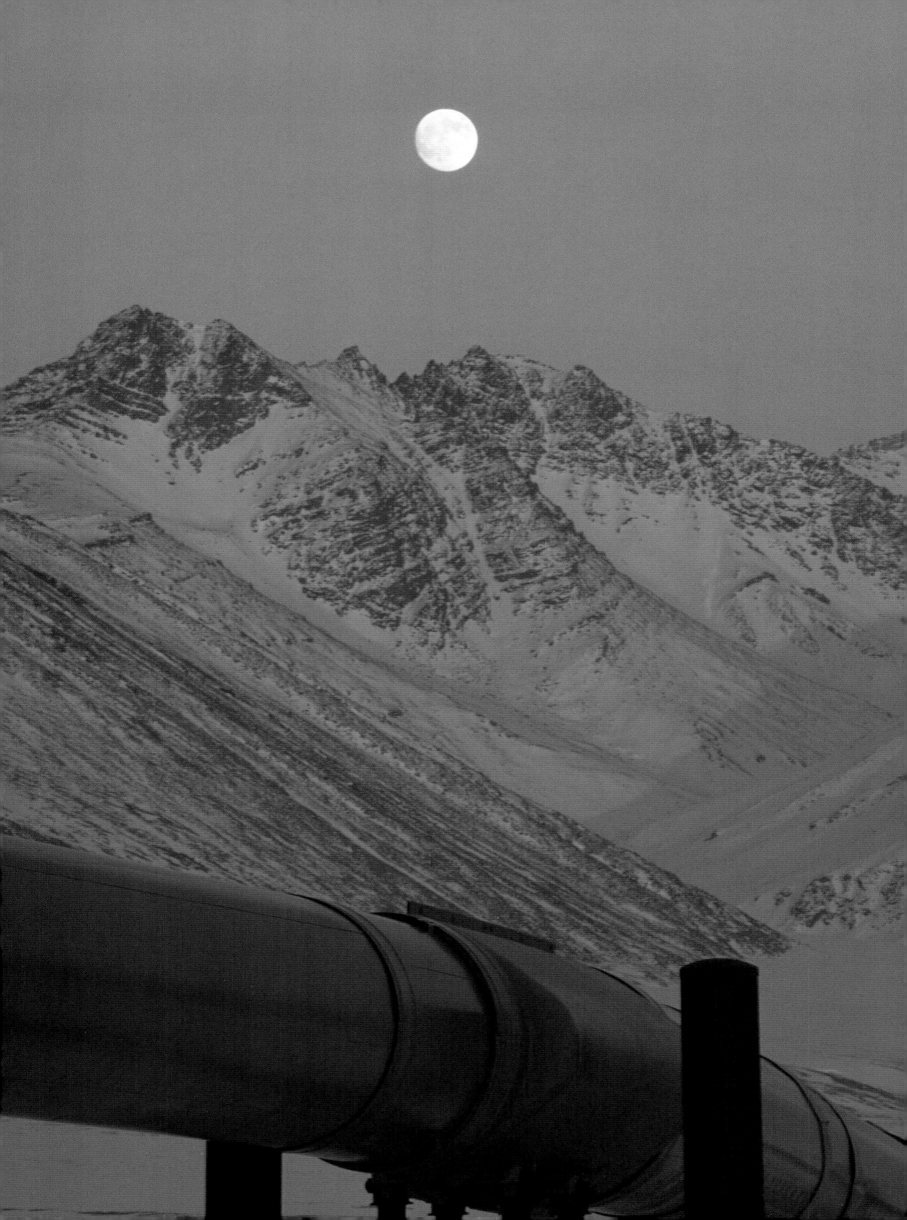

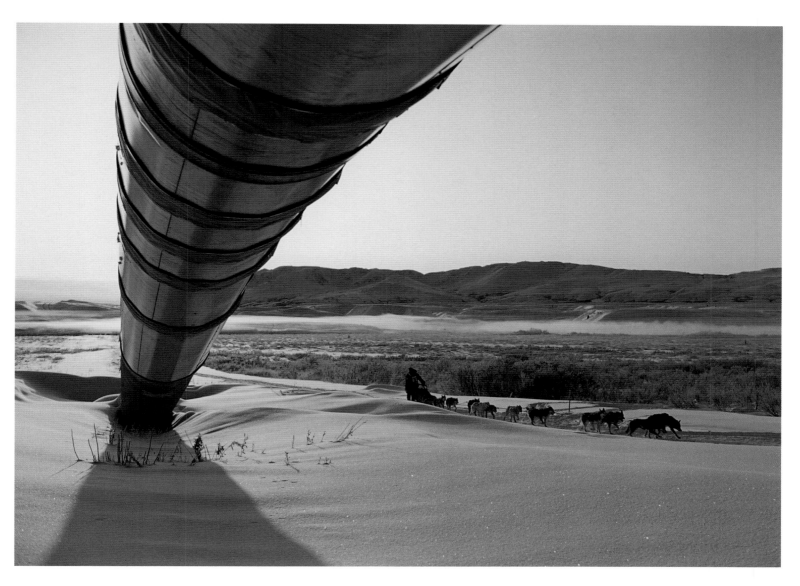

◁ In early May, the moon rises above the striated Brooks Range. The long days and melting snow signal that summer is only a few weeks away. △ This team is participating in the Copper Basin 300 sled dog race. Started in 1990, the race encompasses a three-hundred-mile wilderness circuit of lodges and road-houses in the Copper River country.

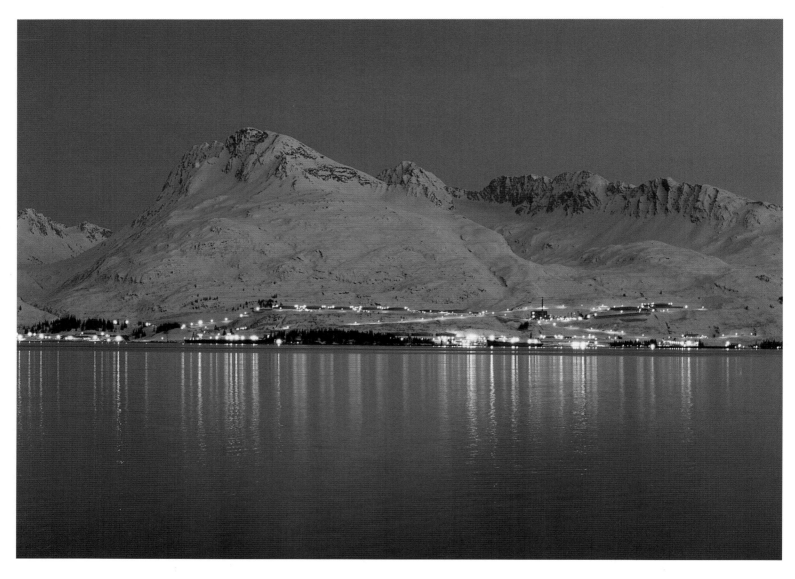

△ Before tankers at the Valdez Marine Terminal are loaded with oil, their holding tanks must be emptied of the oily seawater used as ballast. The terminal's Ballast Water Treatment Facility removes the residual oil, which is transferred to storage tanks. The water is processed in a biological treatment system and released into Port Valdez. All steps in the system are constantly monitored. ▷ At a stream crossing in Interior Alaska, armor rock protects the vertical support members from erosion. By spring breakup in May or June, the ice has almost melted. Willows (*Salix* species), now budding, are an important year-round food source for moose (*Alces alces*).

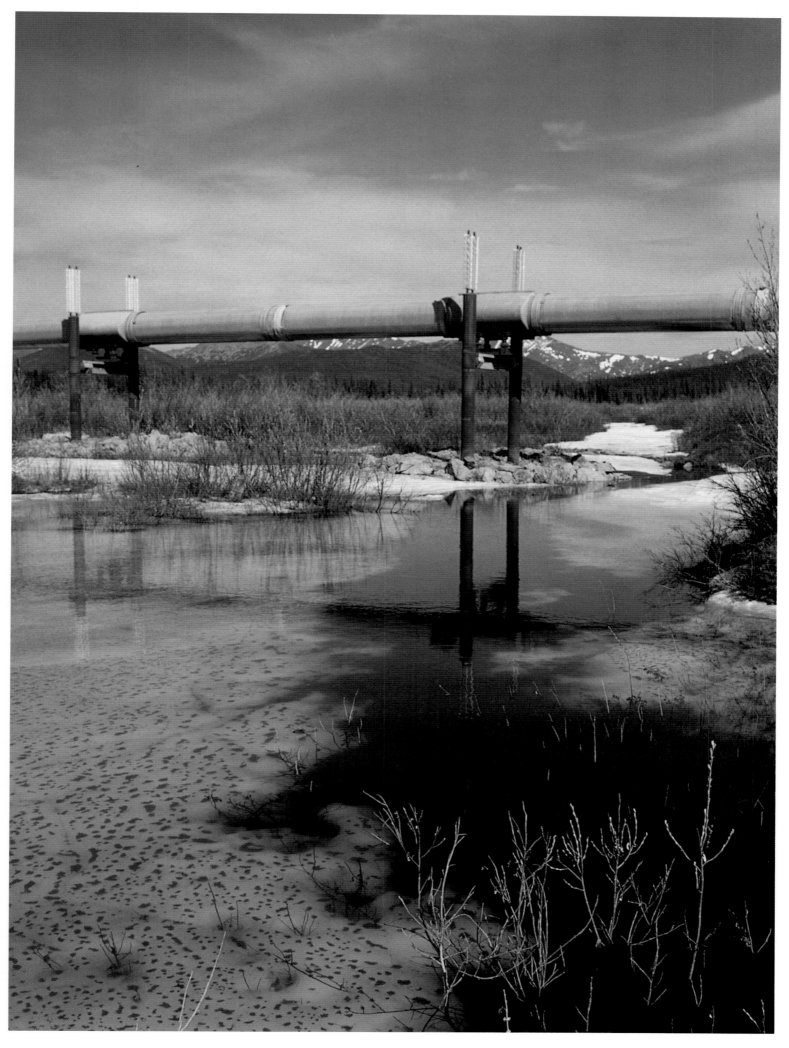

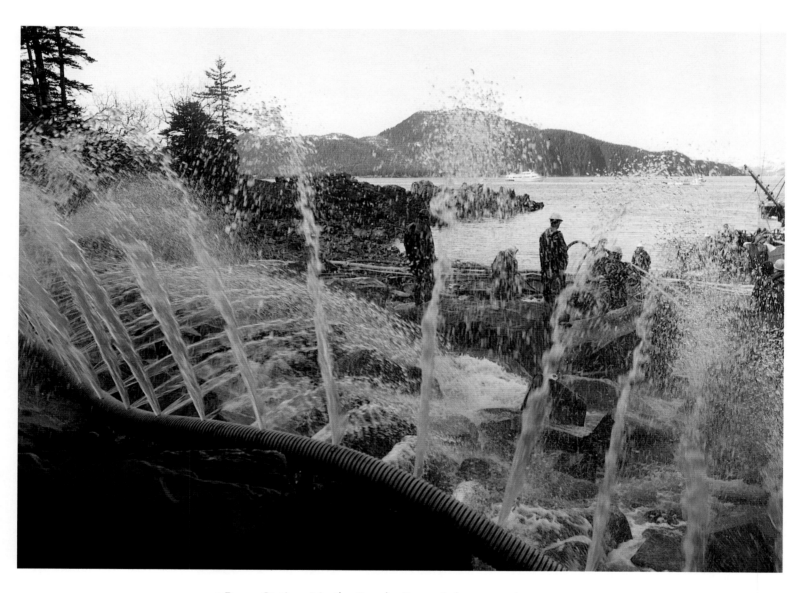

◁ Pump Station 4 in the Brooks Range is home to about twenty-five men and women who work one- or two-week shifts. Each Alyeska pump station is a self-contained facility, incorporating a communication center, a fully equipped kitchen and dining room, living and sleeping quarters, warehouses, maintenance shops, treatment systems for drinking water and wastewater, and its own electrical generation. △ Many techniques were used to clean shorelines after the 1989 *Exxon Valdez* oil spill. On Smith Island in Prince William Sound, crews scrubbed rocks and boulders as water was sprayed onto the beach.

131

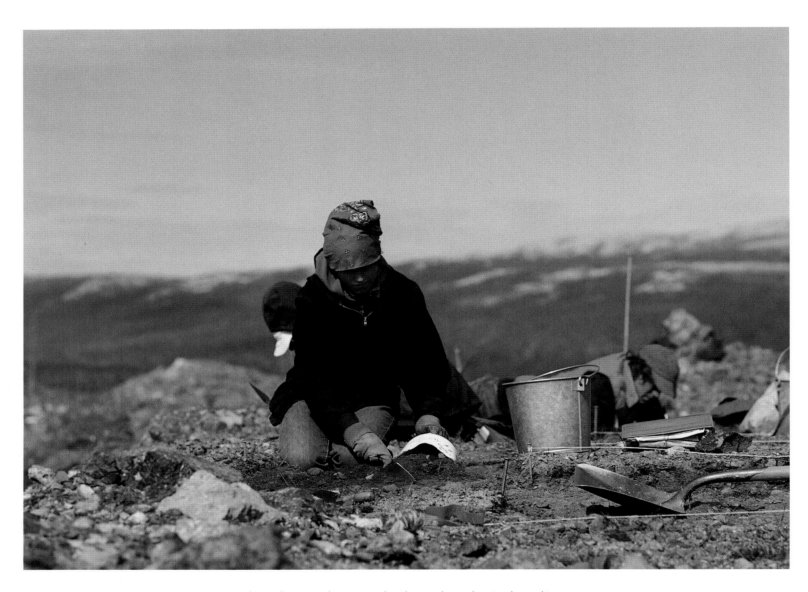

△ Before the pipeline was built, archaeological studies were made along the route to discover, protect, and characterize prehistoric sites. Some 330 sites were excavated in the 1970s, including here near the Kanuti River, where evidence of a nomadic hunting culture was found. ▷ In Interior Alaska, the pipeline passes from buried construction mode into above-ground mode. Heat-dissipating radiators on vertical support members are part of a cooling system to prevent permafrost from melting. In fall, golden aspen *(Populus tremuloides)* contrast with a forest of dark green spruce *(Picea* species).

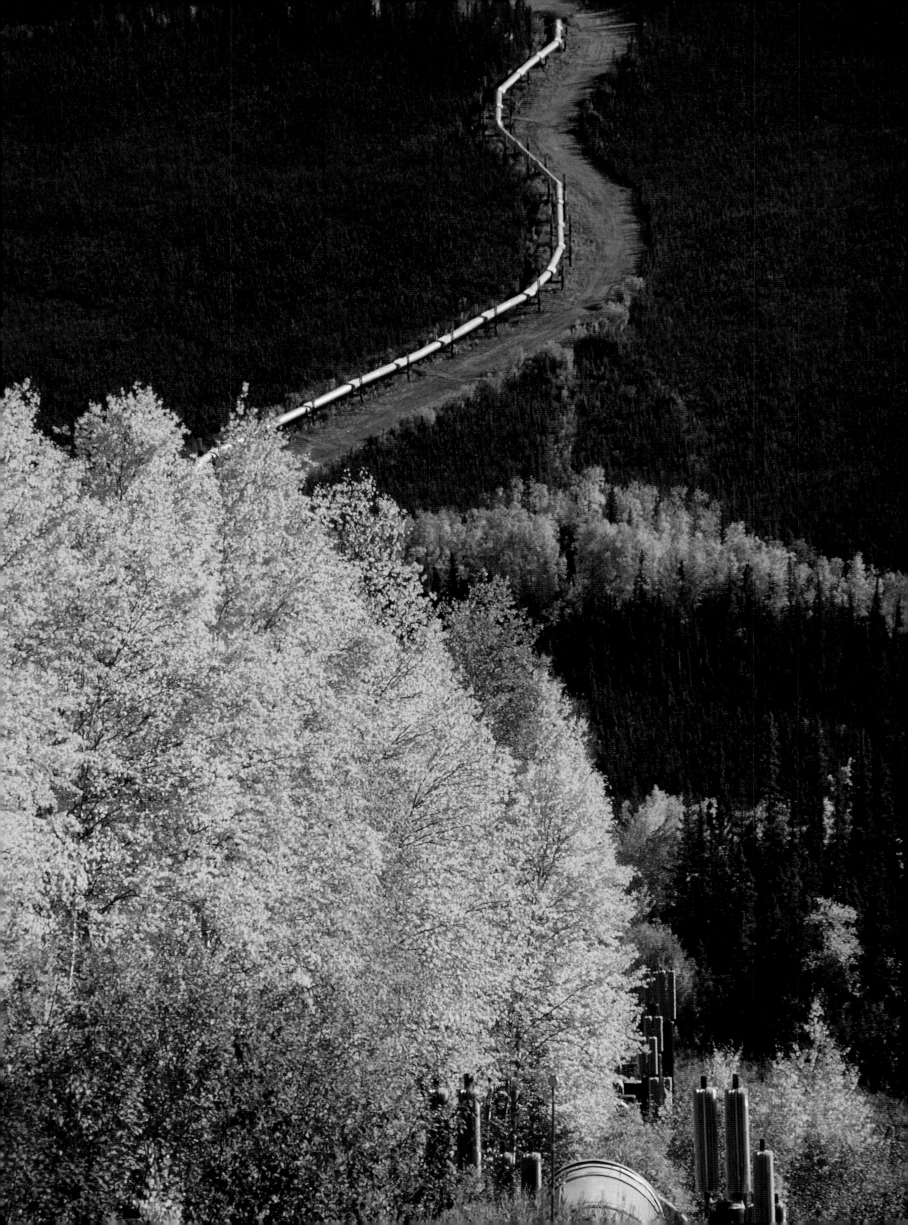

◁ At Isom Creek on the Yukon River, crews from the communities of Rampart and Stevens Village conduct an Alyeska spill-response exercise. In case of a real spill, the creek would be dammed with sandbags. Small culverts would allow water to be separated from the oily surface layer. All rivers and creeks along the pipeline have been studied and response plans developed in case of a spill. △ Frost coats mountain cranberries *(Vaccinium vitis-idaea)* and high-bush cranberry *(Viburnum edule) leaves.* ▷ ▷ Pump Station 3, 104 miles south of Prudhoe Bay, is near the western boundary of the Arctic National Wildlife Refuge.

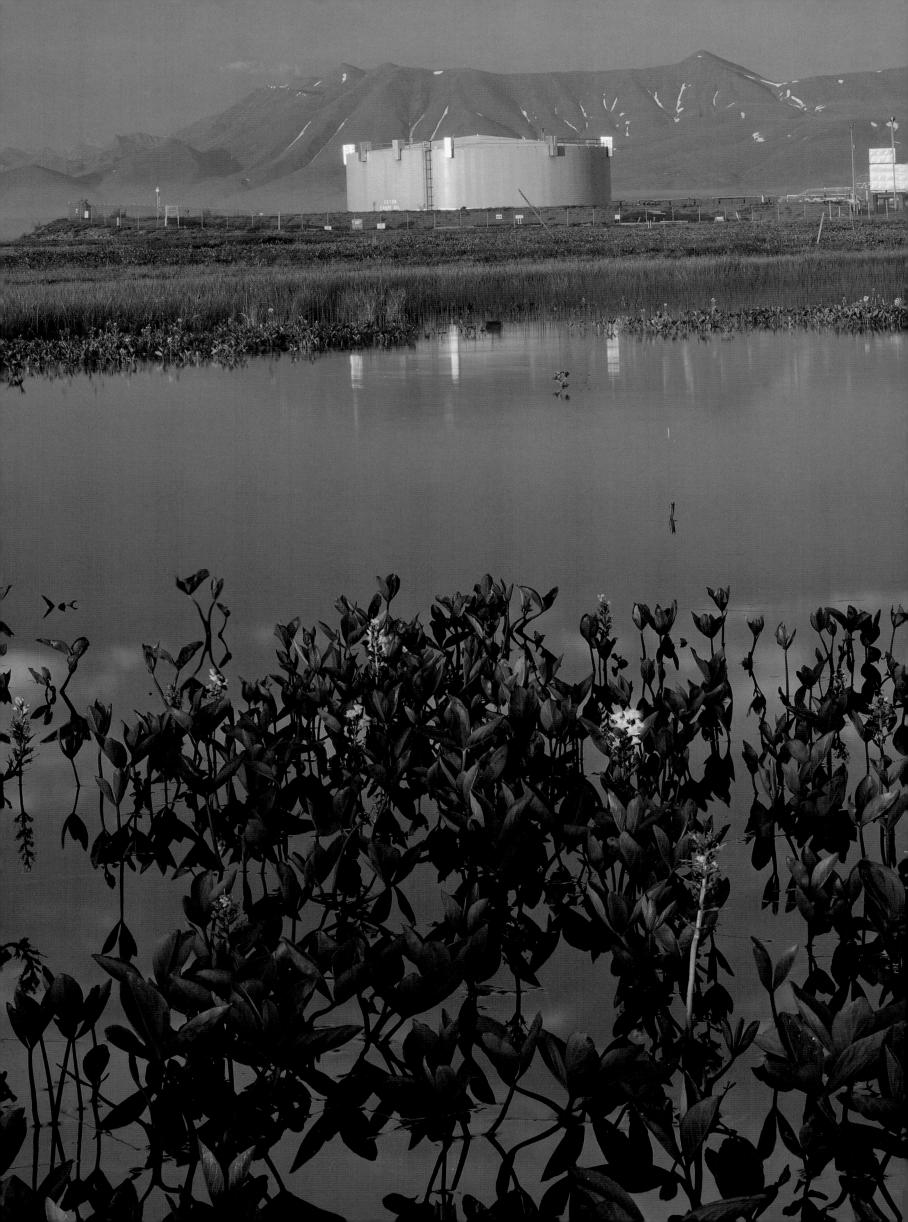

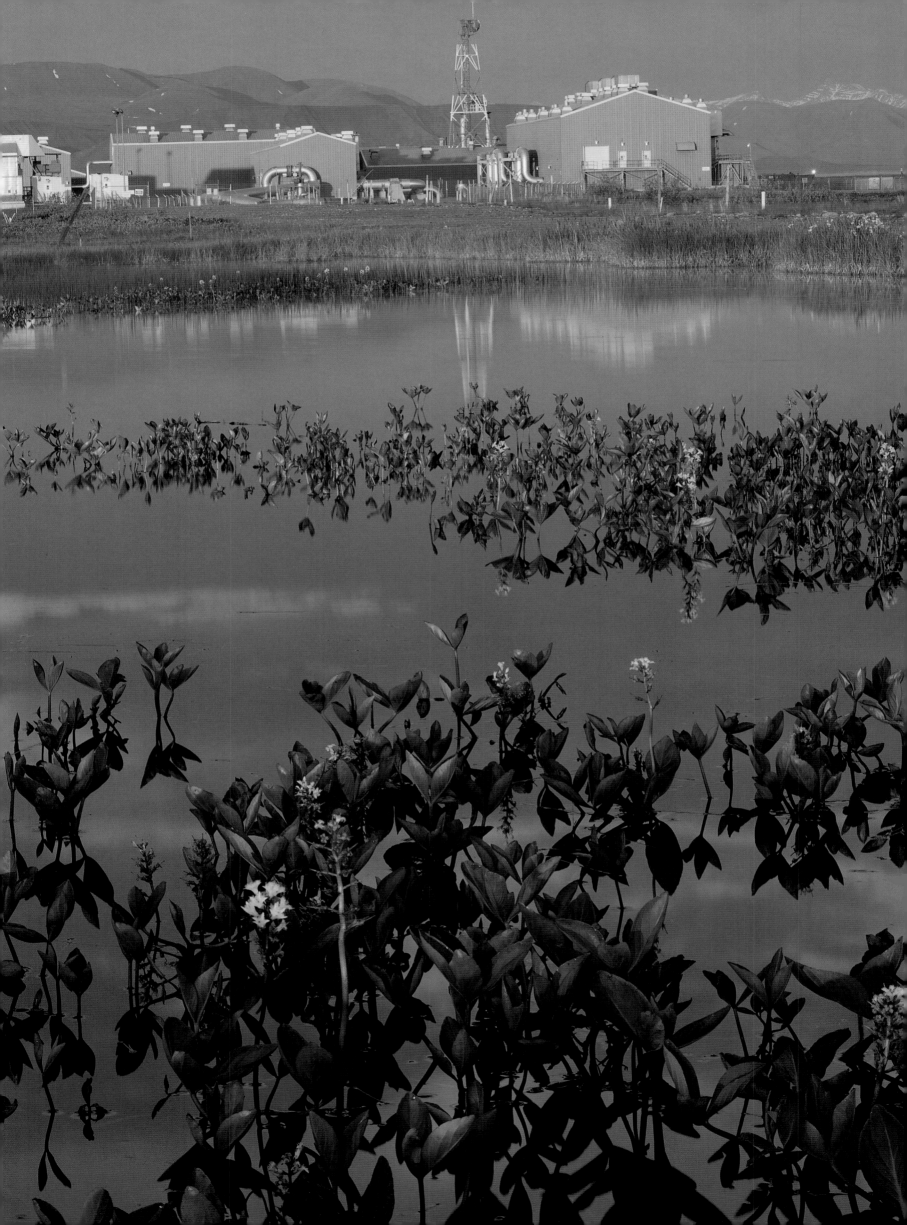

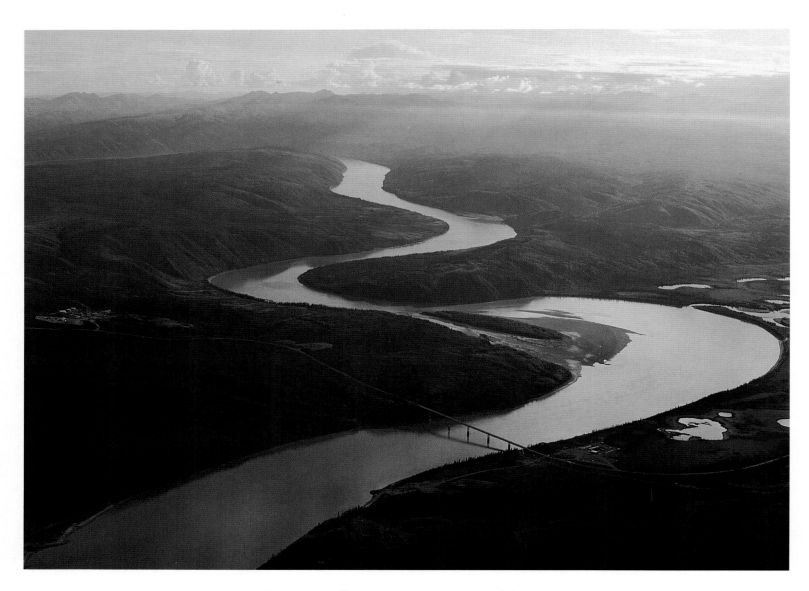

△ The Yukon River follows a sinuous path toward the Bering Sea. The 2,290-foot E. L. Patton Bridge, named after Alyeska's first president, crosses the river with the pipeline adjacent to the bridge deck. Pump Station 6 is visible just to the left of the river. ▷ Aboveground portions of the pipeline are elevated at least five feet to allow unrestricted passage of large mammals such as caribou and moose. The pipe consists of high-tensile carbon steel covered with resin-injected fiberglass insulation bonded to a galvanized steel outer jacket, which gives the pipe its silver shine.

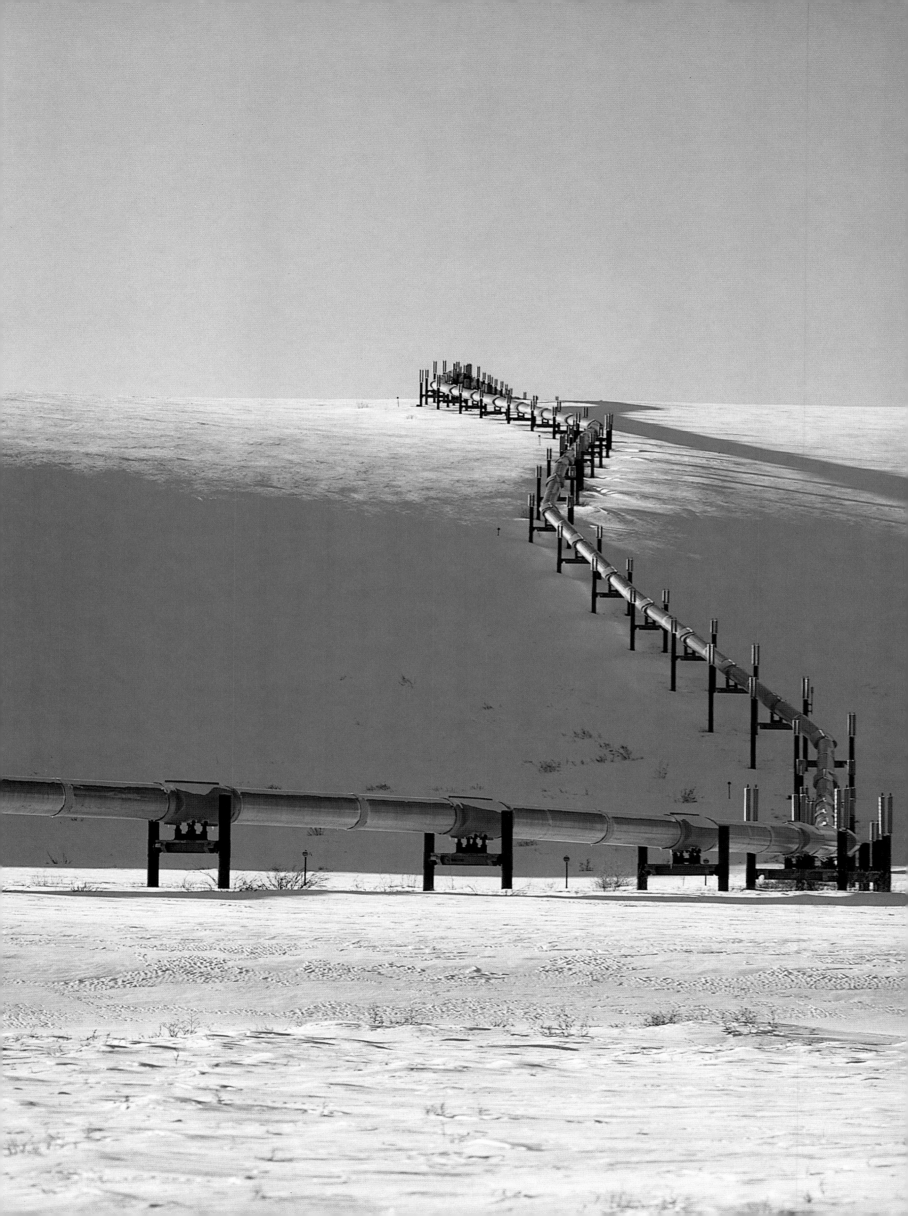

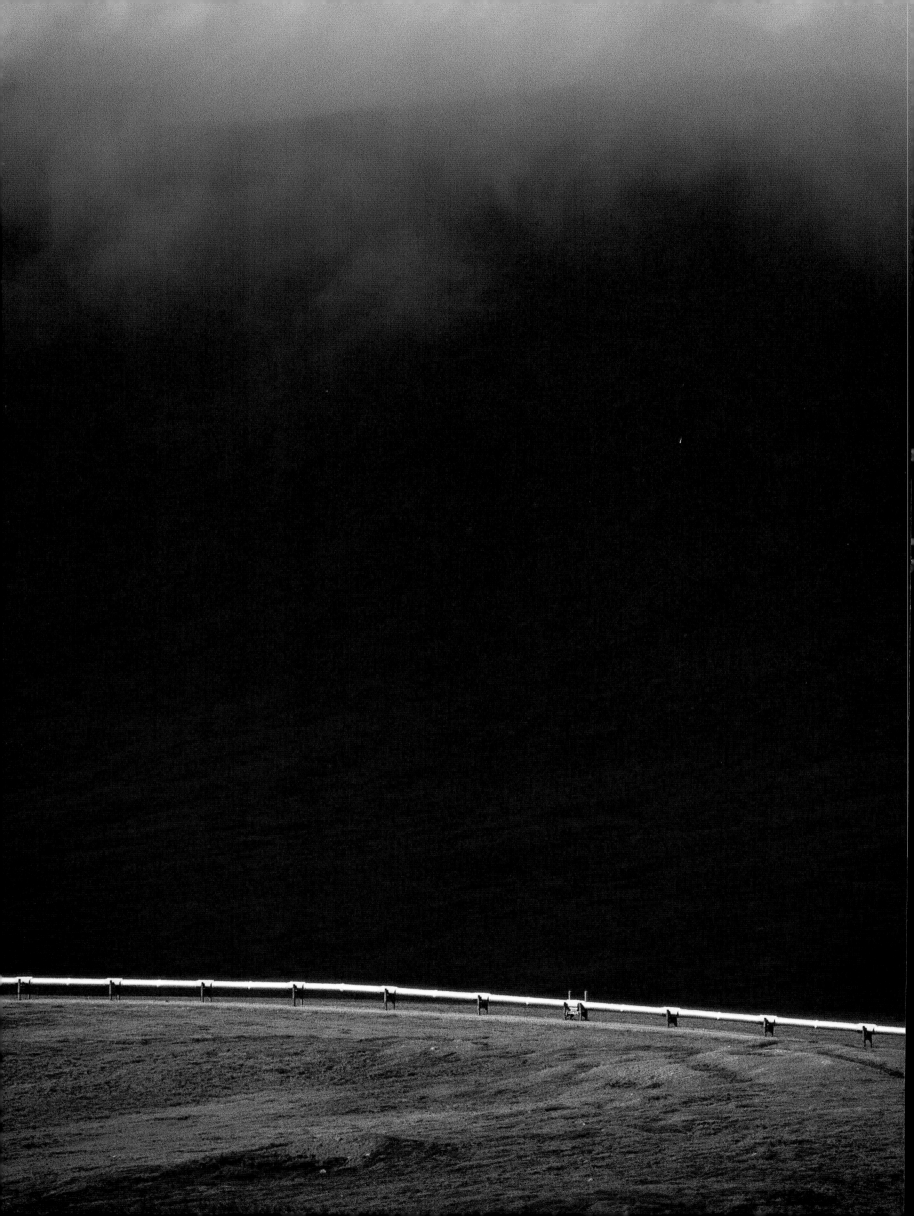

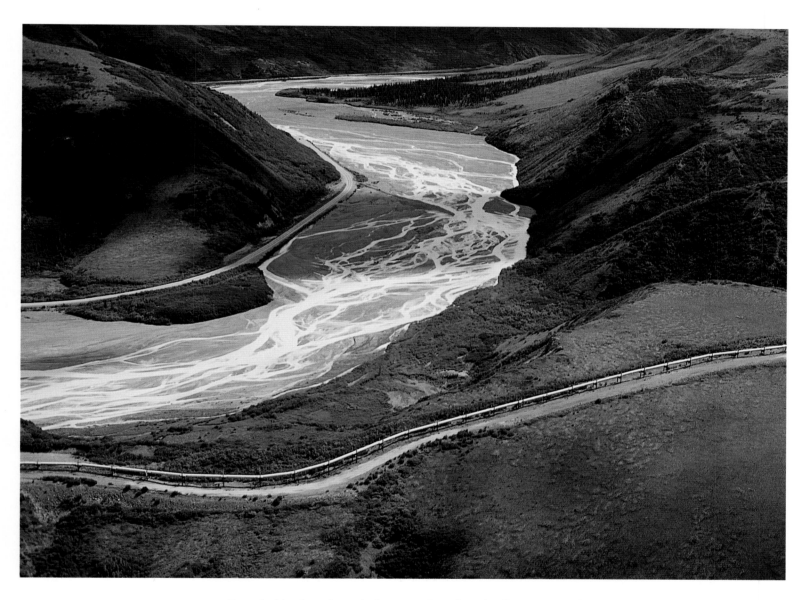

◁ Dwarfed by fog-shrouded mountains, the pipeline crosses the tundra like a silver thread. Here the pipeline is aboveground because the route traverses ice-rich soil. More than any other factor, the presence or absence of thaw-stable permafrost influenced construction techniques along the line. △ Near Pump Station 10, the pipeline crosses the Alaska Range, paralleling the Richardson Highway near the confluence of Phelan Creek and the Delta River. Except at full flood, Phelan Creek shows numerous braided channels typical of many Alaska waterways.

141

△ This twenty-foot-high statue at the Valdez Marine Terminal
commemorates the men and women who built the trans-Alaska
pipeline in three years and two months. The monument, sculpted
by Malcolm Alexander, shows a surveyor, an engineer, a laborer,
a welder, and a Teamster. ▷ The raven *(Corvus corax)* is present
everywhere in Alaska, a status befitting its legendary role of cre-
ator and mischief-maker. On the North Slope, the raven is one of
the few species to see winter come and go, watching people work
on the edge of the world to lift oil from ten thousand feet below
the surface and propel it down eight hundred miles of pipeline.

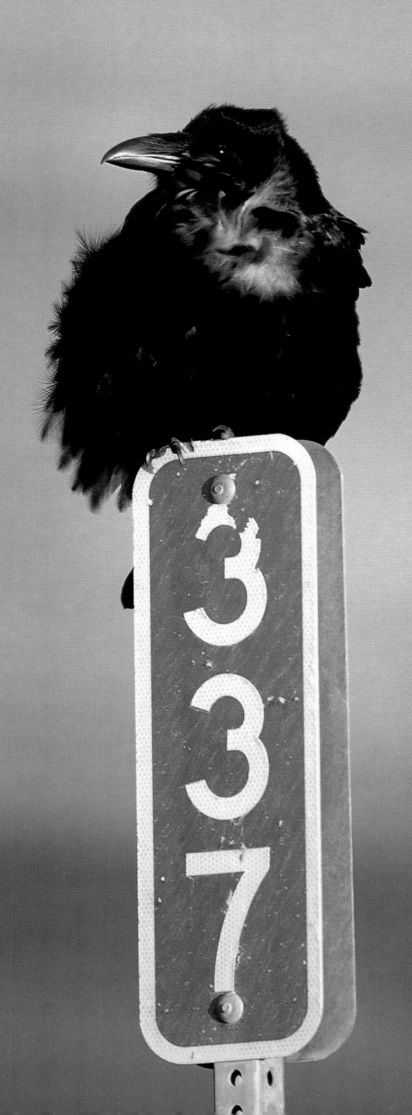

Acknowledgments & Copyright Notice

Graphic Arts Center Publishing Company would like to thank the photographers who provided images for this book: • pages 77, 104, 113, 119, back cover center photo © 1997 by Danny Daniels • pages 2, 11 left, 36, 37, 49 left, 51, 74, 90, 98, 99, 103, 105, 127, 130, back cover upper photo © 1997 by Tom Evans • pages 20, 87, 100, 101 both, 114, 120-121, 123, 131, 132 © 1997 by Frank Flavin • pages 13, 15, 16, 17, 29, 32, 33, 75, 116, 129, 144 © 1997 by Hal Gage • pages 80, 81 © 1997 by Michelle A. Gilders • page 26 © 1997 by Calvin Hall • pages 6, 10, 14, 19, 21, 22, 24, 31, 35, 40-41, 45, 46, 47, 63, 64, 69, 78, 93, 97, 107, 125, back cover lower photo © 1997 by Fred Hirschmann • pages 39, 72-73, 108, 124, 136-137, 143 © 1997 by Randi Hirschmann • page 117 © 1997 by Karen Kasmauski • pages 8, 28, 34, 38, 42, 138, 141 © 1997 by Danny Lehman • page 109 by Kathy Mayo, © 1997 by Alyeska Pipeline Service Company • back flap author photo © 1997 by Lin Mitchell • pages 7, 9, 23, 48, 53, 54, 55, 57, 65, 76, 82, 83, 106, 115, 122, 128, 134 © 1997 by Judy Patrick • pages 25, 110, 126 © 1997 by David Predeger • page 30 by David Predeger, © 1997 by Alyeska Pipeline Service Company • pages 18, 139 © 1997 by Stefan Schott • front cover photo, pages 4, 11 right, 12, 27, 43, 44, 49 right, 52, 56, 58, 59, 60, 61, 62, 66, 67, 68, 71, 79, 84, 85, 86, 88-89, 91, 94, 95, 96, 102, 111, 118, 133, 140, 142 © 1997 by Harry M. Walker • page 92 © 1997 by Pat Welch • pages 50, 70, 112, 135 © 1997 by Pat Wilson • page 1 © 1997 by Kim Yarborough.

The publishing company also thanks Alyeska Pipeline Service Company and its employees for cooperation and assistance during research for the book, and in checking the facts to maintain the accuracy of the text and captions. Our special thanks go to: Anne Brown, Barbara Blackshear, Norma Campbell, Dave Comins, Kathy Gallaher, T. L. Green, Steve Hood, Bill Howitt, Charlie Hubbard, Jordan Jacobsen, Lee Jones, Meg Jones, Larry Ladd, Bob Malone, Kathy Mayo, Ron Miller, Kate Montgomery, Dave Norton, Chuck O'Donnell, Dave O'Neill, Bruce Painter, Tim Rupp, Jennifer Ruys, Dave Schmidt, Lee Schoen, Bob Schoff, Jim Sweeney, David Trudgen, Doug Webb, Hank Wladkowski, and Larry Wood – Alyeska Pipeline Service Company; Alyeska Security Department; Steve Taylor and Simon Lisiecki – BP Exploration (Alaska) Inc.; Carol Hunt – Chugach North Technical Services; Shannon McDade – Compliance Management Inc.; Mike Thompson – Alaska Department of Fish and Game; Phil Brna, Alaska Department of Fish and Game – Joint Pipeline Office; Jerry Brossia, Federal Bureau of Land Management – Joint Pipeline Office; Jim Lukin – Lukin Publications Management; Roger Herrera – Northern Knowledge; Dave Inman – Price/Ahtna; Governor Walter J. Hickel and Bob King – State of Alaska, Office of the Governor; Stevens Village and Rampart residents; Jay McKendrick – University of Alaska Fairbanks; Max Brewer – U.S. Geological Survey; Albert S. Tabor – Vinson & Elkins. Thanks also go to the many others who contributed comments and insights on Alaska, from Prudhoe Bay to Valdez and all points in between.

THE EDITORS